HOUSE OF MASKATI

First published in 2017
Distributed by River Books
396 Maharaj Road, Tatien, Bangkok
T: (66 2) 622-1900, 224-6686
F: (66 2) 225-3861
E: order@riverbooksbk.com
www.riverbooksbk.com

Collective work © A.T.E. Maskati Co. Ltd.

All rights reserved. No part of this book or DVD may be reproduced or transmitted in any form or by any means, electrical or mechanical, including photocopying, recording or by any information or retrieval system without the written permission of the copyright holder.

National Library of Thailand Cataloging in Publication Data

ISBN: 978 616 7339 93 1

Writer: Sarah Rooney
Collaborator (textile & general research): Prapassorn Posrithong
Contributor (text & photography): Sakib Maskati
Designer: Peter Cope
Production manager: Paisarn Piemmettawat
Publisher: Narisa Chakrabongse

Printed and bound in Thailand
by Sirivatana Interprint Public Co., Ltd.

HOUSE OF MASKATI
ONE INDIAN FAMILY'S SIAMESE TEXTILE LEGACY

DEDICATED TO
ABDUL TYEB MASKATI
FOUNDER OF THE
HOUSE OF MASKATI

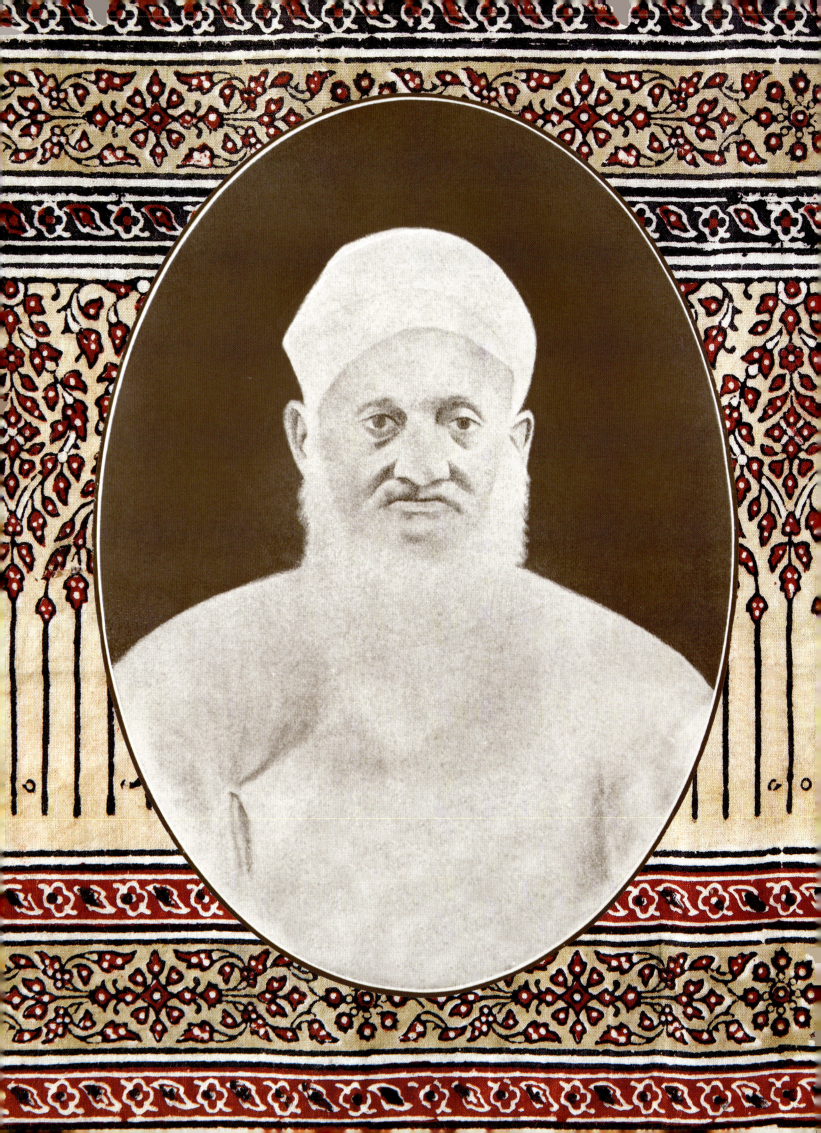

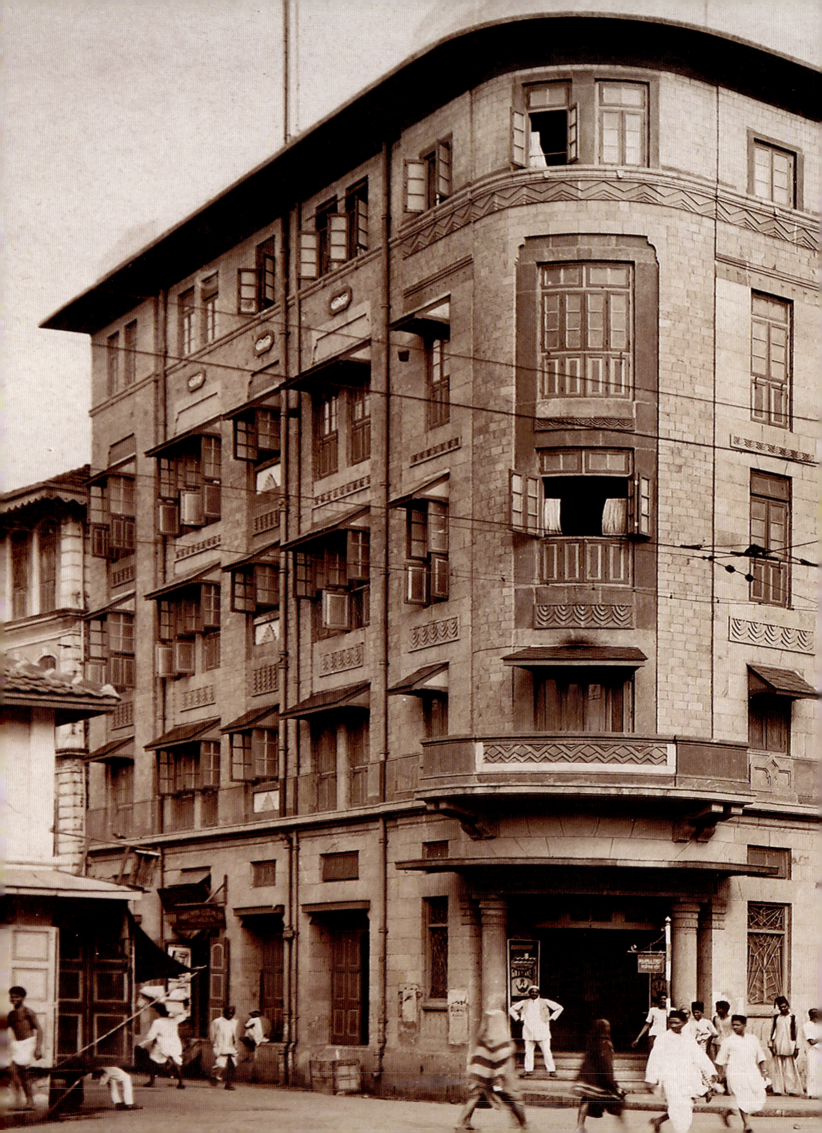

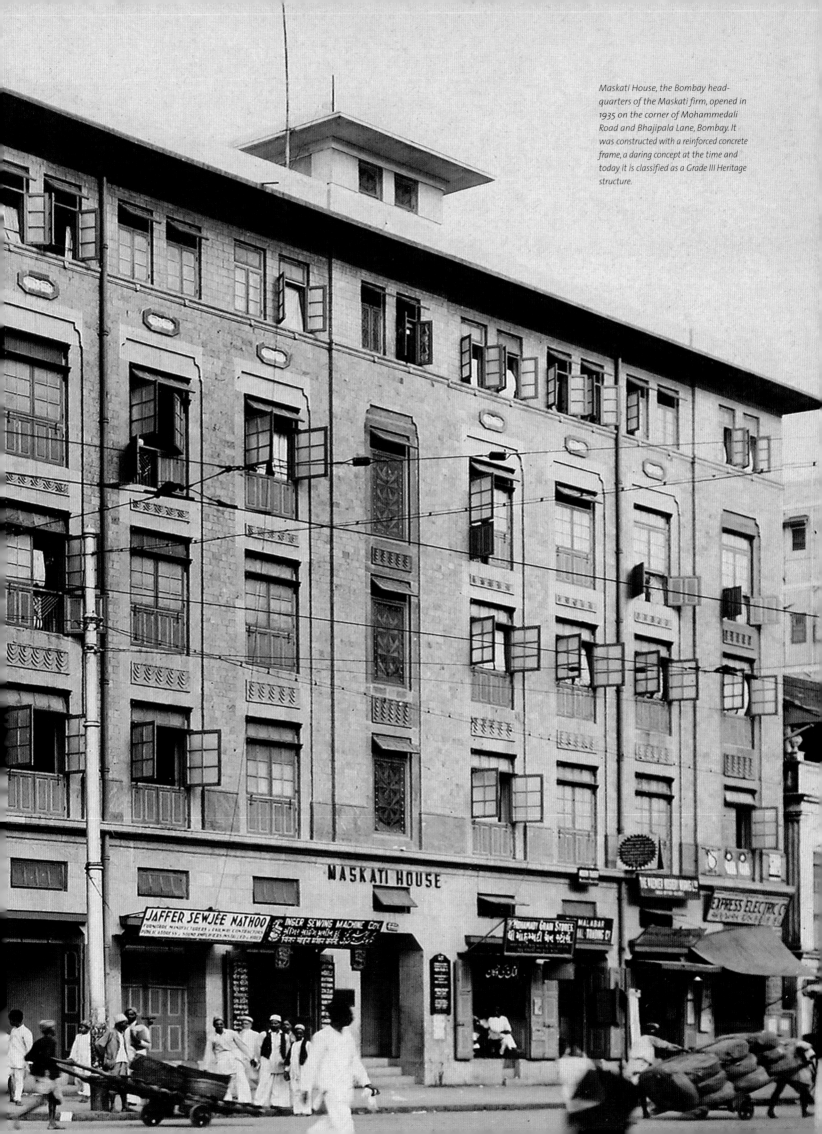

Maskati House, the Bombay headquarters of the Maskati firm, opened in 1935 on the corner of Mohammedali Road and Bhajipala Lane, Bombay. It was constructed with a reinforced concrete frame, a daring concept at the time and today it is classified as a Grade III Heritage structure.

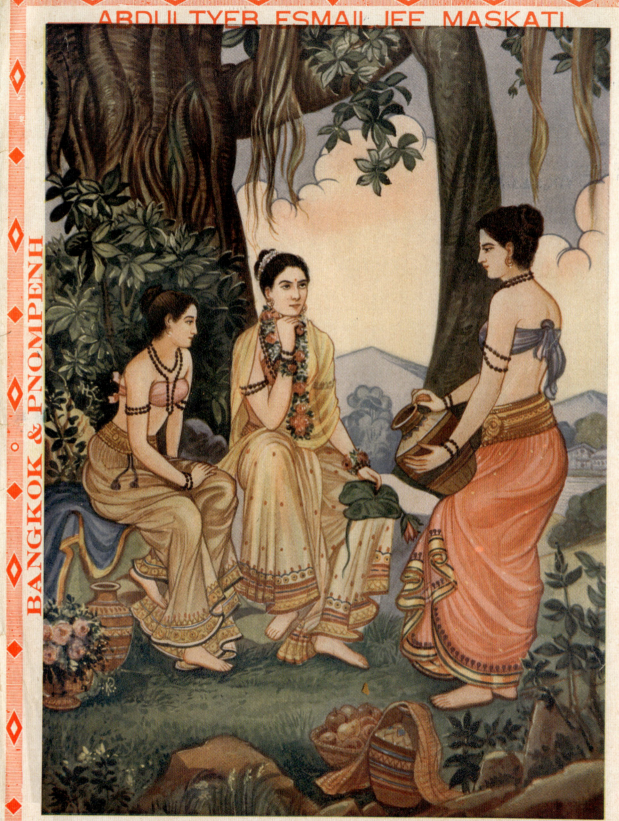

CONTENTS

Maskati label, 1906. Maskati cloth was sold folded flat with a paper label attached to the front. This label is an oleographic print on paper, a printing technique that mimics the look of an oil painting. It was printed for use by the company's main Southeast Asian distribution points in Bangkok, Thailand, and Phnom Penh, Cambodia. The Thai writing across the bottom reads, 'Pha lai [block-printed cloth], specially ordered, House of Maskati'.

Foreword 11

Prologue 12

Foundation 14

Expansion 40

Consolidation 68

Diversification 86

Transformation 112

Prudence 132

Continuity 156

The Art of Saudagiri 174

Family Tree 186

Index 191

Bibliography 196

Acknowledgements 200

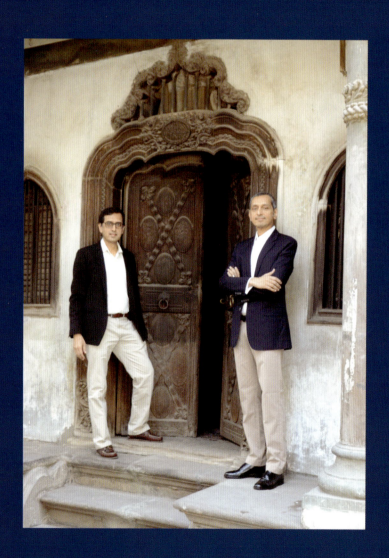

The Maskati brothers, Sakib (left) and Ateeb (right), standing at the entrance of the nineteenth century row-house in Begumpura, Surat, where their great-great-grandfather, Abdul Tyeb Maskati, founded the family business.

FOREWORD

I am honoured to represent my family members in writing a foreword to this book celebrating 160 years of our family business. The thought of producing a family history book arose several years ago. As one of the fifth generation, I realized it must be compiled now or it may never happen; memories and valuable information are lost with each passing year.

It took a while to get started on such a monumental project, particularly trying to find the right person(s) to research and write this book. I was fortunate to have found the perfect combination in Sarah Rooney, a passionate writer with a degree in Asian history who has collaborated on several non-fiction books, and Prapassorn Posrithong, a learned textile scholar. Together, they have crisscrossed countries where our family business had a presence. They have done a remarkable job in bringing historical context to five generations of the family story, such that I believe this book is not just of value to family and friends but will spark the interest of a wider audience.

I am profoundly struck by Sir Isaac Newton's famous quote, *'If I have seen further, it is by standing on the shoulders of giants.'* We are where we are today only because of the strong shoulders of those before us. It is not only the shoulders of my forefathers; I salute all those remarkable men and women employed in our firm who stood by them and served the organisation with integrity and capability. And I thank all those who are standing by us today to continue our journey. They are all the heroes of this book.

I must pay tribute here to Balubhai Lalbhai, the accountant in my great-great-grandfather's office who had the vision to seek permission and document the life story of his boss. Without him we would not know the person who founded the Maskati business in such vivid detail. In the writing of our family's history, his document is a priceless treasure that would have been impossible to hand down by word of mouth.

My thanks go to all our family, staff, and friends who have so richly contributed to this book. In particular, I'd like to acknowledge the enthusiasm, encouragement, and warm support I received from the immediate family – my parents Rasheed and Zahra, Ziya, Sakib, Sharmeen, Azmat, Geoffrey, and Zilika. A special mention to my brother Sakib who has been an indispensable resource on the Indian side by supplying information, verifying facts, photographing key visuals, editing text, and offering advice; my Aunt Ziya for her treasure trove of family documents and photos; and my wife Zilika who has worked tirelessly hand-in-hand with me throughout the life of this project.

On page 76 you will see a colonial-era emblem from our 1909 family property chart, which is displayed on the opposite page. The core value in the symbol – *'honesty is the best policy'* – has held five generations of the business together. Indeed, it has been said that without trust there is no relationship, and without a relationship there can be no business.

Within these pages, the story of business success and hardships is woven together with the personal side of our family story – living, sharing, and giving. In conclusion, I hope this book will provide joy and enduring value to the sixth generation of the Maskati family tree – six beautiful girls and one handsome boy! May they continue to write their own noteworthy story in the sands of time.

Ateeb Maskati
Bangkok, Thailand

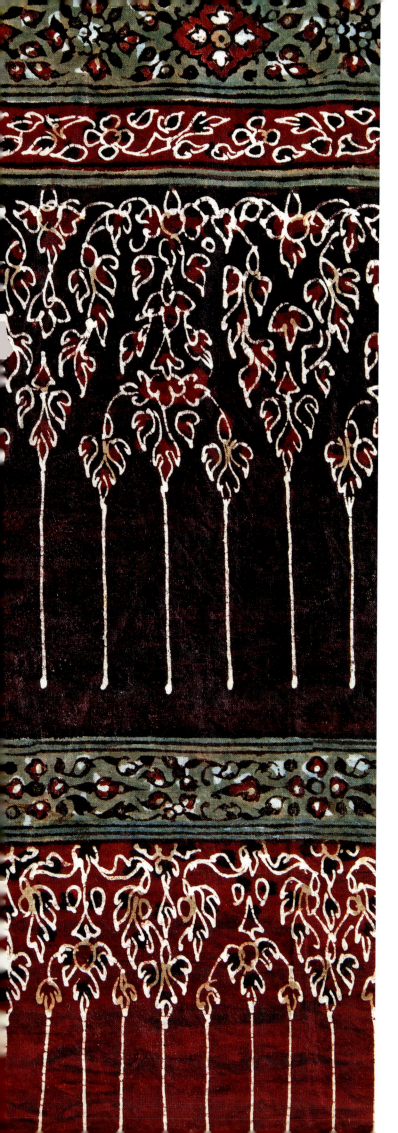

PROLOGUE

On the 4th of February in the year 1933, Balubhai Lalbhai sat down at his desk in Surat, India, and began to write the history of the Maskati family firm. Balubhai wrote from direct experience; as an accountant at the firm for more than half a century he knew both the business and the founder well. The chronicle he began to write was composed partly from his own memories and partly from his memories of the stories told to him by the firm's founder, Abdul Tyeb Esmailji Maskati. Balubhai's aim was to record the stories before they were forgotten.
'As the only surviving member of the old staff,' he wrote, *'it has occurred to me that I should write down whatever I know about the family and its business in tribute to the memory of Abdul Tyeb Maskati and so that the information may be passed on to his present and future heirs.'*

The end result of Balubhai's literary endeavour is a short but compelling tale that tells how one young man, living in poverty in the ancient port town of Surat, left India to seek his fortune overseas and ended up building a business that would span the Asian continent and thrive well beyond his own lifetime (In 2016, his descendants celebrated 160 years in business). Abdul Tyeb's story is a true rags-to-riches tale. Penniless and uneducated, he nevertheless rose to become one of the great merchant princes of Surat. In 1856, when Abdul Tyeb was in his early 20s, he founded a small trading business to ship goods between India and Siam, as Thailand was then known. Of the various items imported and exported between the two countries, the one that became most closely linked with the Maskati name was fabric.

Abdul Tyeb saw the potential in selling Indian-made textiles in Siam and began shipping cloth from Bombay to Bangkok. The fabric he stocked catered to the fashions of Siam at the time and was sold in yard-width sheets

each about three-and-a-half yards long – just the right size for the *jong krabaen*, or folded sarong worn by both Thai men and women in those days. Siamese fashion, led by the fanciful outfits of the Siamese court and taken up by members of the broader population with the means to purchase imported goods, favoured finely patterned cloth that was best achieved through block printing, a craft Indian textile makers had been practicing for centuries. Building on the success of initial sales, Abdul Tyeb set up a block-printing factory in Ahmedabad, then the textile capital of India. There, his block printers laid intricate patterns comprised of three or four colours with blocks made to specific designs drawn up in Siam and carved in India. The end result was a particular pan-Asian hybrid that melded Southeast Asian design with South Asian craftsmanship and technology. In Siam, Maskati cloth (or *pha Maskati*, as it was referred to in Thai) was favoured for the quality of its print and the rich, long-lasting colour of its dyes. The fabric found a ready market in the Siamese capital that soon spread to neighbouring Cambodia, where similar palace-led fashions held sway. By the end of his lifetime, Abdul Tyeb was running offices and sales outlets across Southeast Asia; in Siam, Cambodia, Burma, and Singapore. Built on the allure and popularity of Maskati cloth, his Asian empire established the foundation on which future generations of the Maskati family would build an enduring business that has lasted to this day.

Since Balubhai first set his memories on paper more than 80 years ago, the story of the Maskati family business has taken many twists and turns. Ultimately, as the twentieth century brought with it new modes of transport and models of industry, ways of doing business changed and Abdul Tyeb's grandson, named Abdultyeb Maskati, strove to diversify the family's business interests so that the firm could survive in a more modern era. He sought alternative opportunities in a faster-paced world where electricity, machines, and airplanes were replacing the horse-drawn carriages, gas lamps, and steam ships of his grandfather's day. As the production of cloth was mechanised and textiles were increasingly made locally in Southeast Asia, the Maskati business shifted away from the fabric on which it had been built to encompass a wider variety of products that included Japanese ceramics, American electrical goods, infrastructure engineering equipment from Germany, and jute farmed in Thailand. Like other enterprises in the region, the Maskati family business faced challenges far more threatening than changing technologies when massive political and social upheaval swept across Asia during and after World War II. Following independence from colonial rule in India and other countries around Asia, the rise of communism, and a brutal war in Indochina, the Maskati family firm was transformed once again as parts of the business were lost or dissolved and others rose to prominence.

This book both incorporates and builds upon the writing Balubhai began in 1933. It completes the life cycle of Maskati cloth – its rise and its unravelling over the course of a hundred years – and brings the story of the Maskati family business up to date. Its scope is far broader than Balubhai's original intentions as the facts contained within these pages have been pieced together from company documents, property deeds, photograph albums, and family memory, as well as from newspaper archives, museum collections, and scholastic research. In a sense, it is a sequel to Balubhai's earlier, unpublished efforts and, as such, is written for a similar reason – as a tribute to the past and a repository for the future.

FOUNDATION

FOUNDATION

In the first half of the nineteenth century, the sea route from India to Siam was vulnerable to pirates and buffeted by violent storms during the monsoon season. Yet, despite the perils of the journey, few visitors enthused about their first glimpse of land. The mouth of Siam's major river, the Chao Phraya, was flanked by mangrove forests that were muddy, fetid, and inhabited by crocodiles. Past the mangroves were flat salt marshes as far as the eye could see. As the boat progressed upstream, the monotonous marshland gave way to thick vegetation and spiky nipa palms. Above this uninterrupted wall of greenery rose the slim trunks of countless areca (betel nut) trees and coconut palms. Beyond lay dense, impenetrable jungle.

Abdul Tyeb Esmailji Maskati made the journey in 1851, when he was just 19 years old. Like other travellers he would no doubt have been relieved to see a more promising vista unfold as he proceeded upriver. Approaching Bangkok, the capital of Siam, the scenery began to hum with life. Dozens of Chinese junks with their characteristic mat sails were moored near the city as their crews busily loaded and offloaded rice bound for China or cargo destined for sale in Bangkok. Numerous small vessels – rafts, canoes, and covered punts – carried passengers and goods across the river and slipped down narrow canals that led further into the city. Floating shacks made of wood with sloped roofs of thatched palm leaves lined the river banks on either side. Here and there, against a backdrop thick with trees, was visible the shimmering orange roof of a Buddhist temple or the white crenelated city walls that surrounded Bangkok and protected the capital from invaders. In a city where few structures rose higher than one or two stories above ground level, the Grand Palace – home to the king of Siam and his court – dazzled visitors with its glittering spires and roofs studded with glazed shards that reflected the bright, tropical sunlight. Across the river from the palace was another impressive structure: the towering chedi, or stupa, of Wat Arun, the Temple of Dawn (still an iconic site in Bangkok today).

At the time Abdul Tyeb arrived in Bangkok, most Indians who came to Southeast Asia in search of work or to trade tended to choose more accessible and commonly plied shipping routes that led directly to Burma or Penang and Malacca in today's Malaysia, or the Indonesian islands. Only a few ventured around the Malay peninsula to travel up the Gulf of Siam and follow the Chao Phraya River all the way to the reclusive capital of Bangkok. It was, by any account, an adventurous choice for a young man with limited experience. As the boat dropped anchor in Bangkok, and Abdul Tyeb waited for one of the small feeding vessels coming to take passengers to shore he must have experienced both trepidation and excitement at what lay ahead.

Pirates in the Gulf of Siam, Reports the Bombay Times Correspondent in Bangkok: *'Since writing my last, I have heard that the pirates are in the Gulf. Two junks have arrived, both plundered by these rascals, and so far up as Cin Point, only a few miles from Siam bar.... It was reported [the captain of one junk that had sailed from Singapore], because he had shown some resistance to the pirates, had his ears cut off.'* The Bombay Times and Journal of Commerce, *6 October 1854.*

Opposite, right: View of the Chao Phraya river as Abdul Tyeb Maskati might have seen it as he sailed to Bangkok in the mid-nineteenth century. The temple behind the two-masted merchant ship is Wat Kalayanamitr. Photo by John Thomson, 1865-66.

Right: An early panorama of the Bangkok skyline, taken from Wat Arun, or the Temple of Dawn. John Thomson (1865-1866).

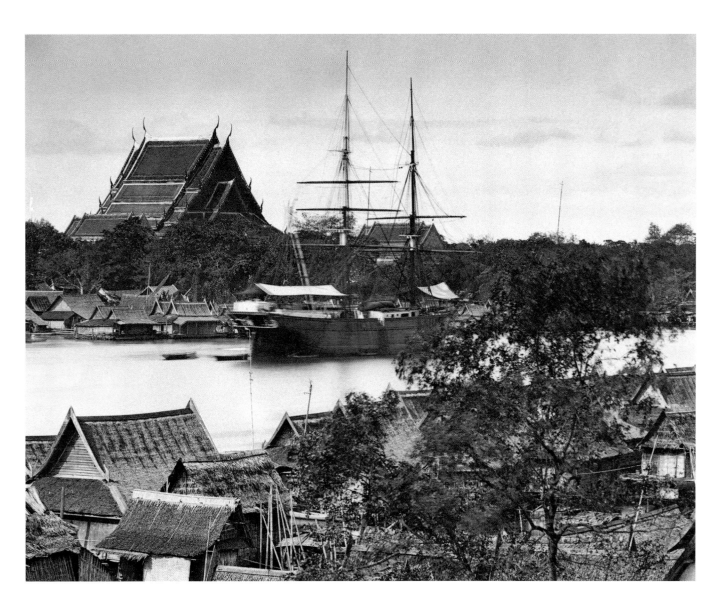
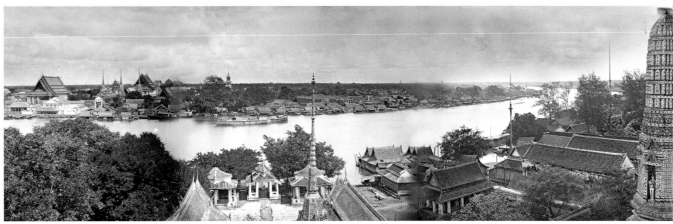

Abdul Tyeb Esmailji Maskati was born in 1832 in Muscat, citadel of the rocky and rugged desert sultanate of Oman on the northeastern tip of the Arabian Peninsula. He was the middle child of three children and the family's only son, with one older and one younger sister. His father, Ismailji Abdul Rahim, ran a small grocery store but, when he died an untimely death in 1842, he left the family with no viable means of support. Together with his mother and sisters, Abdul Tyeb left Muscat and relocated to Surat in India, a short boat trip across the Persian Gulf. As the family were members of the Dawoodi Bohra sect of Shiite Muslims and Surat was the main seat of the Bohras, they may have had a better chance of creating a stable future for themselves amongst the support networks of the close-knit Bohra community. And it was there, probably in acknowledgement of having come from Muscat, that the family took on the distinctive surname 'Maskati'.

Those early years in Surat were hard-scrabble years and the family eked out a frugal existence. They lived in rented accommodation in a neighbourhood called Rehmatpura, just north of the central bazar area around which the city was centred. Abdul Tyeb's mother took on odd jobs and managed to survive on as little as ten rupees a month. She became expert at making a few rupees stretch as far as possible and was able to make a single tin of castor oil last for up to six months. To do this, she used the tiniest amount of oil to light a lamp during her daily Maghrib prayers, prepared and ate her dinner early, and went to bed early so she wouldn't need to keep a lamp lit at night. She also economised on the lamp wick, replacing it with cotton thread used to tie up betel leaves.

Barely ten years old and now head of the family, Abdul Tyeb did what he could to contribute to the household. When he wasn't attending primary school in the nearby neighbourhood of Gopipura, he sold family heirlooms and other household goods carried over from Muscat to generate additional cash for his mother. Still, the family struggled to make ends meet. Abdul Tyeb tried hard to find work that would pay a monthly salary but was unable to gain regular employment.

Though Surat, an ancient port city, had once been a place of great opportunity it was no longer the prosperous trading hub it once was. The peak of its prominence had been during the seventeenth and eighteenth centuries, under the rule of India's Mughal emperors. Then, the city's lifeblood was international trade and its inhabitants boasted connections and networks that spanned the globe. It was said that you could count the flags of up to 84 countries flying from the masts of ships moored at Surat's port, and a dazzling array of merchandise was changing hands. Ships from the Middle East carried quicksilver and pearls plucked from the Gulf of Persia. Gems and ivory were shipped from Africa. British vessels arrived loaded with gold bullion to trade while the Dutch brought exotic spices and peppers grown in the Indonesian isles. From the Far East, the Chinese came with silks and delicate painted porcelain. In India, local merchants travelled overland from places like Agra, Lahore, and Kashmir, bringing indigo, opium, carpets, and yards of spun cotton to trade with buyers from abroad. The large international trading companies of the time established offices in Surat and the population was a cosmopolitan mix of Indians, Europeans, Turks, Jews, Arabs, Persians, and Armenians. Great fortunes were made, and lost, in Surat on the maritime trade. It was, however, the age of empire and European powers were jostling for control over the profitable trade routes and commodities. When the British gained supremacy in India in the eighteenth century and chose Bombay as their commercial entrepôt, they enticed merchants to the new trading capital. Surat had been in decline since the 1600s after being plundered twice by Shivaji, the Maratha king, but with the rise of Bombay its fate was sealed. By the time Abdul Tyeb and his family arrived in Surat in the 1840s, the city's heyday was long over.

Still, the legacy of this lustrous past lingered in the narrow lanes and byways of Surat, in its once-bustling bazars and disused shipyards. And it was amongst these memories that Abdul Tyeb came of age. For a young man wanting to support his family and better his circumstances, the obvious choice was still – as it always had been in Surat – to look to the sea.

A family connection provided Abdul Tyeb with the opportunity he needed to go overseas. Since arriving in Surat, Abdul Tyeb's older sister, Fatambu, had married a man called Abdulali Mogul. When Abdulali travelled to Siam and found lucrative work there he sent word back to Abdul Tyeb to join him. And so it was, that at the age of 19, Abdul Tyeb left home to seek his fortune in Southeast Asia.

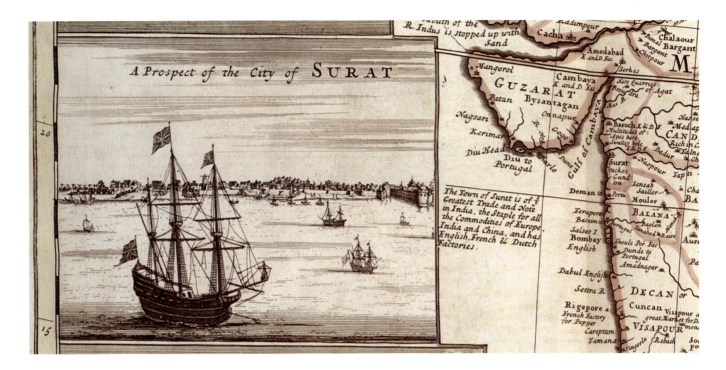

Detail from map of the East Indies, showing Surat as seen on an approach from the Arabian Sea. Drawn by the London-based cartographer and engraver, Herman Moll, circa 1730s.

For centuries past, Indians had been drawn further east across the Indian Ocean. The links between South Asia and Southeast Asia go back some two thousand years. In the realm of legend, several of the Buddhist Jataka tales, which tell of the various incarnations of the Buddha, refer to voyages between India and Suwannabhumi (or Land of Gold), as the Far East was once known. It is believed that Indian traders first charted an oceanic route eastwards as early as the third century A.D. As the centuries passed and Indians travelled further into the region, and settled in major trading hubs, they brought with them Indian concepts of religion, governance, and art. These new ideas merged with local elements and were adopted by the royal courts and elite of Southeast Asia.

By the latter part of the twelfth century, two of the world's great religions, Theravada Buddhism and Islam, were filtering into the region. Buddhism from Sri Lanka became the dominant religion of the mainland states (with the exception of Vietnam), incorporating both the rich animism of the village and the Hinduism of the royal courts. Islam spread along the Indian Ocean maritime routes across the Malay Peninsula and Indonesian archipelago, propagated by Muslim merchants from the Middle East and India.

The arrival of Islam coincided with the rise of the great port of Malacca on the southwest coast of Malaya, which became one of the world's major commercial centres. The prevailing climatic patterns of alternating monsoon winds in the South China Sea and the Indian Ocean allowed for ships sailing southwest from China and Indochina, and southeast from India and Burma to meet in the vicinity of the Straits of Malacca. After Malacca's ruler converted to Islam in the mid-fifteenth century, it became a port favoured by Muslim traders. When the

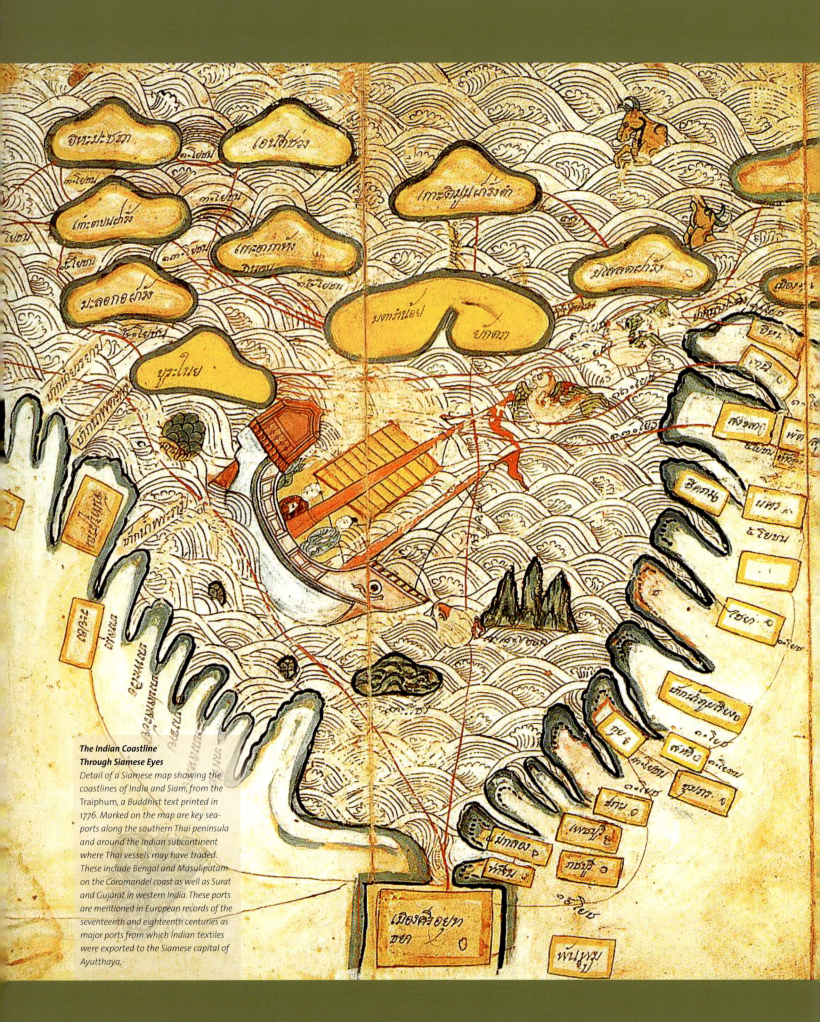

The Indian Coastline Through Siamese Eyes
Detail of a Siamese map showing the coastlines of India and Siam, from the Traiphum, a Buddhist text printed in 1776. Marked on the map are key seaports along the southern Thai peninsula and around the Indian subcontinent where Thai vessels may have traded. These include Bengal and Masulipatam on the Coromandel coast as well as Surat and Gujarat in western India. These ports are mentioned in European records of the seventeenth and eighteenth centuries as major ports from which Indian textiles were exported to the Siamese capital of Ayutthaya.

Exchanging textiles for elephants

Indian cloth has been prized in the Far East for centuries. Bartered in exchange for local goods and later purchased for cash, it has been woven into the fabric of Siamese society since the days of the former royal capital of Ayutthaya.

Long before European traders landed in Siam, the Siamese court had established lively trading relations with countries across Asia. Ayutthaya, the capital of Siam from the twelfth century to 1767 was an early trading hub and, by the beginning of the seventeenth century, had become a powerful and prosperous state. Much of its foreign trade was relegated to Chinese and Muslim merchants. In the reign of King Narai (r. 1656-88), trade links were established with Surat in India and the king employed Muslim merchants and European vessels to conduct crown trade for Ayutthaya.

Muslim merchants shipped goods to Ayutthaya from the Coromandel coast, Bengal, and Gujarat in western India. The goods coming from India were dominated by cloth; European records state that their main competitors in the textile trade in Ayutthaya were Muslim merchants from India and Persia. The Indian merchants bartered textiles for various local goods, among the most prized were elephants, corralled from the wild, marched overland across Tenasserim (the southern part of Burma, today known as the Tanintharyi Region) and then shipped across the Bay of Bengal. Other products traded through Ayutthaya included farm and forest products procured from the surrounding jungle, such as various rare woods, resin, deer hide, and rhinoceros horn.

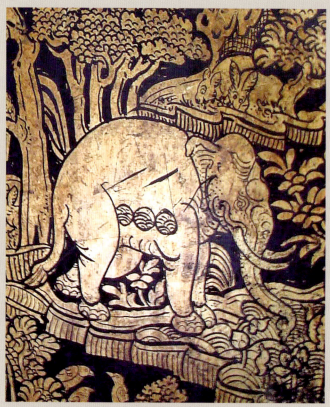

In 1767, the capital of Ayutthaya was sacked by the Burmese and another capital was established at Bangkok. There, a new royal dynasty tried to rebuild the glory of Ayutthaya by replicating its buildings, literature, and laws. As the customs of Ayutthaya were recreated in the new capital so, too, was the need for Indian cloth. The trade continued to be channelled through Surat and Bombay and controlled by Muslim merchants. As John Crawford, who led an embassy from the Governor-General of British India, reported on his visit to Siam in the early 1820s, *'The cotton piece goods of India, especially the chintzes of Surat and the Coromandel Coast, appear from time immemorial to have been articles of considerable demand. About the capital [Bangkok] especially a very large proportion is clothed with these articles. I have been informed that the annual quantity either imported direct by European vessels, brought by junks from Batavia and the Straits of Malacca, or across the peninsula, does not fall short of five hundred bales.'*

When Abdul Tyeb Maskati and his brother-in-law, Abdulali Mogul, began importing Indian textiles to Siam in the mid-nineteenth century it was a continuation of this long history of textile trade between India and Siam.

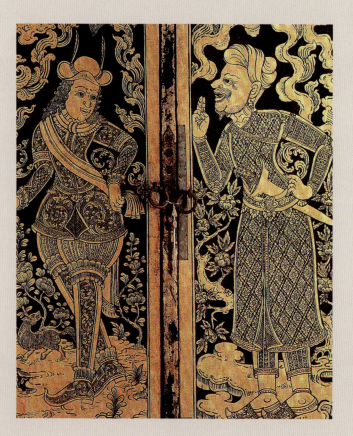

Above: Siamese dress in the Ayutthaya period, from an illustration in Du Royaume de Siam, *by Simon de la Loubère, English language edition, 1693.*

Above: Detail from a nineteenth century temple mural at Wat Matchimawas, Songkhla, Thailand. This courtier at the palace gates is dressing himself in pha lai, *or block-printed cotton. The cloth is being tied in the manner of an Indian* dhoti, *a style known in Thai language as* pha nung jong krabaen.

Opposite, left: Lacquerware details, Siam, seventeenth century or mid-Ayutthaya period. The elephant appears on the wall panels inside the Lacquerware Pavilion at Suan Pakkard Musuem, Bangkok. The picture below shows the door panels of a Buddhist doctrine cabinet in the National Museum, Bangkok, and illustrates prominent merchant types once seen in Ayutthaya, in this case a European and Muslim trader.

Portuguese first visited Malacca in 1509, they noted around one thousand Gujarati merchants living there.

After the Portuguese occupied Malacca in 1511, other European powers ventured into the region, enticed by the great volume of trade conducted between Indian ports and Southeast Asia. By 1800, the Dutch had taken control of the Indian Ocean maritime trade by force and, within a few decades, other European countries began to colonise the rest of the region, with the sole exception of Siam. Merchants from the west were drawn to the region by the lure of exotic produce unavailable in western regions. They came to procure spices such as cloves, mace, and nutmeg, as well as rare aromatic woods like camphor and sandalwood. Most prized among products brought from the west for bartering and trading purposes was fabric, produced mostly in India. In Southeast Asia, fabric was mostly home-made, spun in narrow strips by women using back-strapped handlooms. By then, Indian cloth was being woven on technologically advanced larger-scale wood-frame looms that enabled weavers to produce cloth at greater speed, quantity, quality, and size. As a result, the cloth was cheaper and more versatile than local variants. It was also highly sought after for its vibrant, durable colour achieved through long-lasting mordant dyes.

By the time Abdul Tyeb arrived in Bangkok, in 1851, the region was trading specially cultivated agricultural produce; sugar from Siam, pepper from Sumatra, and coffee from other Indonesian islands. In the decades before his arrival, the market for all these products had grown exponentially, resulting in a corresponding market for imported goods. Top among the list of local demands was cloth.

An early endorsement of Indian cloth:
'In some things the artists of India out-do all the ingenuity of Europe, viz., in the paintings of Chites (chintz, block-printed cloth) or Calicoes, which in Europe cannot be paralleled, either in the brightness and life of the colours, or in their continuance upon the cloth.' John Ovington, A Voyage to Surat in the Year 1689.

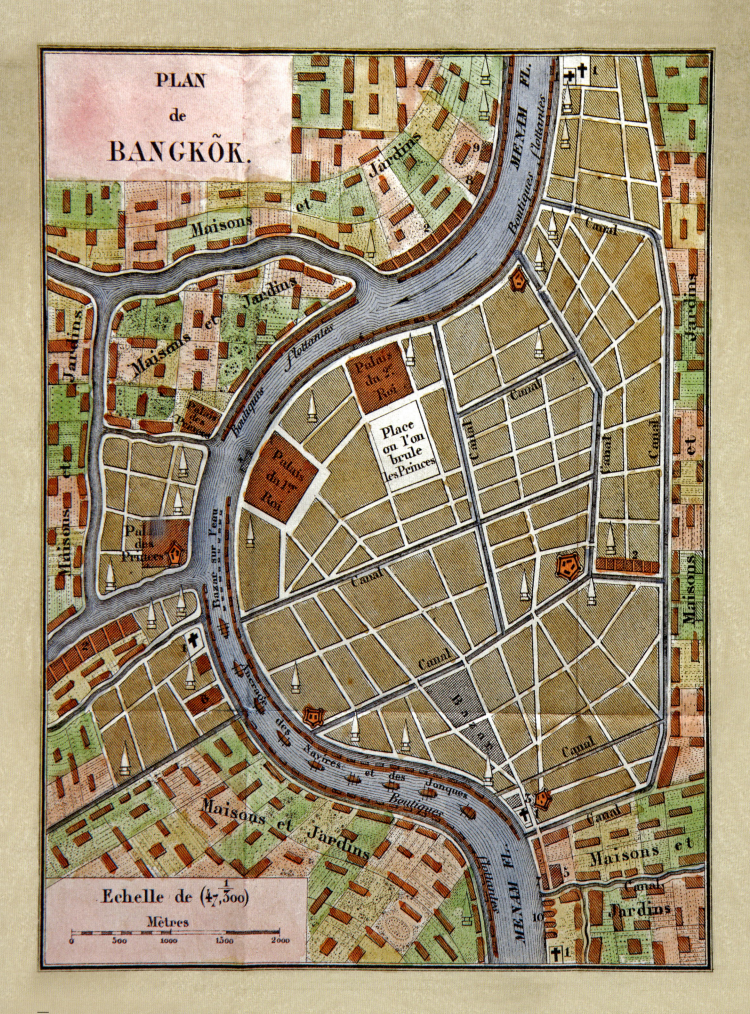

42
AMERICAN STEAM RICE MILL COMPANY.
George A. Dunn & co.
S. P. GOODALE, GEORGE A. DUNN, & MICHAEL GURVEY—*Partners.*

Assistants.

JOHN F. ODELL.	JAMES A. MOORE.
SAMUEL WRIGHT.	ALONZO MOORE.
CHARLES BOWNE.	G. B. HALL, *Engineer.*

Established October, 1858.

Towing & Lightering.
STEAMER "JACK WATERS"
Barges.

CONCHA.	COQUILLE.
D'ALMEIDA.	DESDEMONA.

CHARLES G. ALLEN,—*Proprietor.*

THOMAS MILLER,—*Agent.*

WILLIAM WEST,—*Captain of Str.* | OSCAR JACKSON,—*Engineer.*

Boarding House.
CAPTAIN JAMES WHITE,—*Proprietor.*

Mussulman Merchants.
At the Mussulman Square.

IN THE ORDER OF THEIR ROOMS IN THE WHITE HOUSES FROM THE RIVER ON THE LEFT HAND, GOING ROUND TO THE RIGHT HAND SIDE OF THE SQUARE.

Măhămăd Ishmail	Măhămăd Arraff
Nănla bai	Abdool Ally Iesŏŏbai
Kaimalee Goolămali	Harsăm Esoff
Harsem Goolah Hoosen	Măhămăd Goshe
Năkodah Ajim Bawnea	Măhămăd Aboo
Abdool Teeăp	Ibrahim Măhămăd
Abdool Hoosen	Băwah Măhămăd Hoosen
Ibraheel Ishmail	Goolah Măhămăd Ishmail

AT THE RED HOUSE ABOVE THE SQUARE

Nakodah Abdool Russool. Măhămăd Hoosen.

AT THE MOUTH OF THE CANAL ABOVE.

Nakodah Manchegee. & Abdolah in a Floating House near the Red House.

Above: Page 42 of the Bangkok Calendar *of 1861, an annual English-language almanac published by the American missionary Dr. Dan Beach Bradley, who introduced the first printing press to Siam. This page lists the key Muslim merchants in Bangkok residing at so-called Mussulman Square on the west bank of the Chao Phraya River. Abdul Tyeb Maskati is listed here under the alternate spelling 'Abdool Teeap'.*

Left: A French town plan of Bangkok showing the locations of the palaces of the king, the second king, and the royal princes on the banks of the Chao Phraya River, late nineteenth century. Mussulman Square, where Abdul Tyeb Maskati resided, was located on the first curve of the left bank of the river, in the area marked 'Maisons et Jardins', or Homes and Gardens.

On arriving in Bangkok, Abdul Tyeb took up residence in the Muslim quarter of the city. At the time, Bangkok's foreign inhabitants tended to congregate in the same area so they could share resources, information, and contacts. The Chinese – by far the largest and most prosperous of the city's foreign traders – located themselves in Sampeng (which remains today's Chinatown). The Portuguese clustered around the Santa Cruz Church in Thonburi on the western bank of the Chao Phraya River. Other Europeans and Americans – mostly Christian missionaries – settled in today's Bang Rak area on the eastern bank. There were also Mon, Khmer, and Lao communities that were mostly descendants of slaves captured by previous Siamese kings during war time and used as corvée labour to dig the city's many canals. The Muslim neighbourhood was known as Mussulman Square and was situated on the western bank.

Most of the residents of Mussulman Square were Indian merchants connected to each other through familial links, and many came from Gujarat. When an early adventurer to foreign lands achieved success or found opportunities, he sent word home to invite relatives or friends from his village or neighbourhood to join him. Such invitations were a useful method of acquiring trustworthy workers abroad and it was just such an invitation that drew Abdul Tyeb to Bangkok, through his brother-in-law, Abdulali Mogul. During their time abroad together, Abdul Tyeb and Abdulali cemented a close friendship that would, within a few years, result in the foundation of the Maskati family business.

Abdul Tyeb's first job in Bangkok was as a cook at a trading firm owned by a Bohra merchant called Haribhai Chiniwala. As women tended to stay at home in India, unless their families resettled permanently, domestic chores and cooking had to be performed by men. Trading firms, where employees often lived and worked in a single premise, hired cooks from their own regions to provide workers with familiar food that came as close to the comforts of home as possible. The Bohra trading community took considerable care over their food, for both culinary and social reasons. According to tradition, they ate together from a *thaal*, a large round platter placed on the floor around which they sat and shared communal meals. For Abdul Tyeb, procuring food for the kitchen would not have been difficult; fresh produce was

in plentiful supply at any of Bangkok's many wet markets or from boat vendors who plied the canals selling fish, meat, fruit, and vegetables, as well as ready-made dishes.

In the mid-nineteenth century Bangkok was still a predominately waterlogged city. Famously dubbed the 'Venice of the East', there were no roads and people travelled mostly by boat. Most of the city's residents still led a semi-amphibious existence, living in houses on stilts that perched above the swampland or in floating wooden homes that were hooked to large poles to keep them moored in place along the edge of the waterways. But the landscape of the city was about to change dramatically as Abdul Tyeb had unwittingly arrived in Siam just as the country was on the cusp of a new era.

In the same year as Abdul Tyeb sailed into Bangkok, King Mongkut ascended to the throne. Until his reign, Bangkok was an insular place, more concerned with self-protection and preservation than with commerce and trade. King Mongkut (Rama IV, r. 1851-1868) was a thoughtful and foresightful monarch who had come late to the throne after spending many years as a monk. He was intellectual and deeply curious about the world around him as well as the world beyond Siam. Under King Mongkut's reign, the country started to look outwards and the city began to change as new canals and buildings were constructed in keeping with King Mongkut's vision for his country. Abdul Tyeb would have witnessed the digging of the Padung Krung Kasem canal, which formed a semi-circle around Bangkok and was the city's longest and most ambitious infrastructural project. Work on the canal began the year Abdul Tyeb arrived in the city and took nearly four years to complete. Another major event during those years was the successful construction of what remains today one of the city's most iconic landmarks, the Golden Mount; while previous kings had tried, and failed, to raise a mountain on Bangkok's swampy soil, King Mongkut was determined to see it through. Few visitors could resist climbing to the top and, some years after its completion, one western traveller described the bird's eye view from the summit: *'The general appearance of Bangkok is that of a large, primitive village, situated in and mostly concealed by a virgin forest of almost impenetrable density. On one side beyond the city limits were paddy fields, and on the other to the very horizon stretched the exuberant jungle.'*

Abdul Tyeb spent his first two years in Bangkok cooking at the Chiniwala shop and then shifted to work as a cook for another company owned by a merchant called Moochalawala. Balubhai Lalbhai's biography provides us with few details of these early years in Bangkok but it is tempting to think of the young Abdul Tyeb listening in on conversations that took place in the shops of Chiniwala and Moochalawala – discussions of trade regulations, ideas about what commodities were selling well, as well as tales of failed ventures and disputes between brokers, shippers, and customers. Such conversations would have provided him with a first-hand view of how trade was conducted and, as such, would have amounted to an informal version of business school. The salary he received as a cook earned him enough to send money home to his mother in Surat and, as Balubhai writes, to dabble in 'miscellaneous sorts of business'. It is possible that Abdul Tyeb was already trying his hand at some small trading ventures or making contributions to deals brokered by merchants connected to the Moochalawala shop.

By 1855, at the age of 23, Abdul Tyeb had saved up enough money to return to Surat and marry. While he was back in India, great machinations were afoot in Siam. King Mongkut's progressive policies had resulted in a meeting between the King and the British governor of Hong Kong, Sir John Bowring. What took place during that meeting would change the commercial landscape of the region, as well as the fortunes of one Indian family, for generations to come.

Opposite, top left: King Mongkut (Rama IV, born 1804) was king of Siam from 1851 until his death in 1868, photographed here in his coronation apparel by the Scottish photographer John Thomson, 1865-66.

Opposite, top right: A rare image of Bangkok's iconic Golden Mount under construction. The Golden Mount was commissioned by Rama III but workers encountered structural problems and the project was restarted under the reign of Rama IV when Abdul Tyeb Maskati was resident in Bangkok. John Thomson, 1865-66.

Below right: View of floating houses in Bangkok taken at Klong Tapan Han near Pahurat in Chinatown, circa 1870.

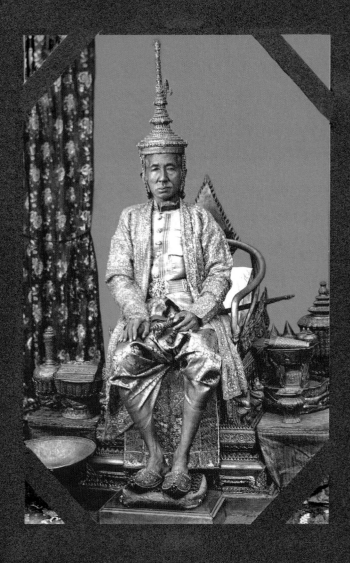
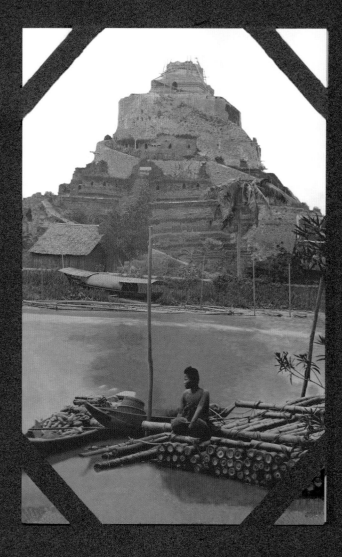
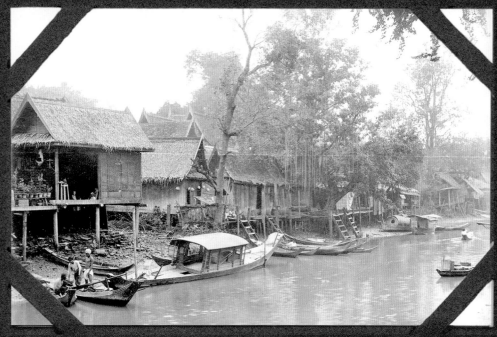

As in the days of the former capital Ayutthaya, the Siamese court in Bangkok placed strict controls on all foreign trade coming into and going out of the country. It was forbidden to trade in rice, salt, teak, or bullion, while heavy duties on imports, such as sugar and pepper, made for a prohibitive trading environment. Foreign merchants were confined to Bangkok and could be expelled at a moment's notice. However, European colonial powers were gaining control over the surrounding region and Siam had cause for concern. With the French in Indochina and the British on either side in neighbouring Burma and Malaya, King Mongkut was wise to reconsider these restrictions.

Sir John Bowring's visit to Siam in 1855 resulted in an Anglo-Siamese agreement that granted extraordinary rights to British subjects. The Bowring Treaty, signed on 18 April 1855, allowed the British to trade freely in all seaports of Siam. Previously denied products were made available for export and certain duties were abolished. British subjects were also granted the right to buy land in and around the capital and were given the right of extraterritoriality, meaning they were not beholden to the laws of Siam.

Above: Sir John Bowring (1792-1872), negotiator of the Anglo-Siamese treaty.

Right: The Colonial Office, London, representing the British side of the Bowring Treaty negotiations.

News from Bangkok: The Bombay Times *Reports on the Landmark Treaty Between Britain & Siam*

The newspaper notes that the Bowring Treaty contains 'much larger concessions than any one acquainted with Siamese affairs had reason to expect' and lists the following key points:

1. The abolition as far as regards foreign trade of the farms and monopolies to which at present almost every article, whether the produce of the country or imported, is subjected.

2. The removal of the prohibition against the exports of rice, teak and other productions of the country.

3. The doing away with the prohibitive tonnage duty to which foreign square rigged vessels are at present subject, substituting in place of it an [sic] uniform duty of 3 per cent on imports.

4. Placing [of] English vessels on the same footing as Siamese and other native vessels.

5. The permitting [of] British subjects to settle and hold lands within a radius of between 50 and 60 miles from Bangkok and to enjoy the free exercise of their religion.

6. The residence of a Consul with exclusive jurisdiction over British subjects.

'With the moderate import duty which is to be levied, we may expect to see a large extension given to the import trade, within a very short period after the treaty comes into operation on 6 April 1856. Of the imports, cotton manufactures are the most important and the demand for them will no doubt keep pace with the reduction in price which they will undergo, consequent on their being carried to market by the more economical medium of square rigged vessels.'

The Bombay Times and Journal of Commerce
6 June 1855

SIAM

For many years past we have taken occasion from time to time to direct attention to the state of our trade with Siam, and advocated the adoption of measures for placing it on a more satisfactory footing. The treaty of 1826 was very imperfect in its provisions, and by imposing an exorbitant tonnage duty on square-rigged vessels, the European trade was placed at a great disadvantage, the effect of which has been seen in the virtual extinction of that trade. Towards the end of the reign of the late King, Sir James Brooke visited Bangkok with the object of endeavoring to form a new treaty, but although he conducted the negociations in the most conciliatory and prudent manner, it was found that the prejudices of the King and the most influential of his advisers against foreigners were too strong to allow of any amended treaty being entered into, and the mission so far proved a failure. But there can be no doubt the intercourse of Sir James Brooke with the present rulers of Siam and other influential persons, at the period of the Mission and afterwards, had a beneficial effect on the subsequent negociations under the new reign. To the personal character of the new Sovreigns, however, we must in a great measure ascribe the success which has attended Sir John Bowring's mission, and which has resulted in a treaty being concluded containing much larger concessions than any one acquainted with Siamese affairs and reason to expect. They embrace the following points: –1st. The abolition as far as regards foreign trade of the farms and monopolies to which at present almost every article, whether the produce of the country or imported, is subjected. 2nd. The removal of the prohibition against the exports of rice, teak and other productions of the country. 3rd. The doing away with the prohibitive tonnage duty to which foreign square rigged vessels are at present subject, substituting in place of it an uniform duty of 3 per cent on imports and a tariff of Export duties of which, altho' higher than could have been wished, will still allow of trade being carried on with some chance of success. 4th. The placing English vessels on the same footing as Siamese and other native vessels. 5th. The permitting British subjects to settle and hold lands within a radius of between 50 and 60 miles from Bangkok, and to enjoy the free exercise of their religion ; and 6th. the residence of a Consul with exclusive jurisdiction over British subjects.

With the moderate import duty which is to be levied, we may expect to see a large extension given to the import trade, within a very short period after the treaty comes into operation on the 6th April 1856. Of the imports, cotton manufactures are the most important and the demand for them will no doubt keep pace with the reduction in price which they will undergo, consequent on their being carried to market by the more economical medium of square rigged vessels.

It is on the export branch of the Siam trade, however, that we may look for the greatest effect being produced by the new tariff. Siam is naturally very fertile and nothing but the extraordinary system hitherto pursued by the Siamese government, has prevented the export trade expanding to twice or thrice its present amount. In one article only– Sugar, we may look for an almost unlimited increase, especially if to the industry and painstaking of the Chinese cultivators is added the skill and mechanical appliances of European manufacturers. Previous to 1840 the cultivation of sugar was entirely free and for years previously the production exhibited a very large progressive increase, reaching in 1840 to about 256,000 piculs. A monopoly was then established by the late King and the produce diminished greatly, the quality also becoming deteriorated. In 1846 the quality of sugar manufactured had fallen to 150,000 piculs, and we do not suppose that at the present time, under a continuance of the same system of farming or monopoly, it can amount to so much. Next in importance we may mention rice, the production of which has been greatly hindred by its export being prohibited. The cereal grows exuberantly in the low and fertile lands of Siam and now when the export is permitted, the cultivators will have a chance of being remunerated for their labour, instead of having the mortification of seeing, as has sometimes happened in past years, their crops rotting on the ground from there being no motive to gather them, the stock rice already being stored being sufficient for the consumption of the population, and its sale for export prohibited. Coffee, Cotton, Indigo hemp, Gambouge, Pepper and other natural products of value in commerce, all grow luxuriantly in different districts of Siam, and from an increased demand for them there will naturally result an extended cultivation and production.

The provisions of the treaty with Siam promise to be beneficial in another respect, apart from the increase which they will lead to in the imports and exports. We allude to the extended employment which they will afford to British shipping. At present the resort of British ships to Siam has almost ceased in consequence of the heavy tonnage duty and the privileges granted to Siamese and Chinese vessels. But when British vessels are enabled to enter the Siamese ports on the same terms as the latter, we may expect that the superior advantages whichsquare rigged vessels present in regard to eco-nomy of time, security from pirates, facilities for insurance, &c. will transfer a great part ofthe trade between Siam and the ports with which she maintains commercial intercourse from the junks to British vessels. This will be a very important consequence as regards the tradebering more than two hundred, which used toline the whole town frontage, there were only found three or four when the Mission was at Bangkok. Piracy and the troubles in China are the principal causes of the falling off – causes which in China itself are strongly operating to induce the Chinese to employ square rigged vessels in their own coast trade ; and for such short voyages as from Amoy to Shanghae, andfrom intermediate ports not legally open to foreign ships, English and American vesselsnow receive from Chinese enormous freights. Itmay be presumed that the Chinese will be stillmore likely to charter them for a long voyage toSiam and back, when they know that they cando so on the same terms as their own junks.

Such are a few of the advantages which occur to us as likely to arise from Sir John Bowring's treaty with Siam, some of them promising to be immediate, others requiring time for their full development. We have little doubt, however, that within a very short period of years we shall see the anticipations expressed in the subjoined correspondence fully borne out, and the King of Siam will then have reason to rejoice that he had the wisdom and firmness to enter into a treaty which will so honorably mark his reign.

To His Excellency SIR JOHN BOWRING,
H. M. Plenipotentiary, &c. &c. &c.
Chamber of Commerce,
Singapore, 3rd May, 1855.

News of this landmark treaty would have been quick to reach India. As British subjects, Indians were free to avail themselves of its benefits. Though the negotiations that led up to the treaty took place in the imposing offices of foreign trade in London and behind the thick white walls of the Grand Palace in Bangkok, their progress was no doubt carefully followed by the Bohra trading community as they exchanged news, tips, suggestions, and contacts. At the very moment when Siamese trade was about to be transformed, Abdul Tyeb found himself to be a man with the right credentials who happened to be in the right place at the right time. Eager to seize the opportunities presented by the Bowring Treaty and to build on his experience and contacts in Bangkok, he began to plan his own private venture, which began the following year in 1856.

By now, Abdul Tyeb Maskati was married to his first wife, Fatmabu. He had also organised and hosted his younger sister's wedding and it was not long after the ceremony that his mother passed away. With the prospect of a new family to look after, he set sail once more for Siam. He went, not with the intention of joining someone else's firm as an employee, but to establish his own enterprise.

Together with his brother-in-law, Abdulali Mogul, Abdul Tyeb set up a small shop in Bangkok in 1856. The location of this first shop is unknown but it may well have been one of the city's famous floating shops. The contemporaneous French explorer Henri Mouhot described how shopping in Bangkok was conducted mostly by boat: *'...and here you can purchase your supplies with very little trouble, by stopping your boat and pointing out what you want in the wide open room before you, or having the goods handed into your boat for inspection.'* The shop, operating under the joint name of 'Abdul Tyeb Abdulali', proved profitable and the partners decided to expand their inventory to include Indian textiles. It was agreed that Abdul Tyeb would return to Surat and use their accumulated proceeds to procure the textiles, while Abdulali stayed in Bangkok to manage the shop. In India, Abdul Tyeb purchased bales of block-printed cloth from Ahmedabad and Bombay to export to Bangkok.

The instinct to invest in the textile trade was a good one. The commercial changes set in motion by the policies of King Mongkut had a knock-on effect on Siamese fashions and, as the country opened up to the outside world, the market for textiles grew rapidly. Indian textiles – long renowned throughout Southeast Asia for their superior quality – were now in even greater demand. Confident that they were on to a good thing, the partners decided to invest heavily in the textile business and borrowed money in Surat to finance the purchase of additional bales of cloth. The gamble paid off and from the profits they earned, both Abdul Tyeb and Abdulali were able to treat their wives to rare gifts of gold ornaments.

But running a pan-Asian enterprise in those days was fraught with risk. Without any quick or easy means of communication between countries, much depended on human relations and trust, both of which had to be sustained over great distances and long periods of time.

In this context, networks based on kin and community made the most sense. The Bohra community, well-versed in the ways and methods of international trade, provided a ready-made network of money lenders, bankers, suppliers, brokers, and ship-owners. In 1864, when Abdulali returned to India after many long years of managing the shop in Bangkok, the network the partners had set in place was put to the test. In Abdulali's absence, the shop had been entrusted to an employee and was poorly run. When the accounts were tallied the following year it was found they had suffered a loss of up to 20,000 rupees – enough to sink the business. To help pay the debts incurred in Bangkok, the wives had to return the gold ornaments their husbands had given them so the pieces could be sold to generate cash.

Such a setback might have destroyed the ambitions of less determined men but Abdul Tyeb and Abdulali's prompt repayment of their debts ended up earning them respect in the business community and enhanced their reputation as reliable businessmen within their network of brokers. At the end of 1866, just a year after their near-disastrous fiscal meltdown, they were able to obtain another loan to continue their business. This time round, they were determined not to repeat the same mistakes.

Left: Thai version of the Bowring Treaty, produced in the characteristic Siamese style with white text on a black background. It is shown prior to being affixed with the Great Seal of the Realm, citing the approval of the British Empire.

Below: Floating shops in Bangkok along Klong Kut Mai (or 'Newly Dug Canal'), today known as Klong Hua Lamphong).

Siamese Fashions: What to Wear in Nineteenth Century Bangkok

The traditional dress of Siam did not change much from the time of the former capital, Ayutthaya, to the early Bangkok period. Both men and women favoured an un-tailored piece of cloth about three-and-a-half yards long that was worn as a lower garment and called a *pha nung* (literally, cloth to wear). Another unisex style was known as the *jong krabaen* in which the same cloth was tied at the waist, passed between the thighs and tied around the waist once more.

Before European fashions influenced the dress of the Siamese court in the latter half of the nineteenth century, few people wore upper garments due to the hot weather. When the progressive monarch, King Mongkut (Rama IV, r. 1851-1868), ordered courtiers to cover their torsos in his presence, fashions began to change. Women used a separate breast-cloth called a *sabai*, made of cotton, linen, or silk, that could be embroidered or decorated according to the taste and wealth of the wearer.

Photographs from the mid-nineteenth century onwards show that Indian brocade came into fashion and was used in tailored shirts for Thai dignitaries and courtiers. For lower garments, two types of cloth were favoured: *pha poom*, or Cambodian ikat silk, and *pha lai*, Indian painted or block-printed cotton.

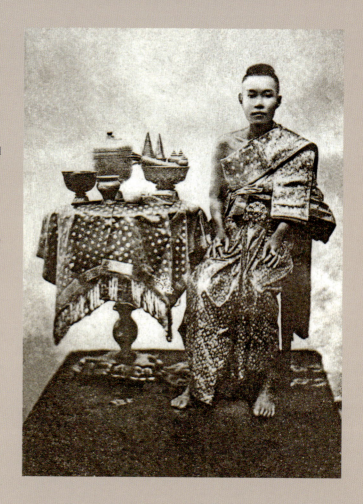

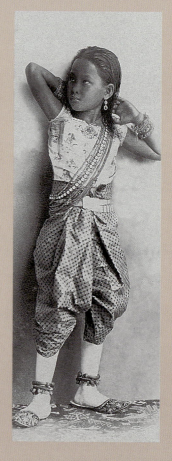

Left: (clockwise), Queen Debsirindra (1834-1862) in full Siamese court dress, including pha lai, with royal regalia on the table. Probably photographed at the studio of Robert Lenz or Gustav Lambert.

A child dressed in pha lai.

Chao Phraya Paskornwongse, writer of the report on importation of pha lai to Siam pictured on page 58, here dressed in pha lai.

Below: Wife of the Prime Minister of Siam seated in front of her home and Prince Chulalongkorn (then the Crown Prince of Siam and later King Chulalongkorn, or Rama V), both dressed in pha lai.

Right: Photographs of cotton merchants in Bombay taken by the celebrated British photographer Francis Frith, 1850-1870.

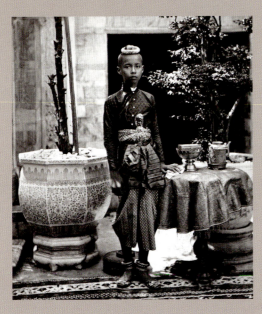

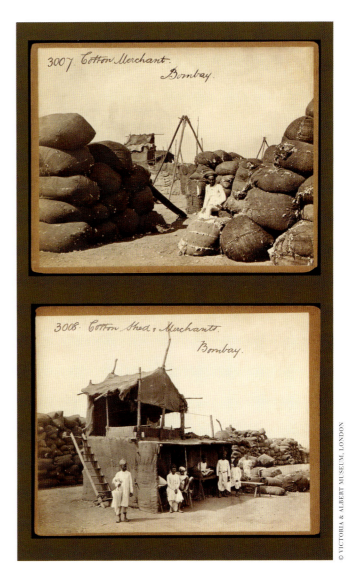

The modern cotton industry was booming in India. The industrialisation of the textile industry had begun in Bombay in around 1850 with the country's first textile mill being established in the mid-1850s. The industry was given a tremendous boost after the outbreak of the American Civil War in 1861 when an embargo was placed on raw cotton from the southern states. American cotton fields had been supplying the ever-hungry mills of northern England and a new source had to be found. Almost overnight, India became the world's main supplier of raw cotton with most of its produce destined for the Lancashire mills.

Cotton gathered from cotton fields across central India was transported to Bombay for onwards shipping. As the sudden surge in demand drove prices up and farmers rallied to meet dramatically increased needs, it was a heady time for the city. Over the next few years,

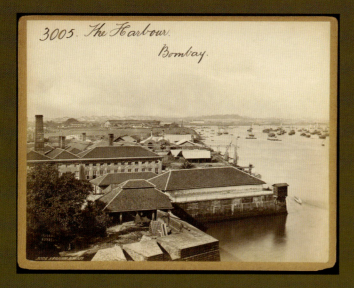
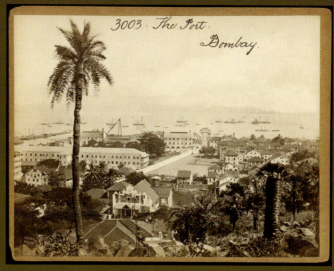
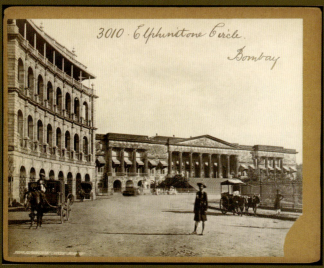
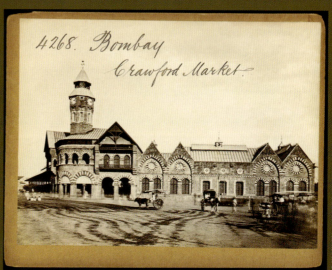

great fortunes were quickly accrued and entrepreneurs and speculators flocked to Bombay to partake of the gold-rush. The sudden enthusiasm for investing and speculating resulted in what the Bombay Gazetteer describes as 'share mania' and a widespread urge to spend: *'At the outset, speculation was confined to ventures in cotton and piece goods; but as the money made in this way accumulated and adventurers from all parts were attracted to Bombay all sorts of ingenious schemes were devised for putting the newly acquired wealth to use.'*

The Gazetteer refers to the 1860s as a decade of *'feverish activity'* and points to the critical decade as a turning point in Bombay's history, when it went from being a mercantile town to a *'splendid and populous city'*. Indeed, infrastructure proceeded apace with the booming economy as new roads were laid and the cityscape was transformed. Land reclamations were launched along the east and west sea-bound edges of the city to expand its landmass. The Bombay, Baroda, and Central India Railway was launched in 1864 to cater to the new inland trade routes and connect Bombay to the cotton-growing areas of Gujarat and central India. As it seemed like a conclusion to the American Civil War was still far off, the Gazetteer further noted that, *'No bounds therefore, it was assumed, could be set to the flowing tide of Bombay's prosperity, and everyone hastened to plunge in and let himself be borne upwards to fame and fortune.'*

It was in this fortuitous environment that Abdul Tyeb Maskati and Abdulali Mogul were able to salvage the remnants of their business. First, they needed capital

and – given their own track record for returning loans and the giddy, spendthrift mood of the time – this wasn't hard to find. With a second loan, the partners purchased bales of cloth to sell in Siam. They bought the fabric in Ahmedabad. Located within Gujarat, which was then part of the Bombay Presidency under the British colonial administration, the ancient city of Ahmedabad was situated some 500 kilometres north of Bombay. Its first textile mill was made operational in 1861 and it was fast becoming the textile capital of India.

Abdulali returned to Bangkok with the cloth so that he could personally oversee its sale. In Bangkok, the demand for *pha lai* had grown and their entire stock was quickly sold with a wide profit margin of three-to-four times the original price. As soon as the news reached Abdul Tyeb in Surat, he made plans to replenish the store's stock with more cloth and travelled once more to Ahmedabad. There, he negotiated with textile agents to purchase cloth on credit in order to quickly provide the Bangkok shop with a renewed supply. He entered into deals with a number of reputable agents, two of whom Balubhai Lalbhai lists in his biographical notes as Vrajlal Jeevan and Chhagan Kuberd. Such agents or brokers acted as middlemen, connecting businessmen with the textiles mills or communities of weavers and craftsmen in the surrounding villages. Through them, Abdul Tyeb took his first steps into the new textile trade networks that were forming thick and fast around Ahmedabad and Bombay.

In addition to the ready-made bales of cloth, Abdul Tyeb commissioned specially made fabric that would cater specifically to the tastes of the Siamese market. Abdulali had sent notes from Bangkok with samples of patterns and colours currently in vogue in Siam. An early guidebook called *Siam: Some General Remarks* authored by D. E. Malloch and published in Calcutta, examines imports to Siam over a three-year period in the mid-nineteenth century and notes that Indian cloth imported to Siam tended to have bright red, light blue, or bottle green backgrounds and was decorated with small stars, flowers, or dots.

Left: (clockwise from top left), Bombay scenes portraying the harbour, port, Crawford Market and Elphinstone Circle. Photographed by the celebrated British photographer Francis Frith (1850-1870).

Above: View of Bombay from the History of the Indian Mutiny, 1858.

Bombay's boom years came to a crashing end in 1866 due to a commercial crisis in England and the end of the American Civil War. Many of the great fortunes made during that time of excess were lost, along with the financial institutions that had supported them. Businesses were liquidated and banks collapsed; only those not headquartered in Bombay were able to withstand the shock and loss of revenue.

Possibly because he had looked to the east rather than the west, Abdul Tyeb's business appears to have been untouched by the crash. Balubhai makes no mention of any hardship in his biography. Rather, he notes that the turnover was quick and the partners scored big profits the following year. Their profits continued to increase and they were soon able to order new ornaments for their wives to replace those that the women had to return a couple of years earlier.

Abdul Tyeb also expanded his own business in the wake of the crash by setting up an office in Bombay, perhaps rented at a good rate from one of the city's many bankrupt businessmen. The office was a small shop-house on Nagdevi Street not far from the famous

'Bombay did not question your caste or creed, did not care whether you were a pauper or a king, for the city belonged to no one and to everyone. So people came, armed with their ambitions, ready to endure hardship and heartache and disappointment. Fortune lurked around the corner, a dream away, a scheme away. The city kept their dreams alive and, in time, Bombay itself became the dream.' – Yasmeen Premji, Days of Gold & Sepia

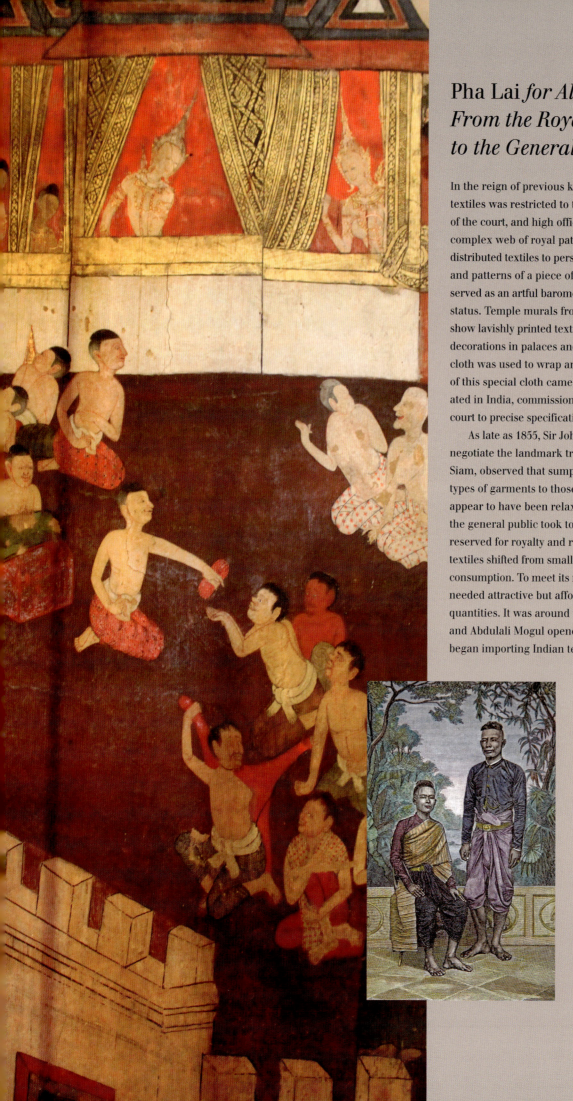

Pha Lai *for All:*
From the Royal Court to the General Public

In the reign of previous kings, the use of fine, imported textiles was restricted to the Siamese royal family, members of the court, and high officials chosen by the monarch. A complex web of royal patronage existed whereby the king distributed textiles to persons of favour. The quality, colour, and patterns of a piece of cloth worn or displayed at home served as an artful barometer of a person's wealth or social status. Temple murals from the Ayutthaya era (1350-1767) show lavishly printed textiles used as partitioning screens or decorations in palaces and temples. In monasteries, the cloth was used to wrap and protect holy manuscripts. Some of this special cloth came from China but much of it originated in India, commissioned by the Siamese monarch or court to precise specifications of size, colour, and design.

As late as 1855, Sir John Bowring, who went to Siam to negotiate the landmark treaty between Great Britain and Siam, observed that sumptuary laws still restricted certain types of garments to those of high rank. But restrictions appear to have been relaxed in the years that followed as the general public took to dressing in printed cloth once reserved for royalty and rank. The market for imported textiles shifted from small-scale high-end to mass-market consumption. To meet its new fashion requirements, Siam needed attractive but affordable Indian textiles in large quantities. It was around this time that Abdul Tyeb Maskati and Abdulali Mogul opened their first shop in Bangkok and began importing Indian textiles to Siam.

Left: Court scene from a temple mural at Wat Suwannaram in Bangkok showing a Siamese king distributing Indian textiles to courtiers, early nineteenth century.

Hand-coloured sketch of a couple wearing pha lai, *from a photograph by the photographer John Thomson during his travels to Phetchaburi province, 1865-66.*

Right: Photographs from the 1890s showing women and children dressed in pha lai. *Top to bottom: Woman standing, photographed by Gustav Lambert; Woman with water jar, photographed by Robert Lenz; Women and children, photographed by Gustav Lambert.*

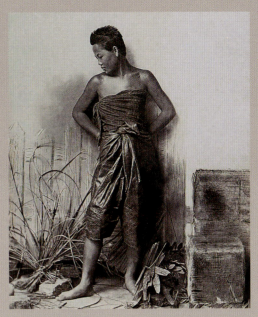
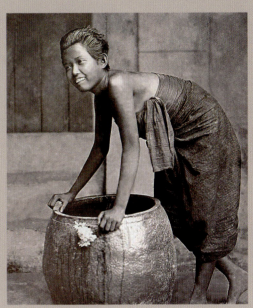
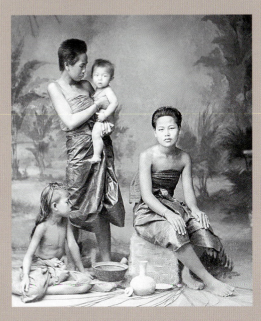

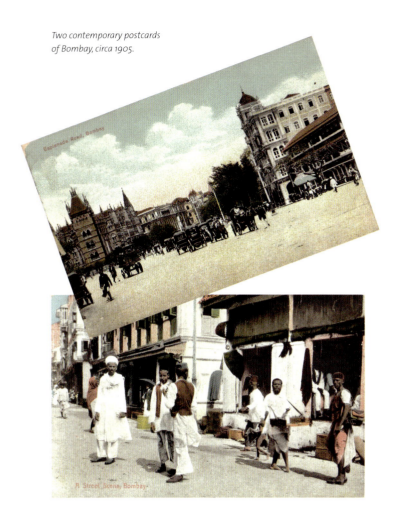

Two contemporary postcards of Bombay, circa 1905.

Crawford Market (see photo, page 24) in the heart of the city's commercial district. Crawford Market had just been built in 1865 to accommodate stalls selling fresh fruits, vegetables, and groceries. Nagdevi Street and the bustling area around it was known then – as it is now – for hardware goods.

Until that time, Abdul Tyeb and Abdulali had no staff and performed all necessary tasks themselves. Now, with their sudden profits and the prospect of more to come, they were able for the first time to hire clerks and servants. The partners had already built up a reliable network of money lenders, shipping agents, and brokers that made possible the transportation of cloth from India to Siam – a complicated task that involved negotiating the potentially treacherous open seas as well as customs regulations in both countries. With the changing fashion trends in Siam enlarging the market for imported textiles, it was time to cement the foundations of their company and grow their business in earnest.

Fifteen years after his first trip to Bangkok as a 19-year-old novice, Abdul Tyeb Maskati was running a thriving international business, with offices in Bombay, Surat, and Bangkok. Though Abdul Tyeb never again returned to Bangkok, Siam and the countries around it would be inextricably linked with the Maskati family fortunes for generations to come. In Indian business circles, Abdul Tyeb was often referred to as 'Siam-walla' (meaning a man whose business is connected to Siam).

In accounting for Abdul Tyeb's early success, Balubhai Lalbhai writes: *'Though he was a very hot-tempered person he was at the same time very pure-hearted, honest, and kind.'* His congenial manner and conscientious nature when it came to matters of money enabled him to build a network of colleagues beyond his own community and expertise; brokers, bankers, and Hindu merchants were happy to do business with him. Work and family were his primary focus. Though he did not have a wide circle of personal friends and rarely went out for entertainment, Abdul Tyeb had a special knack for selecting the right people to advise him on business matters.

Balubhai's thesis is that Abdul Tyeb was an especially lucky man. Certainly, his timing – to seize the opportunities that presented themselves after the Bowring Treaty in Siam and during Bombay's cotton boom and bust – was impeccable. In Balubhai's biography he highlights a conviction that both he and Abdul Tyeb both shared: *'Once luck becomes favourable, even faulty steps yield favourable results.'*

The Bohras of Surat: 'The wealthiest and most tightly organized of all Muslim communities in Surat was the Daudi [Dawoodi] Bohras. … Their prosperity grew during the seventeenth and eighteenth centuries as many built successful businesses through intracommunity networks of trust and shared resources. By the late nineteenth century many had established comfortable livings as shopkeepers dealing in commodities such as hardware, books, spices, sweets, groceries, and hides throughout western India. Some were extremely wealthy dealers in piece goods, with businesses stretching to Thailand, China, Arabia, and South Africa.' – Douglas E. Haynes, Rhetoric and Ritual in Colonial India: The Shaping of a Public Culture in Surat City, 1852–1928

In 1868, Abdul Tyeb Maskati rented two floors of a row-house in Begumpura, a neighbourhood in the centre of Surat. Headquartered in an office he set up there, he would expand his business in Southeast Asia from Bangkok, Siam, to Singapore and onto Phnom Penh and Battambang in Cambodia. Just over ten years after he first moved in, having earned substantial profits from exporting Indian cloth to Southeast Asia, he was able to purchase the entire building. Abdul Tyeb's accountant and biographer, Balubhai Lalbhai, records that he paid Rs. 8,000 for the property and then spent nearly twice that amount to have the whole structure renovated.

The ground floor of the building functioned as the head office of the Maskati firm. Business was conducted Gujarati style; seated, or reclining, on thin white mattresses known as *gaadi* that were laid across the tiled floor. Here, Abdul Tyeb and his staff sat at knee-high wooden tables and processed their daily transactions; receiving news and accounts, and negotiating with shipping agents, brokers, and clients. Due to the building's elongated footprint and resulting lack of windows,

House of Memories: A Home & Headquarters in Nineteenth Century Surat

From a tall, thin row-house in the heart of the ancient port city of Surat on the western coast of India, Abdul Tyeb Maskati ran his pan-Asian empire. Today, more than 150 years after he first took up residence, the once-grand home and headquarters stands empty.

the room was almost completely dark when the heavy wooden front door was shut and had to be lit, first by gas lamps and later – once the neighbourhood was wired up to municipal electricity supplies – by ceiling lights. A shed out back was used for temporary storage and samples, though the bulk of merchandise was stored at godowns in Ahmedabad and Bombay. Across the road was a stable for the carriage horses.

The four storeys of the house were linked by a stairwell and a central courtyard that allowed light and air to circulate. The upper storeys were used as living and sleeping areas for the family and, with each ascending floor, the decor became more elegant and less utilitarian.

Rooms lit by chandeliers of hand-blown pink glass were divided by curvaceous ogee arches and lined with Persian carpets. Filigreed blackwood cabinets, carved by Surat's famed woodworkers and polished to a high sheen by household staff, hung on the walls. In the sleeping quarters on the upper storeys, where four-poster beds were draped with feather-light mosquito nets, murals were painted onto the pistachio-green walls; beautifully executed still lives of fruits and flowers, and scenic wave-lashed landscapes. At either end of each

storey, stained-glass windows stamped with geometric patterns spilled coloured light in lace-like patterns across the floor.

Certain practicalities were necessary for living and working in such a long, narrow house. The kitchen was located on the top-most floor so that smoke and smells from cooking wouldn't trouble the inhabitants. In the building's early days, the only toilet was located on the ground floor above a container accessible to the city's night-soil collectors. Later, rain water was funnelled into an underground collection tank where it was purified with sulphur and charcoal, and then piped through the

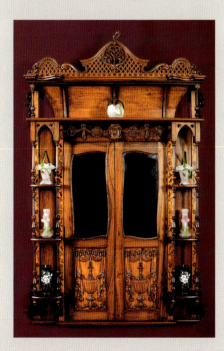

house using hand pumps. Messengers bearing invitations to weddings or other social events would shout their news from the central courtyard so that their cries would echo throughout the building.

In the decades that followed World War II, after the Maskati business headquarters shifted to Bombay, the house was used less often. As rooms were closed off, the furniture, such as the hanging lamps and wall cabinet, (see this page) was repurposed for the homes of Abdul Tyeb's descendants. Today, the only resident is a caretaker and only one room is maintained as a sitting room for family members who return to Surat to visit relatives or friends and spend time in the house where it all began.

Escape to Athwa Lines

In addition to his Surat home and office, Abdul Tyeb Maskati purchased land at Athwa Lines, which was then located just outside the city. It had long been the tradition of Surat's well-off inhabitants to maintain a residence beyond the congested confines of the city so their families could enjoy the quietude and cleaner, healthier surroundings of the countryside. Abdul Tyeb had the land levelled, constructed a house on the property, and planted the surrounding area with trees. He and his family spent their days at Begumpura during business hours, and then travelled by horse and carriage to Athwa Lines to spend the night – a journey that would have taken no more than half an hour. Later in life, he chose to live permanently at Athwa Lines. Though the property was sold by his great-grandchildren, and the land developed into housing and apartment blocks, some older residents of Surat still refer to the area as the Maskati Plots.

EXPANSION

EXPANSION

Capitalising on his good fortune and hard work, Abdul Tyeb Maskati set about building up his business in Southeast Asia. In 1871, he and his brother-in-law, Abdulali Mogul, opened a branch of their firm in Singapore by establishing an office in a prime corner location on Finlayson Green.

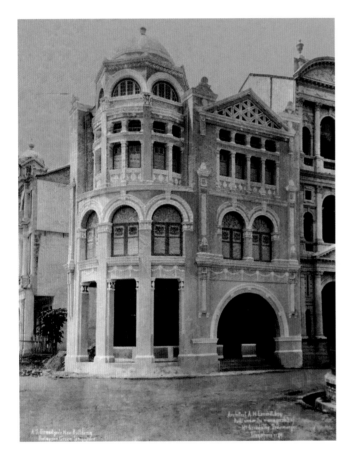

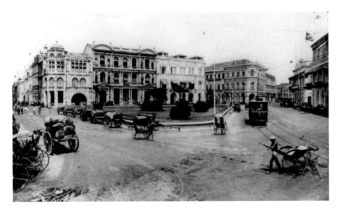

Singapore was then a relatively new port city. The landscape was still lush with vegetation and the sand-packed roads were lined with bamboo hedges, over-sized ferns, and traveller's palms. The up-and-coming urban areas were skirted by sprawling rubber and coconut plantations. When the British colonial administrator, Sir Stamford Raffles, first landed on the island just over 50 years earlier, he had seen the great potential of its geographic location and immediately began negotiating a treaty for British control. Raffles envisioned, and very quickly created, an 'emporium of the East' that would become a lucrative and efficient hub for East-West trade.

Singapore's early growth was boosted by successive waves of Indian immigrants. Raffles had arrived with a regiment of the Bengal Native Infantry and later ordered shiploads of Indian convicts as forced labour to construct his dream city. In the first decades of its founding, Indian labour was crucial to Singapore's infrastructure both in the surrounding plantations and on the construction sites of the city itself. Indian merchants were soon drawn to the fast-growing entrepôt, along with moneylenders and shipping brokers. The British administration was also stacked with Indians working as clerks and the police force was made up predominately of Sikhs. For efficiency and ease, Singapore was mapped with designated areas for each of the many nationalities that flocked to the new island nation; neighbourhoods were established for Armenians, Arabs, Bugis (from Sulawesi, Indonesia), Chinese, Europeans, and Indians. Little India, as Singapore's Indian enclave is known, still survives and thrives today.

With its newly constructed British colonial buildings, tropical vegetation, and orientation toward a developing harbour and international marine trade, there was much

Left: Seen from the waterfront, the Maskati office at 3 Finlayson Green. Designed by architect Alfred Lermit, it occupied a prime location in the early years of Singapore's development.

Above: The first office of the Maskati family firm in Singapore, established in 1871. The Maskati office was later moved to Raffles Place and then to Cecil Street.

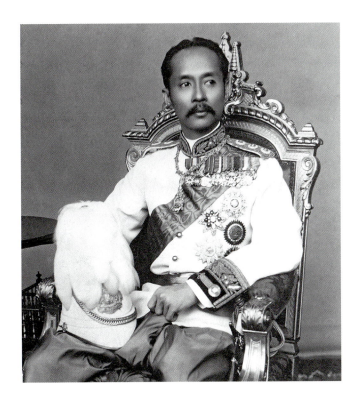

that would have felt familiar to a man coming from Bombay. As Singapore became the natural stop-off point for East-West trade it was an obvious extension for Abdul Tyeb and Abdulali's business. Established there under the joint name 'Abdul Tyeb Abdulali', they started off importing shirting and cotton products, which were in great demand by both European and Asian residents of the Straits Settlements. The venture was, again, a well-timed one that tapped into the changing fortunes and commercial trends of the region. Singapore was designed and built explicitly for commerce and, to that end, operating a business there was easy compared to the challenges of Bangkok.

In Bangkok, meanwhile, the new monarch, King Chulalongkorn (Rama V, r. 1868-1910), was preparing the capital of Siam for its own transformation. Because the young king was just 16 years old when his father died, Siam was ruled by a regent until he came of age and his official coronation took place in 1873. In the coming decades, King Chulalongkorn would introduce revolutionary new ideas to his kingdom and set in place major reforms that he hoped would bring Siam into the modern era.

Ties between Siam and India were cemented by a state visit by the young monarch. In 1872, King Chulalongkorn travelled to India, touring Calcutta, Delhi, and Bombay. As India was then under British rule, on his return he hosted a state dinner for the British Consul General and members of the consulate at which he thanked them for their hospitality and stated, *'May the good relations of friendship prosper and increase more, and never diminish.'*

Blueprinted for Trade: *'Singapore is certainly the handiest city I ever saw, as well planned and carefully executed as though built entirely by one man. It is like a big desk, full of drawers and pigeon-holes, where everything has its place, and can always be found in it.'* - William Hornaday (American zoologist and taxidermist), 1885.

Above: King Chulalongkorn (Rama V, born 1853), king of Siam from 1868 until his death in 1910.

Left: Singapore boat quay.

In 1874, Abdul Tyeb Maskati and Abdulali Mogul expanded their business in Siam and joined with a third partner, Abdulhussein Mulla Isabhai, to open a second shop under the name of Abdulhussein Hyderbhai & Co. Through two well-known commission agents named Jethabhai Ranchhod and Dahyabhai Maneklal in Bombay, they shipped bales of cloth from India to Bangkok.

At that time, the market for cotton goods in Siam was poised for expansion. As royal restrictions on certain types of textiles had been lifted, the number of people wanting imported cloth spread across the country and grew each year. Bartered for rice or exchanged for cash, the ever-increasing amount of *pha lai* (printed cloth) coming into the country was a significant indicator of Siam's economic growth during the last quarter of the nineteenth century. The in-country trade was conducted by Chinese merchants who bought rice from the central plains of Siam and exchanged it for imported Indian textiles, which they then distributed along trade networks through the interior. The textiles were sold in bundles known as *culie* (a Thai word derived from the common Indian trading term *corge*[1] or *khorji*), which amounted to 20 pieces of cloth. Siamese customers often preferred to purchase an entire *culie* so they could gift pieces of cloth to family members, friends, and their communities for special events such as the Thai New Year or Buddhist merit-making festivals – wearing new clothes on such occasions was believed to embody the promise of fresh beginnings and good fortune to the wearer.

How Imported Goods Came to Bangkok in the Nineteenth Century:

'According to rule, the captain [of an incoming ship] is compelled to anchor and land at the custom-house, a large bamboo shed with a palm-leaf roof and containing nothing but a table and two or three chairs. A Siamese official in native dress – a short white jacket and a strip of cloth around the waist and drawn between the thighs – presents a common blank-book in which the captain writes his report…" – Frank Vincent Jr., The Land of the White Elephant: Sights and Scenes in South-Eastern Asia, *1874.*

1. *Corgi, Coorge, &c., s. A mercantile term for 'a score' [20 pieces]. The word is in use among the trading Arabs and others, as well as in India.* ~ Col. Henry Yule, Hobson Jobson: A Glossary of Colloquial Anglo-Indian Words, *1886.*

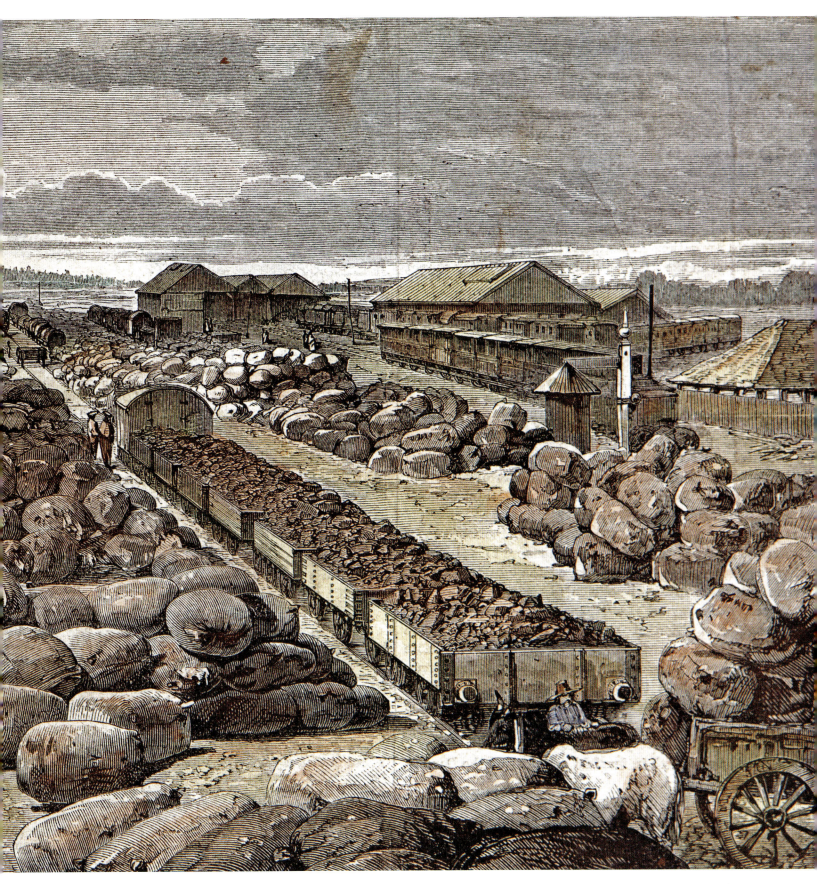

An etching captioned, 'Cotton bales lying at the terminus of the Great Indian Peninsula Railway ready for shipment to England', 1890s.

As Abdul Tyeb's empire expanded, so too did his family. He had a son (Haiderbhai) and daughter (Jenbu) from his first wife. With his second wife, Aminabu, whom he is believed to have married after the untimely death of his first wife, he had two daughters (Amtullabai and Fatmabai). After Aminabu's subsequent death, he married a third and final time, in 1873, to Nemtullabai. A year later, Nemtullabai gave birth to a son who was given his grandfather's name as a first name and his father's name as a middle name and so became known as Esmailji Abdultyeb Maskati. Of all Abdul Tyeb's immediate family, it would be Esmailji and his mother, Nemtullabai, who were destined to control the future of his business.

By the 1870s, Abdul Tyeb had moved his family from the area where he, his mother, and sisters first lived when they arrived in Surat to a better neighbourhood called Begumpura. Located at the heart of Surat within a quarter once surrounded by the city walls, Begumpura was a densely populated Bohra neighbourhood of narrow lanes lined with elegant row-houses. The streets – shaded for most of the day by continuous lines of buildings – were plied by mobile vendors who called out their wares and peopled with residents who sat in shaded alcoves at the front of their houses keeping an eye on their businesses, chatting with neighbours, and watching the world go by.

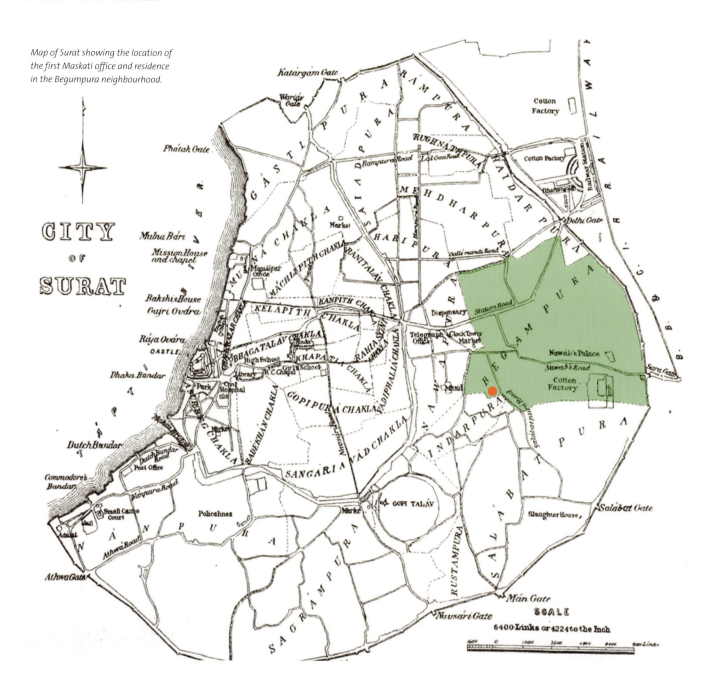

Map of Surat showing the location of the first Maskati office and residence in the Begumpura neighbourhood.

46

Abdul Tyeb set up his office in the building he rented in Begumpura (see pages 38-39). He hired a chief accountant and cashier and, from this new headquarters on the ground floor of his Begumpura house, began to grow his pan-Asian business empire.

Advancements in communications technology were beginning to make the job of controlling distant offices a little easier. As news came by ship, hand written or passed on through emissaries who sailed the routes between India and Southeast Asia, Abdul Tyeb had to wait many long weeks to receive updates from his offices in Siam and Singapore. Goods entrusted to shipping agencies were out of contact between ports and it could be months before he learned of successful deliveries and subsequent sales, and many more months by the time a record of accounts was delivered to Surat. But, by 1871, a submarine cable laid between Singapore and Madras meant that telegraphs could be sent to and from India and that Abdul Tyeb could receive news, at least from Singapore, within days.

It was in the year 1875 that Balubhai Lalbhai, author of Abdul Tyeb's biography, began working for the firm. He was then just 15 years old and had been recommended to Abdul Tyeb through a mutual connection as a good candidate for the job of accountant. Trusting his friend's opinion and his own instincts, Abdul Tyeb hired Balubhai on the spot. For a short period of time, he observed Balubhai transcribing figures into the company's account books. Satisfied that Balubhai would prove useful to the firm, he soon entrusted him with the work of taking down entries from the cash books maintained at Bombay and Singapore. Balubhai ended up staying with the Maskati firm for the remainder of Abdul Tyeb's life and until his own retirement. From the descriptions in his biographical notes – written some years after Abdul Tyeb's death – it is clear he admired his boss, both for his self-made qualities and for his integrity.

In one section of the biography, Balubhai describes how Abdul Tyeb was willing to take a personal loss for the sake of the firm. When one accountant was relocated from the Bombay office to work as a cashier at Surat, he was given strict instructions not to write off any amounts that remained untraceable under miscellaneous expenses but to charge such amounts to Abdul Tyeb's personal account. Though most of the money had been spent in connection with office work, the details could not be accounted for and Abdul Tyeb withdrew money from his own account so there would be no objections from the firm's partners. In 1874, Rs. 30,000 was written off in this manner – an amount far greater than the Rs. 20,000 that nearly sunk the business in Bangkok just a decade earlier.

Balubhai also highlighted Abdul Tyeb's frugal nature and described how his employer had an extreme dislike for *'all improper display of wealth'*. One of Abdul Tyeb's descendants, Jamil Merchant, still heeds advice passed down to him through his grandfather, Abdul Tyeb's first son, Haiderbhai, who recalled Abdul Tyeb advising him to use only a straw bag when he went out to the market. Such bags were only carried by servants and Haiderbhai complained to his father: *'Why should I have to carry a servant's bag?'*

Pointing out that wealth comes and goes, Abdul Tyeb replied, *'If tomorrow comes and you find that you no longer have any money and are forced to carry such a bag, no one will bat an eyelid.'*

Having lost all financial security as a young boy, built up his own business from scratch, and then nearly lost that too, Abdul Tyeb understood the potential impermanence of wealth and the inevitable cycles of loss and gain.

A traditional Bohra wedding, however, was no time to exercise frugality and, in 1876, Abdul Tyeb duly arranged marriages for his two eldest daughters, Jenbu and Amtulla-bai. One of these unions served to further cement his already close ties with the Mogul family through the union of Amtullabai and Mohammadali, Abdulali Mogul's son. The partners shared the expense of both marriages and a lavish ceremony was held at Abdulali's house in Surat, a large Begumpura mansion renowned for its size and grandeur. Some 200 guests were treated to board and lodging over the course of the wedding, and presented with shawls and other gifts.

Later that year, however, Abdulali underwent surgery for a throat disease and never recovered. He died just a few days after the operation. Following his death, there was confusion amongst his heirs as to how to divide his shares in the company. To simplify the issue and protect her children, his widow, Fatambu (Abdul Tyeb's older sister), decided to rescind her rightful partnership in the company and agreed to accept whatever compensation the surviving partners saw fit to provide. Independent

206. - PNOM-PENH. - La Pagode Royale et la Statue du Roi Norodom

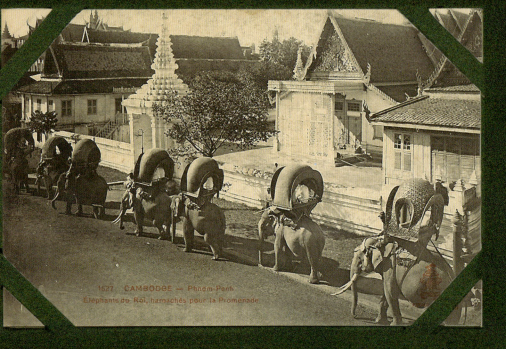

1527 CAMBODGE — Phnom-Penh
Éléphants du Roi, harnachés pour la Promenade

arbitrators were hired to calculate her dues and three years later, she received a settlement of Rs. 102,100.

In 1880, just a few years after Abdulali's death, Abdul Tyeb's other partner in Siam, Abdulhussein Mulla Isabhai, died in Bangkok, where he had been managing the store. In the wake of his death, the company suffered a loss, incurred debts, and his family was reduced to poverty. Taking pity on Abdulhussein's young children, Abdul Tyeb bore the loss without taking any action but the matter did not rest there and, years later, came back to haunt him.

As the sole remaining proprietor of his businesses in Southeast Asia, Abdul Tyeb changed the names of the stores in Bangkok to Abdul Tyeb Esmailji & Company. Doing business long distance remained a challenging endeavour and when the manager of one of his stores in Bangkok, Dawudbhai Shekh Abdulali, appeared to be fiddling the account books, Abdul Tyeb recalled him to India and sent a new manager to Bangkok to replace him in 1883. Though Abdul Tyeb came into possession of papers that proved Dawudbhai had been misappropriating money from the firm, he chose not to take legal action. The dispute between the two men went on for nearly three years, reaching a peak in 1885 when Abdul Tyeb learned that Dawudbhai was planning to return to Bangkok. Taking advantage of Abdul Tyeb's preoccupation with preparations for the weddings of his eldest son, Haiderbhai and Fatmabai, a daughter with his second wife, Dawudbhai tried to slip away. Dawudbhai was an influential man in his own right and Abdul Tyeb was concerned that he would badmouth the firm in Bangkok and damage its reputation. Determined to prevent this from happening, he instructed his employees to organise the wedding without him and prepared to travel to Bombay and set sail for Bangkok. However, a friend and fellow merchant in Bombay intervened before either man could leave for Bangkok and convinced Dawudbhai to take an oath in the name of god and pay Abdul Tyeb a sum of Rs. 25,000 to settle their affairs. He also persuaded Abdul Tyeb to pardon Dawudbhai and the two men returned to Surat with their relationship repaired. Dawudbhai attended the wedding of Abdul Tyeb's children and at the ceremony Abdul Tyeb even presented him with the gift of a white shawl.

Left: Scenes of the Royal Palace in Phnom Penh, Cambodia. The Maskati office was situated on Rue Ohier Street (now Ang Eng Street), not far from the Palace.

Indicative of his increased status and resources, the wedding Abdul Tyeb hosted for his son was far grander than the one hosted for his daughters nearly a decade earlier. The guest list of up to 700 guests was drawn from the well-to-do mercantile community of Surat and Bombay. Female guests received *dupattas* (shawls) and men were presented with *pugrees* (turban cloths). No donations or gifts were accepted from guests and those who travelled from outside Surat to attend the ceremonies had their transport costs covered and were given sweetmeat boxes to eat on their return journey. At least three lavish feasts were served over the course of the wedding and the bridegroom's procession led a crowd of some 2,000 well-wishers that included Hindus, Muslims, and Parsis. When the marriage party returned home after the wedding, firework displays arranged along their route lit up the sky above Surat.

At the end of the 1870s, Abdul Tyeb expanded his business further across mainland Southeast Asia by opening a shop in Phnom Penh, the capital of what was then French-ruled Cambodia, part of colonial Indochina.

In terms of its commercial development, Phnom Penh was younger even than Singapore. As a settlement, it was centuries old and had served as the capital of the Khmer kingdom during the fifteenth century. The royal citadel was later relocated to several other locations and it wasn't until after the French took control of the country that the modern-day capital was established once again at Phnom Penh in 1865. Then, Phnom Penh was little more than a riverside town of thatched huts and wooden buildings with a population of around 10,000 people. It hadn't enlarged much by the time Abdul Tyeb opened a shop there but the imprint of its future expansion was just visible as King Norodom had erected his Royal Palace complex near the Tonle Sap River and the colonial administration was establishing a European architectural aesthetic with French-style masonry buildings. Although he had acquiesced to colonial rule, King Norodom still clung to the traditional pomp and spectacle of kingship, asserting the age-old visual splendour of his lineage. The French explorer, Auguste Pavie, describes the king returning to his palace after an outing: *'Two hundred elephants, rolling the ancient seats, gilded or black, which they support, carry the king and the princes under roofs of scarlet bamboo screening and*

pass like a parade, filled with women of the harem and with dancers half naked beneath their scarves. They disappear with the horsemen, the carriages, and those on foot, in a cloud of dust, leaving the impression of an unforgettable enchanted picture.'

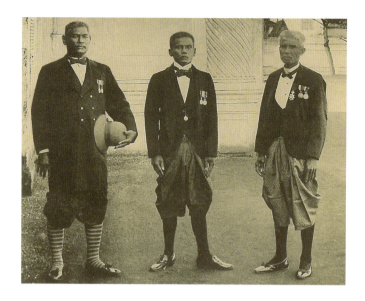

Despite Cambodia being a small and as yet undeveloped market, Abdul Tyeb must have sensed its potential. Dress and fashion tastes were similar to Siam, and Indian material sold in Bangkok was being transported on to Cambodia. And, with the advent of French rule across Indochina, international trade would increase and the market would grow.

Abdul Tyeb's Phnom Penh shop was named 'Kamruddin Abdultyeb', after his third and youngest son with Nemtullabai. Later evidence shows that it stocked elaborate cloth and haberdasheries, of the type used for the dress of traditional Cambodian dancers. A 1919 catalogue of products sold in Indochina lists the Maskati stock as, *'Bombay fabrics made in imitation of Cambodian and Siamese* sampot *[the Khmer word for* pha nung, *a cloth that can be wrapped like a* sarong *or wound between the legs like a* jong krabaen *or* dhoti*].'* Additional items included gold lamé, pure gold thread, and gold spangles used for the embellishment of traditional costumes worn by both male and female dancers. Abdul Tyeb purchased the gold threads in Surat, where they were known in Gujarati as *jari* and were made from flattened strands of gold or silver wrapped around silk thread.

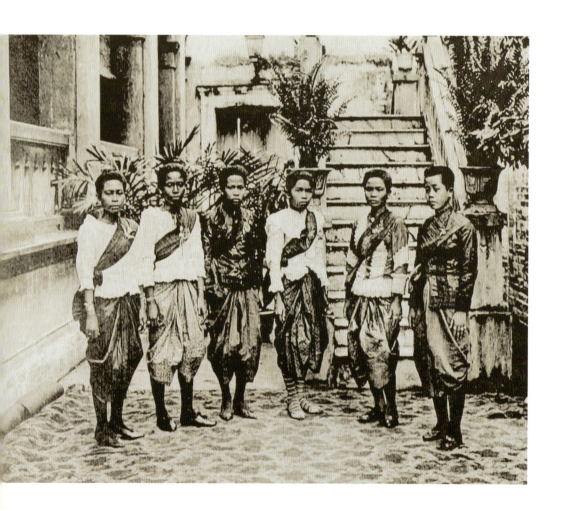

Left and above: Images showing Cambodian men and women dressed in pha lai, 1900s.

Right: Postcards of Khmer, or Cambodian, dancers. Under French-ruled Cambodia, the Phnom Penh stock list of 'Monsieur Maskati' included cotton fabric in Cambodian and Siamese styles as well as Indian brocade and threads made of pure gold used to adorn traditional dance costumes.

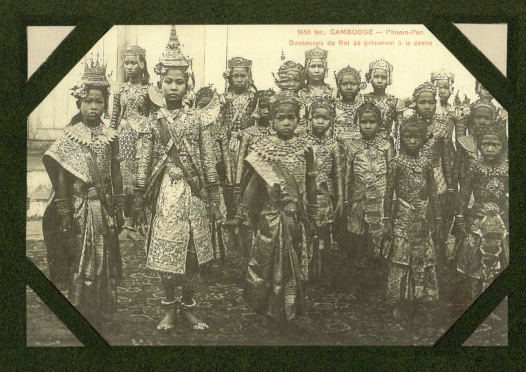

1658 ter. CAMBODGE — Phnom-Pen
Danseuses du Roi se préparant à la danse

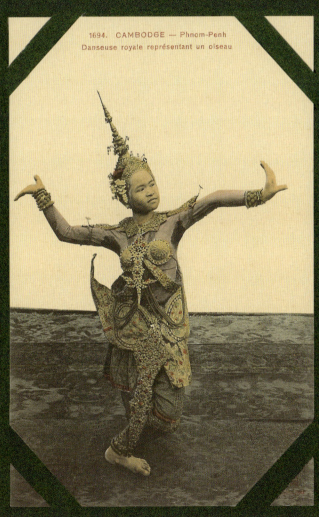

1694. CAMBODGE — Phnom-Penh
Danseuse royale représentant un oiseau

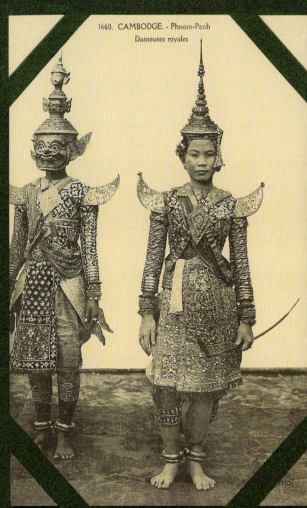

1660. CAMBODGE. - Phnom-Penh
Danseuses royales

It was around the time Abdul Tyeb Maskati extended his business to Cambodia that he decided to move into textile production. He may have been spurred on by a financial dispute with his agents in Ahmedabad, Vrajlal Jeevan and Chhagan Kuberd, from whom he had been ordering textiles for over a decade. Before ending his arrangement with them he settled his account in its entirety and paid all amounts they considered due to them in order to avoid any ill-feeling. By then, his sales outlets had expanded considerably; he was supplying cloth to numerous countries in Southeast Asia and he had tapped into a steady demand for material that needed to be met on a regular basis. In keeping with his dictum that even 'faulty steps' can turn out to be favourable, Abdul Tyeb's disagreement with his Ahmedabad agents preceded his decision to cut the middlemen out of his supply chain and begin producing his own cloth.

As the process of creating block-printed cloth was then performed entirely by hand, it was time-consuming and logistically complex. Firstly, special printing blocks had to be commissioned. These were made according to designs sent from Siam so that the resulting cloth would cater directly to market tastes. Based on drawings they received, block cutters in Gujarat prepared an overall design for each sheet of cloth, adjusting it as necessary for aesthetic reasons or to fit the required size. Their completed designs were then sent back to Bangkok for a final inspection before the designs were carved into wooden printing blocks. As the samples had to be transported by ship, this part of the process alone could take months. The cloth, produced at mills in Manchester or Bombay, had to be bleached and dyed before it was printed in successive layers to achieve the distinctive effect that came to be known as *saudagiri*, or 'trade' textiles after the Persian word, *saudii*, meaning goods for sale (see The Art of *Saudagiri*, page 174.)

Traditionally, the printing process was conducted by women who worked individually in their own homes. Agents who accepted commissions from traders delivered cloth, blocks, and dyes to the women's houses and then returned to collect the printed sheets. A single piece of cloth sometimes passed through as many as six homes before being completed as each household tended to be responsible for just one colour, or one layer of the overall design. When Abdul Tyeb developed his own printing

Woven in Stone: Cambodian Dress Through the Ages

Evidence that Indian textiles had long been favoured in Cambodia can be seen on sculptures and bas reliefs of the ancient temples of the kingdom of Angkor. The thirteenth-century Chinese diplomat, Zhou Daguan [also spelled, Chou Takuan], whose writings inform much of the historical understanding of life at Angkor, noticed that, *'although certain fabrics are woven in Cambodia, many are imported from Siam and Champa [a kingdom that once spread across central and southern Vietnam], preference being given to the Indian weaving for its skill and delicacy.'* By the time of his visit, the maritime routes bringing Indian textiles and influence to Southeast Asia were already well-established and Indian culture had a strong presence in Cambodia through Brahmins who were conducting religious rituals in the royal court and the absorption of Hindu deities and epics into local and religious lore. In her paper 'Indic Impetus', the textile historian Gillian Green notes that Indian textiles probably arrived at the Gulf of Siam on ships that had sailed around the Malay peninsula. They would then have been carried overland via Battambang. At Angkor, Khmer stone masons appear to have modelled details in the dress and decorations they carved for the female deities known as *apsara* on the backdrops of temples and royal residences on real textiles imported from India or China. While Chinese cloth was predominately silk, textiles imported from India would have been hand-painted or block-printed cotton. The designs woven into the stones of Angkor show repeated geometric patterns or natural shapes such as flowers, leaves, waves, and stars that can be matched to samples of Indian cloth from that same era. More than 600 years later, with the kingdom of Angkor long in ruins, the same motifs were once again visible on the printed Indian cotton that Abdul Tyeb Maskati was importing to Cambodia.

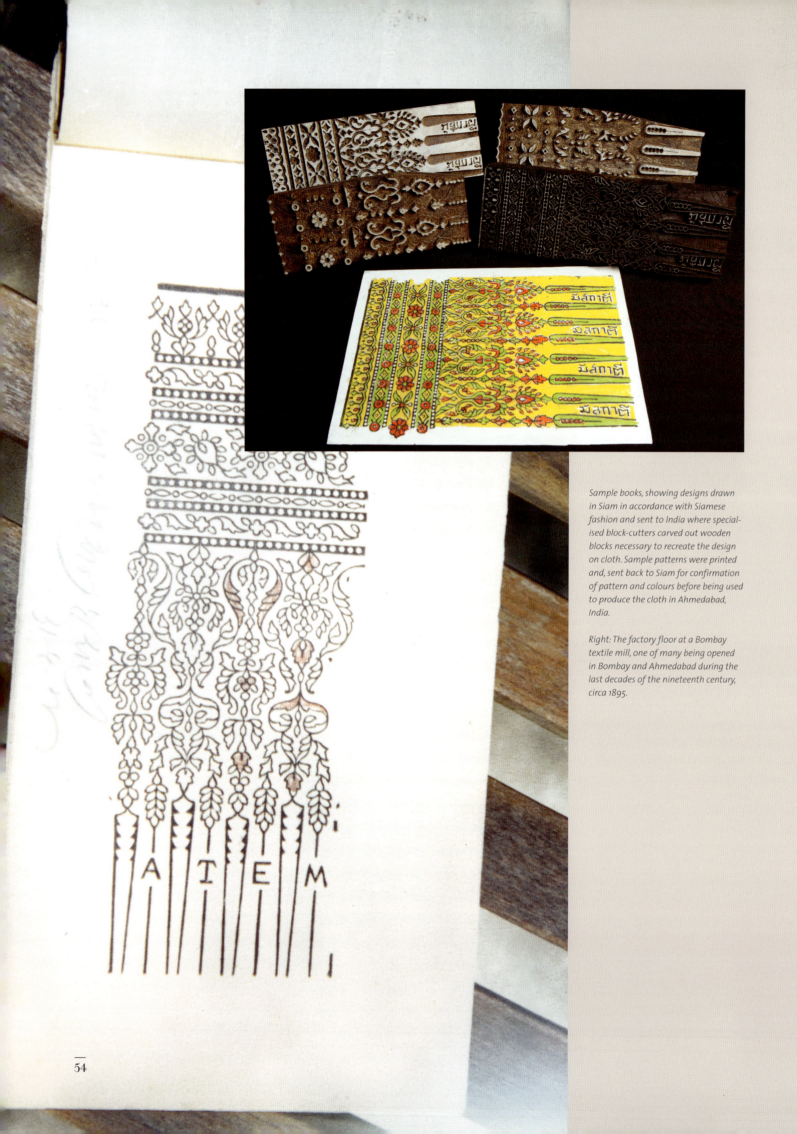

Sample books, showing designs drawn in Siam in accordance with Siamese fashion and sent to India where specialised block-cutters carved out wooden blocks necessary to recreate the design on cloth. Sample patterns were printed and, sent back to Siam for confirmation of pattern and colours before being used to produce the cloth in Ahmedabad, India.

Right: The factory floor at a Bombay textile mill, one of many being opened in Bombay and Ahmedabad during the last decades of the nineteenth century, circa 1895.

business, he assembled a team of male *chippas*, a printing caste who specialised in dyeing and printing cloth. To simplify the process and maximise production and quality control, he brought the printers together in a single workshop. One workshop was located in Astodia, a neighbourhood inside the city walls of Ahmedabad, which had just been dismantled in the early 1870s. It was a convenient location as the *chippas* who worked for Abdul Tyeb could find accommodation in and around the surrounding *pols*, as the gated lanes of old Ahmedabad were known, and it was not too far from the Sabarmati River, where the cloth was taken to be rinsed and sun-dried in the open air. Abdul Tyeb also purchased additional properties in Ahmedabad that were used for different stages of the process, from initial production through to pre-shipping storage. Later, when the technology became more readily available, he purchased calendaring machines so the cloth could be mechanically smoothed, rolled, and measured before being transported to Siam.

Abdul Tyeb started off by engaging two or three Bohra employees in Ahmedabad but it turned out that they didn't have enough experience to do the work properly so he hired a Gujarati man called Trikamlal Chhaganlal. Later, he sent one of his nephews to serve as an apprentice under Trikamlal to make sure that at least one member of his family fully understood the art, craft, and patient skill required to produce *saudagiri*.

It was uncommon for traders to make and sell their own products, and Abdul Tyeb may have been inspired by other societal forces that were ascendant in India at the time. One of these was the nationalist *swadeshi* movement, which was rippling across Gujarat in the 1870s. In an essay penned in 1876, the Gujarati educationist, Navalram, wrote, *'Today, the country whose weavers once clothed the world, has to look overseas to an obscure place called Manchester for even a simple hank of yarn…'* His words awakened an urge to revitalise the country's 'ruined industries' so that India would not have to be so dependent on Europe. In Ahmedabad, this clarion call was interpreted from an entrepreneurial perspective and helped fuel the rise of the city's cotton industry, which was funded entirely by Indian investors.

As the cotton industry took over Bombay and Ahmedabad, there was a strong conviction that the future lay in textiles. In the wake of the dizzying boom-and-bust of the 1860s, as investors looked for means of recovery and new entrepreneurs sought to establish a commercial foothold, many turned to the textile industry. In Bombay, more than 60 yarn and cotton mills were constructed between 1870 and 1890, and much of the resulting trade was driven by the far eastern market as India had begun to export large quantities of yarn to China. The textile industry was also generating jobs across the social spectrum, from the traders and brokers who sold cloth to the dock workers and railwaymen who transported it. In Ahmedabad, which followed closely on the heels of Bombay, the industry would transform not only the shape of the city but the fortunes of many of its individuals and families. As the home industries of yarn-making, weaving, and printing shifted from living-room floors to larger-scale production houses, the number of mills and factories in Ahmedabad grew steadily. In 1879, the year Abdul Tyeb began his own production line, Ahmedabad had four mills that employed some 60 workers. Within just 20 years, 27 mills were employing nearly 16,000 workers and the city's ancient minarets were dwarfed by the towering chimneys of the cotton mills. Abdul Tyeb had caught a wave of expansion and enthusiasm that was sweeping the region.

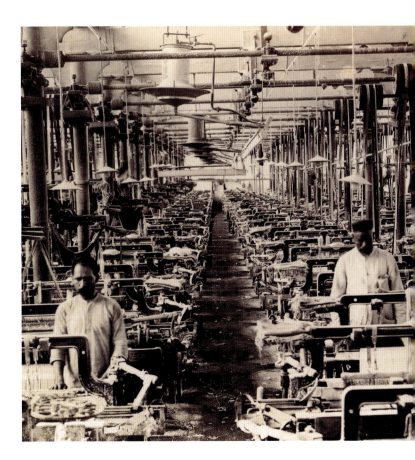

Abdul Tyeb Maskati's business empire was growing but his own world had begun to shrink as he entered his 50s. He was devastated when Jenbu, his daughter from his first wife, contracted tuberculosis. Abdul Tyeb was especially fond of her and had described her to Balubhai Lalbhai as a very *'sober and wise'* woman. He spent a considerable sum of money on her medical treatment but it was to no avail. In 1882 she died from the illness and Balubhai writes that her death was a great shock to Abdul Tyeb.

The following year brought more hardship as Surat was engulfed by flooding. Overflow from the Tapti River, which runs alongside Surat, was a regular occurrence but the floods of 1883 were recorded as the worst to hit the city in 70 years. Much of the city was submerged in water that was ten feet deep in places. As the flood lingered for a week, the usual methods of transport – trains and horse-drawn carriages – were unable to reach the city and business came to a standstill. When the water finally abated, it left behind a devastated city: thousands were destitute as their homes had been washed away and the streets were ankle-deep in mud and slime. A local newspaper, the Loke Mitra, opined, *'Surat is once more a scene of dire misery.'*

Block-Printing in India as Seen by a Siamese Prince

Prince Damrong (1862-1943), a younger brother of King Chulalongkorn, visited India in 1891 when he was Siam's Minister of Education. There, he went to view the production of *saudagiri* (or *pha lai* as the block-printed cloth was known in Siam). His interest was sparked because the material was being imported to Siam in great quantity. In a personal letter written to another of the king's brothers, Prince Naris, he describes the process as it was done traditionally, by women in their homes: *'There is nothing that looks like a factory. Only women and youngsters working in their houses. They use white cloth imported from England, cut it into desirable sizes, and wash it to remove the starch. Then the cloth is placed on the floor and stamped in its entirety with a wooden block. Other blocks dipped in different colours are then stamped [on the cloth] to complete the design. This is all done by hand and within the household. Textile agents provide only the white cloth and then return to collect their orders.'* Prince Damrong is pictured here (seated centre) at Asman Garh Palace Hyderabad with his host, the Nawab Sir Asman Jah Bahadur, on the right, 1891/92.

Abdul Tyeb's Begumpura property was spared the worst of the flooding. The water submerged and destroyed his stables and his horses had to be shifted into the main compound. The flood reached the rear gates of the building but rose no higher. Personally, however, Abdul Tyeb was struck down by the aftermath when the city suffered a particularly vicious cholera outbreak following the flood. He survived a bout of cholera only to be diagnosed a year later with heart disease. His doctors advised him to spend more time in the fresh air and cautioned against raising his voice, exercising vigorously, or lifting heavy weights.

The diagnosis was serious and his doctors pressed upon him the fact that his condition was life-threatening.

Heeding these warnings, Abdul Tyeb moved permanently to his bungalow at Athwa Lines. He stopped travelling to Bombay and Ahmedabad unless it was absolutely necessary. If he had to go for work, he limited his visits to a maximum of three days and made a point of sleeping outside in the open air so as not to spend the night in a stuffy room. Following his diagnosis, he never spent another night at the Begumpura residence; if he returned to Surat from a work trip, even if it was after midnight, he still insisted on travelling on to his Athwa Lines residence.

In addition to following the advice of his doctors, Abdul Tyeb was probably also paying heed to astrological predictions. Balubhai writes that Abdul Tyeb was a great believer in astrology. Trikamlal, his manager at Ahmedabad, had recommended a reliable astrologer there and Abdul Tyeb commissioned a ten-year forecast from him. Many of the predictions turned out to be true and Abdul Tyeb placed great faith in the document. In Surat, he frequently hosted the astrologer Shri Harishankar Joshi and had him prepare individual horoscopes for each of his children.

An official letter written in 1884 to King Chulalongkorn described the system whereby *pha lai* (as *saudagiri* was known in Thai) was being sold in Siam. In the letter, Chao Phraya Paskornwongse, chief officer of the Bangkok Customs House, explains that Indian merchants, like Abdul Tyeb Maskati who imported printed cloth from India, sold their stock wholesale to dealers, mostly small-scale Chinese merchants, who transported the cloth across Siam, selling it in smaller amounts from smaller shops to individual customers. The cloth was purchased on credit and accounts had to be settled every four months. The letter mentions Abdul Tyeb as being one of two prominent textile traders in Bangkok who owned a big shop selling cheaply priced *pha lai* that catered to a mass market and was distributed throughout the countryside of Siam.

Indeed, business was booming as *pha lai* sales rose each year. An 1887 report of trade in Bangkok records the importation of 68,361 *culies* (20-sheet rolls) of Indian painted and printed cotton worth 549,380 baht. In 1888, the amount increased to 102,587 *culies* worth 671,460 baht, showing that in just one year, more than two million pieces of *pha lai*, or *saudagiri*, were imported to Bangkok.

ทูลพระพุทธเจ้ากระยาหลวงทรง ของพระภูทานปกกบปะคุมกุลกระกรุณา
ทรงทรบเกล้าสรวจสิทธะยาก กระภูษาญาเป็นล้นเกล้า ๑

ค่ายฝ่ายเป็นสิปค่าเต็มมาในกรุงเทพๆ ปี ๑ เป็นภาษิง ๑๐๐๐๐ รูเศศ
แรกเศศที่เป็นผู้มันภูกเต็มมารายปีอยู่ ๔ ทัง การที่สิยกรักภาษีนั้น อยู่ค่างระเลีย
เปรียบจกก่ำมาก คุเหมือนเท่าภาษีอยู่ในบังคับบอกก่ำแล้วแต่กะบอกก่ำนวนแรกกาการ
ระเบต มิได้ทะรกกให้ถูกถ้ำนตามบาญชี แลก็เห็นสิงของที่ระเยียกรักภาษีทามสมาคม
กับกดไม่ เพราะสิงใดสียว่ารักภาษีเป็นสิงของใกลเก่าๆ ก็ใม่สิงทะทะณทามที่ที่ทานได้
ทรรมเนียมที่ก่ำมาก่อนนั้น ทั้งผ่ายเข้ามาแล้วก็กำรกบาญชีจำนวนแรกกาเป็นส่า
สาฉกทั้ง ๒ เก็บบัง มาบอกท่านรรอนุญาติมันสิงของใบ ภายหลังที่กันพักมาปลึงเก่าเบ็ดก้
ทะภาษีทามกัน สิลุกท้าสารองในได้แล้ว ก็ไม่ได้ทากราบนับจำนวนศักภูกตัน รายะนัง
บากท่าน แลก็เห็นเฉียยากที่ระเยียกรักภาษี ให้สมภาคกับภากสิบบอกทาบไม่ จำนัดมีน
บอกท่อรภาษีมา ก็ได้แต่ผ่อย่าง กลาง ๑ แทบทั้นนั้น แลภากผ่ายที่บอกก่านนั้น
เตา
ก็อย่างระบ่า เกินกับภาคาที่รอายกับในก้อนน้ำ ผ้า ๔ ค่อกบอกภาคาสิงกุสิละ ๕๑ เบีญ
ผ้า ๒ ค่อกบอกกก ๔ ให้เรียน ผ้า ๓ คิบบอกกก ๓ เพียน, ผ้า ๓ คิบบอกกก ๒ เบีญ
ท่านระของรักภาษีเป็นสิน ชึงรมแต่ทาเพระยาเบนากทั้งสิริยงก์ กระภูษาผู้ ๒ คราก รบเบิ้ก
ทะเยียกุสิละ ๑ ถูกก็ก็ใม่ยอมระสียภาษีให้เป็นสิน ในเดือน ๕ ปีทะภูกมาก็ใม่
ให้เยียกรักภาษีไปตามทรรมเนียมเดิมที่สำทันพักงานก่ำมาแต่ก่อนนั้น ให้ผ่าท้ายสิ ๑๐๐ คูติ
เศศ เป็นแต่ผ่อย่าง กลาง ๑ แทบทั้นนั้น แลก็สิบบอกภาบเทพๆ ว่า อุบายของแรกก็ที่ถิก
เตา
โกงเอาเปรียบข้อภาษี ผ้อยู่หายบภาก ครันระปล่อยให้ทำเร่นอย่างเดิมพ่อเปริก กะใม
ภาสระเล้า การกัยับนาอยู่ ๕๑ นีผลปะลียนของแผ่นตินก็ถกเปร้ยเสมอ
ทระพุทะเก็งใกลบกปเสียไหม่ ให้ทำกันงานประทับภาคบัยบัน แลเก็ดสิทิมาย
โปรดกับต่อลานั้น สุกคำรับไปแล้วไห้พันกายผู้ที่ทาสังของ กับพนักงานผู้เก็บ

As the *pha lai* trade continued to grow, the Siamese customs authority placed more stringent controls on the trade. Until 1889, British Indian merchants importing cloth from Bombay were granted permits to offload the cloth from their ships and transport it to their godowns before it was checked by the authorities. Customs officers would later visit the godowns, examine the goods, and collect the required duties in kind or in cash. But, with the trade growing so fast, it became impractical for customs officials to grant such leeway to the textile importers and an order was issued to regulate the importation and inspection of cloth from India. From the beginning of that year, cloth imports had to be examined at the Customs House and necessary duties were paid in cash before the goods could be released and taken to the godowns.

Numerous reforms and regulations were promulgated under the reign of King Chulalongkorn as he sought to modernise the city and place it on an even keel with European metropolises. Construction began on the country's first railway line in 1891 and Siam now had its own postal system. Electricity was being installed in parts of Bangkok and resulted in the introduction, in 1894, of an electric tram service. Roads were being constructed throughout the city, accompanied by bridges straddling the many canals.

By the 1890s, Bangkok's centre for business and trade was concentrated on the west bank and most of the Indian traders residing in Mussulman Square had moved their business across the river. Abdul Tyeb's main Bangkok office was established conveniently close to a riverside pier in the Ratchawongse neighbourhood on what was then the edge of the Chinese quarters. As the sale and distribution of *pha lai* was conducted by Chinese retailers, it made logistical and economic sense to be located in Chinatown, which was then the pulsing, commercial heart of Bangkok.

A report on American trade with Siam, published in 1898, describes Bangkok around that time: '*Bangkok, the capital of Siam, is one of the largest and most important cities of Asia. Its population is estimated at from 600,000 to 800,000, and it is growing rapidly. Although hot and dirty, it is more progressive than most of its northern neighbors. It has an excellent electric street car system, electric light on the leading streets, telephones and telegraphs, railroads, hotels, clubs, libraries and banks, while the river [Chao Phraya], flowing through its heart, is lined with the godowns, offices and wharves of exporting, importing and general shipping firms, as well as with the numerous rice and saw mills of Chinese companies.*'

Left: This report of pha lai *importation tax by Chao Phraya Paskornwongse (pictured page 33) was written for King Chulalongkorn in 1884 and mentions Abdul Tyeb Esmailji Maskati as one of the major traders of* pha lai *in Bangkok.*

Right: Scene of modernising Bangkok, showing a tram on Charoen Krung Road and indicating how traffic began to shift from canals to roads at the turn of the twentieth century. Robert Lenz, 1900s.

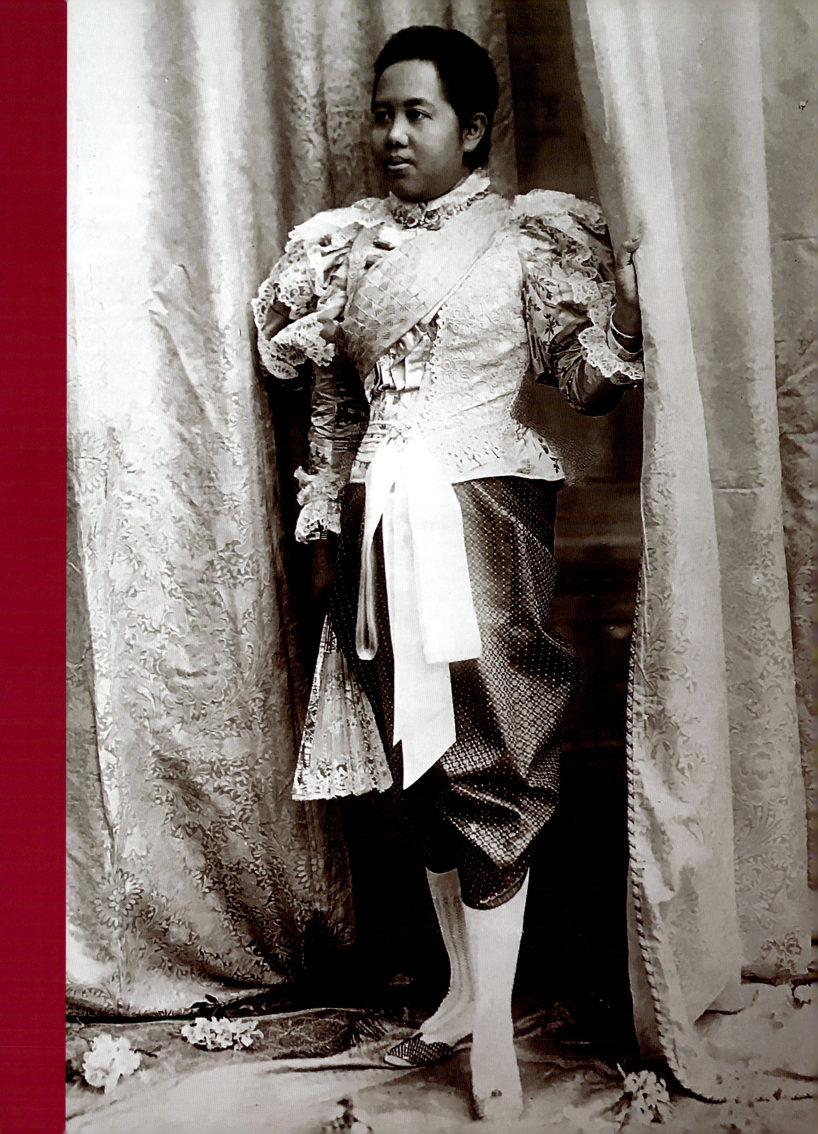

Inspired by the King's Travels: Bangkok's Hybrid East-West Look

Siam's taste for textiles was changing. As the upper echelons of society turned to Europe for inspiration and fabric, a larger market was opening up beyond palace realms. King Chulalongkorn was the first Siamese monarch to travel outside of Siam. Following visits to Malaysia, Singapore, Indonesia, India, and Europe, he brought back new ideas about governance, architecture, education, and fashion. After his trip to India in 1872, he introduced a shirt called the Rajapataen, or 'King's pattern'. The white, high-collared shirt with five central buttons was worn over a *jong krabaen*. European fashions filtered into the court long before the king's European tour in 1897, and his wives and daughters took to wearing Victorian lace blouses together with the traditional *sabai* (draped shoulder cloth), silk *jong krabaen*, and western high-heeled leather shoes. While these hybrid fashions led to a decline in the use of Indian textiles for royal dress, fine Indian cloth continued to be used in royal ceremonies such as coronations, funerals, and Buddhist rituals. Catering to the hybrid fashion tastes of the Bangkok elite, western tailors and department stores opened up in the city – among them Messrs Grimm & Co., Ramsay & Co., and Harry A. Badman & Co. Outside of elite circles, however, the *pha nung*, or sarong, was still favoured by both men and women across Thailand, and it was this expansive market that Abdul Tyeb's *pha lai*, or *saudagiri*, imports aimed to supply.

Queen Saowapha (1861-1919), principal wife of King Chulalongkorn and leading fashion icon of her time, shown here in her hybrid East-West look that inspired many women in the Siamese court and beyond. Robert Lenz, 1896.

Bombay V. Manchester: *'The price in Bangkok of chowls [bales of cloth] manufactured in Bombay varied from 11 shillings and 6 pence a corge of 20 pieces for the small kind mostly used by women to 2 pounds 7 shillings 11 pence for the larger specimens. Chowls of Manchester manufacture were sold at a price varying from 19 shillings and 2 pence to 1 pound 14 shillings and 6 pence per corge, being all of equal size, but of different qualities. The Bombay chowls, having the advantage of being woven in fast colours, stand in higher estimation with the native population than the Manchester goods, and command better prices.'* – The Times of India, *22 October 1890.*

Balubhai Lalbhai, accountant and self-appointed biographer of Abdul Tyeb was intensely loyal to his employer and, in return, his employer was loyal to him. Balubhai writes, '[Abdul Tyeb] treated his employees who were honest as well as his well-wishers very well and always took care to see that they did not leave his service.' At the beginning of the 1890s, Abdul Tyeb summoned Balubhai and another colleague to tell them he had found a business for them to invest in. Abdul Tyeb had heard that woollen cloth for suits was in great demand in Singapore and suggested that the two men purchase such cloth in India and sell it through his Singapore shop so they could earn an income above and beyond the salaries he was paying them. Four boxes of woollen cloth were sent to Singapore under the names of Balubhai and his colleague. Abdul Tyeb took no commission for the service and the two men made a handsome profit from the exchange. The arrangement was, in essence, the equivalent of a modern-day stock option.

Balubhai also notes that Abdul Tyeb was very religious minded and was a *'kind-hearted and a very practical person'*. When Abdul Tyeb learned that Rehmatpura (the original neighbourhood he and his mother and sisters had moved to when they first arrived in Surat) was wracked with poverty, he began hosting feasts during religious festivals so that the residents would have a chance to eat well and share a communal meal at regular intervals. He ordered the best quality rice and pure ghee from Ahmedabad and, as the feasts became annual events, he put great care into planning the menus. In addition to these feasts, Abdul Tyeb made

regular donations of cash, clothing, and grains wherever he came across people in need.

In his own affairs, Abdul Tyeb maintained his lifelong habit of frugality. He withdrew from his company a minimal salary of Rs. 100, which he used to pay the servants who looked after his bungalow and garden at Athwa Lines. He gave his wife, Nemtullabai, Rs. 50 every month to pay for daily household necessities such as vegetables, milk, and ghee, with a separate allowance for grains and clothing. Owing perhaps to inflation or at her own request, the monthly household allowance was doubled in 1885 to Rs. 100.

In 1896, plague broke out in Bombay and threatened to spread to Surat, where terrified people fled the city in their thousands. Schools and shops were closed and the city's burgeoning industries were placed at risk by the health scare. It was the worst outbreak of the century and the British administration enacted tough measures to try and control it. So-called 'Plague Committees' conducted house-to-house searches and had the right to evacuate and quarantine sick residents. In Bombay, these unpop-ular searches resulted in riots but in Surat they were carried out with the assistance of local communities. Though municipal authorities had been

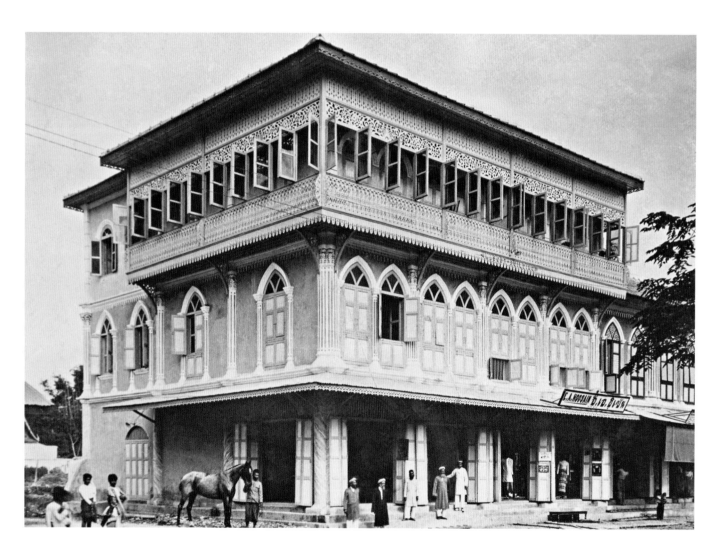

The original Maskati headquarters on Anuwongse Road, Bangkok, built with an office on the ground floor and residences for staff and family on the upper storeys, was later replaced by a new office-cum-residential building constructed in the 1970s (see page 152).

checking passengers arriving on incoming trains it was still felt necessary to conduct house-to-house searches within the city. In March 1897, one such committee prepared to search the Bohra quarters around Zampa Bazar where Abdul Tyeb's Begumpura residence was located. To conduct the search, the local authorities arrived with 30 armed sepoys from the Frontier Force, an equal number of armed police, and 80 unarmed police. The area was cordoned off to prevent anyone from leaving during the search. The authorities fully anticipated the same kind of resistance they had met in Bombay, especially since many of the houses were home to women in purdah who would not welcome strangers in their homes. To their surprise, the search went by without a hitch, and not a single case of plague was found.

Balubhai, however, wasn't so fortunate. He lost his brother-in-law and four or five family members to the plague within just a few days of the outbreak. As soon as Abdul Tyeb heard this, he sent a colleague to help relocate Balubhai and his family to his bungalow at Athwa Lines. Balubhai was reluctant to impose on his employer but Abdul Tyeb insisted and set up a separate apartment for him on the upper floor of the horse's stable. Though Balubhai and his family arrived at Athwa Lines late at night, Abdul Tyeb came out to meet them and get them settled in their new accommodation. When the plague abated and the situation began to normalise, Balubhai made preparations to return home but Abdul Tyeb insisted he stay through the winter and he ended up staying at Athwa Lines for around six months, until Abdul Tyeb was convinced it was safe for him to go home.

In the final decade of his life, Abdul Tyeb's thoughts turned to his legacy and he began to think about the division of his assets and the preparation of his legal will. He had good reason to put some thought into the matter. A decade had passed since the death of his partner, Abdulhussein Mulla Isabhai, in Bangkok, but Abdulhussein's son was threatening Abdul Tyeb with a court case and demanding payment of accumulated dividends since his father's death in 1880. To assuage him, Abdul Tyeb offered to give him a plot of land but he refused and the resulting court case dragged on for four years, eventually ruling in Abdul Tyeb's favour. Abdul Tyeb had also seen firsthand the protracted struggles over the estate of his first partner and brother-in-law, Abdulali Mogul. Aware that his extended family of eight surviving children from three different wives might not always be able to maintain cordial relations, he tried to establish mechanisms that would prevent any future wrangling between them.

To this end, Abdul Tyeb broke his no-travel rule in 1894 and set off with his lawyer on a trip to Bombay where he consulted a judge and other legal experts. Upon his return, he decided to leave his children from his first two marriages, whose mothers were deceased, out of the will and make early payments to them instead. His relations with all three surviving children from his first two marriages were troubled. His differences with his son from his first marriage, Haiderbhai, had already led to the severing of Haiderbhai's allowance. He had also been disappointed when Fatmabai, his daughter from his second marriage, divorced her husband. He had arranged the marriage and the wedding ceremony had been a grand affair held at his expense in 1885. When her second arranged marriage also broke down, as Balubhai Lalbhai puts it, Abdul Tyeb 'lost all affection' for his headstrong daughter.

Abdul Tyeb's legal will was destined to be a complicated affair and in order to complete it, he invited Balubhai and a lawyer to stay with him at Athwa Lines. The three men spent nearly a month holed up at the residence clarifying the division of assets. A list of executors was selected and appointed; the list included Balubhai and Nemtullabai, as well as trusted accountants from various offices in Ahmedabad, Bombay, Surat, and Bangkok.

Abdul Tyeb made careful provisions for his third wife, Nemtullabai, and their five children. He invested roughly half his income in purchasing real estate in their names. He transferred the Begumpura house and all its contents into Nemtullabai's name and a registrar officially handed her the keys to the property; Abdul Tyeb even paid rent to Nemtullabai for the use of the office space on the ground floor.

Meanwhile, Abdul Tyeb's eldest son with Nemtullabai, Esmailji, opened a separate office in 1895 located in a rented building opposite the firm's Nagdevi headquarters in Bombay. He set up and ran the business without borrowing any money from Abdul Tyeb but by

using some money from his mother and Rs. 50,000 his father had set aside for his and his brother's weddings. The main purpose of the enterprise was to have another established business – separate in name, location, and ownership – that could continue to operate and take over the tasks of the ongoing business if Abdul Tyeb's children from his first two marriages decided to cause trouble or legal disruptions. To these children, he made early payments. To his eldest surviving son, Haiderbhai, he left Rs. 45,000 and a bungalow in Singapore. In accordance with Sharia law, a daughter – who was assumed to be cared for within her husband's household – was eligible for half of whatever a son received and so Abdul Tyeb's two surviving daughters, Amtullabai and Fatmabai, each received Rs. 22,500 in cash. To protect the rest of his family, he made each of them sign a written affidavit forgoing any additional claim on his property.

Harsh as Abdul Tyeb's measures may seem, they were a foresightful tactic aimed at protecting the business he had spent his life building up. Islamic inheritance law requires that property and assets be divided amongst all male and female descendants. This meant that wealth, estates, and businesses often did not remain intact; as assets were divided so business empires were decimated and weakened. Great fortunes amassed in one lifetime could evaporate in that of the following generation, in some cases leaving the successive descendants of wealthy merchants in ignominious poverty. As a result, names that commanded great respect in the nineteenth century were often lost to history. Abdul Tyeb must have understood this and the legal preparations he made in his final decade were an attempt to keep his empire intact.

Though Abdul Tyeb's efforts were ultimately successful, none of the measures he put in place were enough to stop the family squabble that rumbled for years until it finally reached a climax in the Bombay High Court a decade after his death.

Given his dedication to astrological predictions, Abdul Tyeb may have had some sense that his days were numbered. In the last few years of his life, having assigned his assets, he set about organising a few final details. In 1896, he made the revered Arbaeen Pilgrimage to Karbala in Iraq. Two years later, he saw his son, Esmailji, married. The arrangements he had made for Esmailji's first engagement had fallen through when the bride-to-be backed out of the wedding. As a result of this inauspicious event, Esmailji's actual wedding – to Safiyabu, the daughter of a friend of Abdul Tyeb – was a quiet affair attended by a few select guests from Ahmedabad and Bombay. Though the gathering was small, those who attended were treated to a sumptuous feast and the usual honorary gifts bestowed by Abdul Tyeb.

In that same year, when Balubhai Lalbhai and a colleague went on their regular trip to Ahmedabad to check the accounts, Abdul Tyeb insisted that they return immediately to Surat as soon as their work was completed. According to his horoscope, the coming month was supposed to be especially dangerous for him and he was so concerned that he told them he would alert them by telegram if there was any deterioration in his health. Balubhai returned from Ahmedabad, the days passed, and there was no health scare.

Left: Two years before his death, Abdul Tyeb Maskati made a pilgrimage to the holy Muslim site of Karbala in Iraq. This is a view of Karbala in 1886 from a French engraving.

Right: Partially eroded by Bombay's intense humidity, this portrait of Abdul Tyeb Maskati (1832-1898) has gained an ethereal quality befitting of an image used here to mark the end of his life.

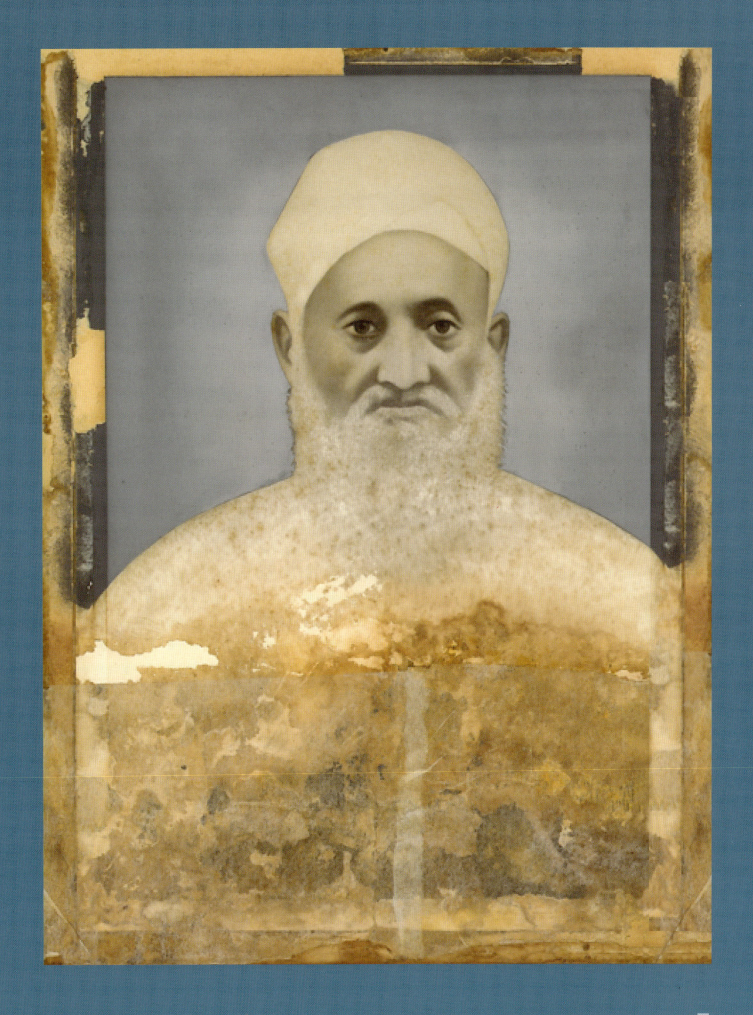

Inspired by an Insult: A Holiday Home at Dumas

Despite its curious origins, the bungalow Abdul Tyeb Maskati purchased at Dumas became the favourite residence of his wife, Nemtullabai. Though it has since been demolished, it remains standing in the memories of their descendants.

Left: Water tower at Dumas. Plumbing at the Dumas house involved two bullocks dragging a large leather sack of water drawn from a well up a ramp and into the water tower for release into gullies that ensured fresh supplies throughout the garden and orchard as well as the household plunge pool.

Top: The Dumas house (now demolished). Built of Burmese teak on land bought at auction in 1888.

Above: Commuting between Surat and Dumas, or the house at Athwa Lines, was done by horse-drawn tonga.

The Maskati holiday home at Dumas originated over an insult. In the summer of 1885, Abdul Tyeb Esmailji Maskati had gone to stay with a friend at a bungalow in Dumas, a coastal area and popular holiday spot not far from Surat that was ruled by the Nawab of Sachin as part of his princely state. While staying with his friend, Abdul Tyeb was appalled by the impoliteness of the staff working at the bungalow.

Insulted by their rude language, he cut short his stay and returned in haste to his home at Athwa Lines. He was so outraged he decided he would never again stay at another man's bungalow in Dumas and declared that, one day, he would build his own bungalow there.

Some years later, in 1888, Abdul Tyeb heard that the government was auctioning plots of land in Dumas. He sent an agent to the auction and was able to purchase a three-acre piece of land for Rs. 225. It turned out he had been lucky to get the land at such a good price; a friend of his from Surat had also been present at the auction and had bid for the land but when he learned he was bidding against Abdul Tyeb decided to bow out. When Abdul Tyeb was informed of his friend's courtesy, he promptly divided the land in two and sold half of it to his friend for Rs. 112.50, exactly one half the amount he had paid at the auction.

Abdul Tyeb cleared his Dumas plot of the tenacious and thorny baval trees that are ubiquitous to the area and set about constructing his own bungalow. The house was built of teak wood that had been shipped from Burma and buried in the sand to let it mature and strengthen. Within a year, the compound had been landscaped into a garden and the bungalow was ready for habitation. The house – an open, airy structure, with large rooms and wide balconies – became Nemtullabai's favourite residence.

Over the years, numerous well-to-do Bohra families built and maintained bungalows in the area and Ziya Maskati, Abdul Tyeb's great-granddaughter, has fond memories of her childhood and teenage years when in-laws, cousins, friends, and colleagues descended upon Dumas over the hot summer months of the school holidays. 'There were parties all the time,' she recalls. '*The various families used to have mango parties when mangoes were in season, card parties, and evening rides in bullock carts lined with carpets. It was somewhat like the social life that Jane Austen describes in her books!*'

Then, on 8 July, 1898, Abdul Tyeb went to his Athwa Lines bungalow, travelling by his usual carriage pulled by two Arabian horses he had recently purchased. Upon finishing his customary tea and refreshments, he changed into his home clothes and settled into his favourite easy chair to prepare his nightly *paan*, or betel nut parcel, for chewing. He asked his trusted colleague, Tyabali Mohammedali, to sit with him and read to him from the newspaper about a particular court case that was going on at the time. Listening to Tyabali relate the day's news, Abdul Tyeb placed the *paan* in his mouth and began to chew. A few minutes later, he coughed, threw his head back, and collapsed. The family doctor was summoned immediately but Adbul Tyeb had died instantly. His body was placed in his carriage and the Arabian horses cantered back to Surat for a funeral ceremony and burial in the plot he had reserved for himself at the Bohra cemetery. A telegram announcing his death was sent to each of his offices in India and across Southeast Asia.

The Immemorial Kinship between India & Siam

Though Abdul Tyeb never returned to Siam after establishing his first shop in Bangkok in 1856, both his personal success and his family's future were inextricably linked with that country. When the great Indian poet, writer, and philosopher Rabindranath Tagore visited Bangkok years later, in 1927, he penned a farewell note to Siam. His words evoke what he described as an 'immemorial kinship' between the two countries that was created, strengthened, and perpetuated over the centuries by adventurers and traders like Abdul Tyeb Esmailji Maskati.

While I stood before thee, Siam,
I felt that love's signet ring had pressed thy name
 on my mind in life's unconscious dawn,
and that my traveller's hasty moments were big
with the remembrance of an ancient meeting.

Today at this hour of parting I stand in thy courtyard,
gaze in thine eyes
and leave thee crowned with a garland
whose ever-fresh flowers blossomed ages ago.

Rabindranath Tagore

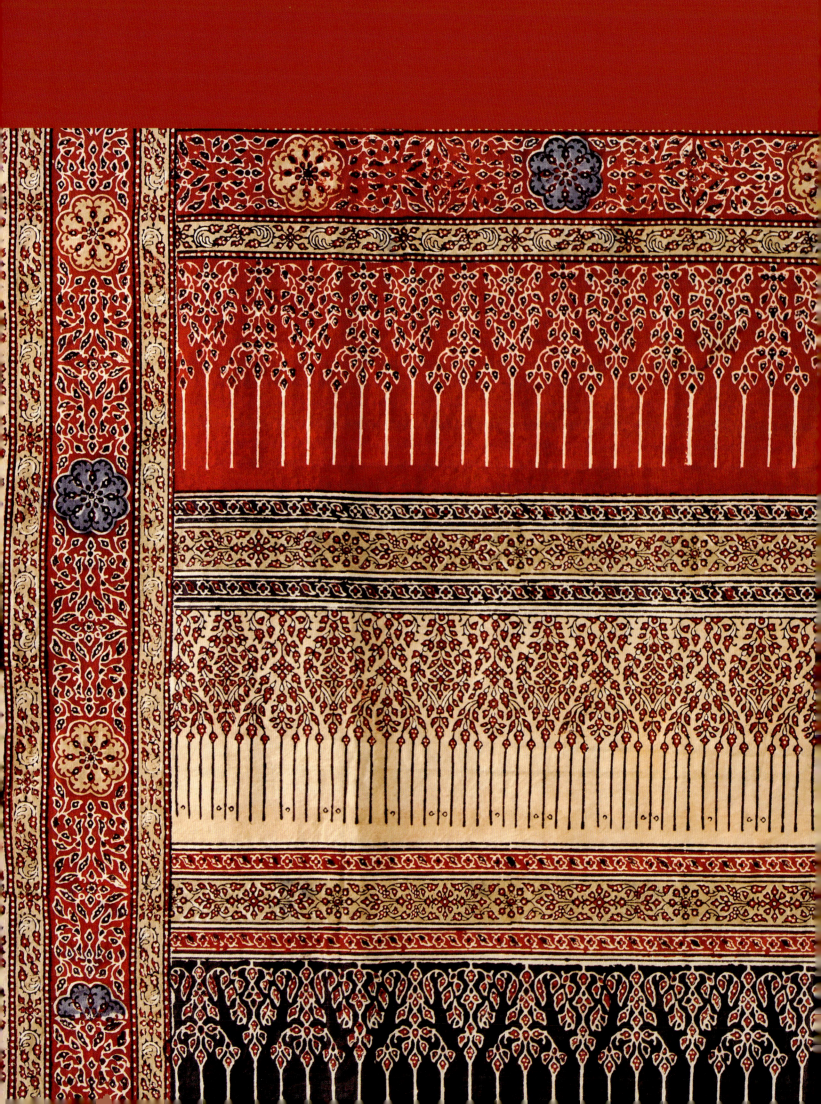

CONSOLIDATION

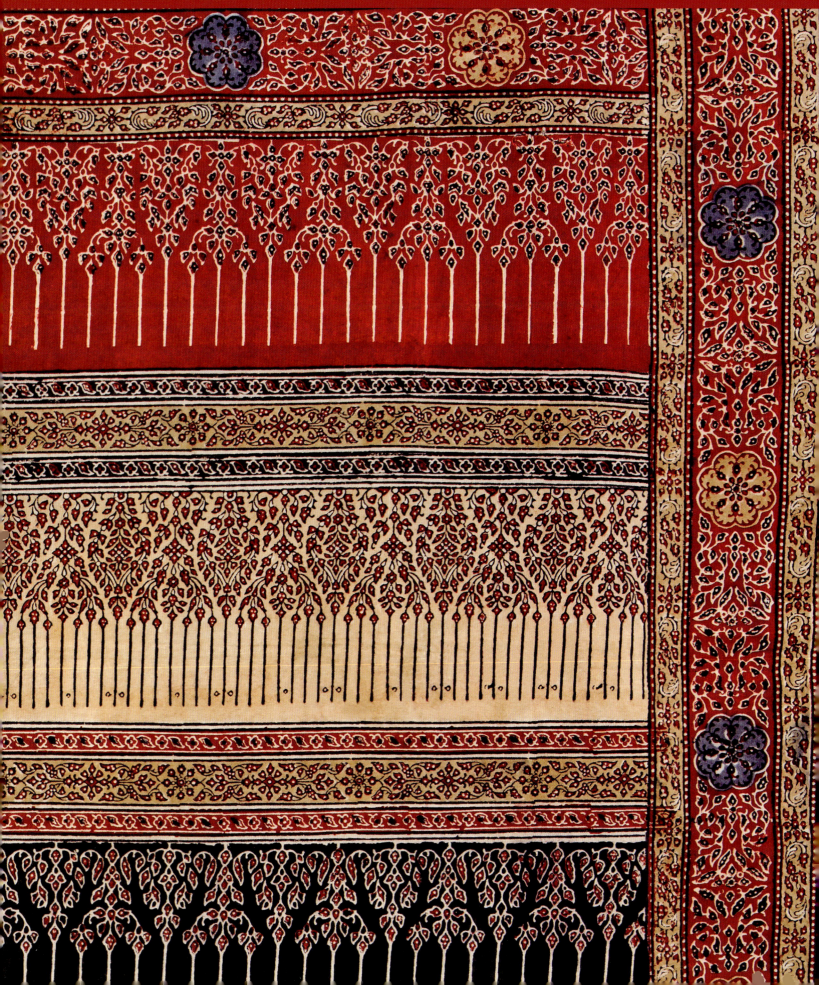

CONSOLIDATION

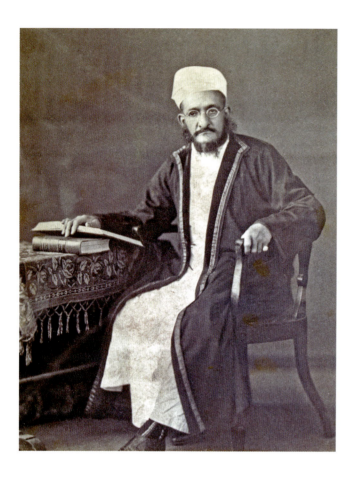

Esmailji Abdultyeb Maskati was 24 years old when his father, Abdul Tyeb Esmailji Maskati, died in 1898. He had no extended formal education but had learned about his father's business in the way of all businessmen of that era – through hands-on practice. It was the habit of merchant families like the Maskatis to involve male children from a young age so Esmailji would have sat with his father on a *gaadi* (mattress) on the ground floor of the Begumpura house in Surat or the bungalow at Athwa Lines, watching and listening as Abdul Tyeb conducted the company's daily business transactions. By the time of Abdul Tyeb's death, Esmailji would have been well-groomed to take over the pan-Asian business empire his father left in his care.

In Esmailji's case, however, there was one major obstacle to overcome. Esmailji had glaucoma, a degenerative ocular disease for which a viable treatment was not yet known. As a result of his failing eyesight, he would need some assistance in running the business. That help ended up coming from a surprising and unlikely quarter.

In turn-of-the-century Surat, most women from Bohra families were still in purdah, or seclusion, which meant they couldn't be seen in public. Outside the home, they moved about covered from head-to-toe in veils and travelled in curtained carriages. At home, they only appeared before select visitors. The strictness of purdah varied from family to family but for most women it restricted their movements and ability to engage in activities beyond the household, effectively barring them the world of business and commerce. This did not, however, turn out to be the case for Nemtullabai, Abdul Tyeb's third wife and surviving widow, as she emerged from the seclusion of purdah to assist her son, Esmailji. Her involvement in the family business led to the establishment of lasting institutions and charities that exist to this day.

One of Nemtullabai's first projects was the founding of a market for textile traders in Ahmedabad. Since Abdul Tyeb's time, the number of mills had continued to increase and, by 1905, around 15 percent of India's mills were located in Ahmedabad. The city had been dubbed the 'Manchester of India' for its many mills and thriving textile industry.

The Maskati Cloth Market was opened on 24 April 1906. As an institution, it was designed to enable traders of wholesale textiles to conduct their business efficiently and conveniently. The marketplace initially had space for around 90 shops and was laid on an L-shaped footprint that connected two major commercial thoroughfares in Ahmedabad, the Kapasia Bazar Road and the Sakar Bazar Road. It was a success with traders and their customers, and quickly became an enduring city landmark.

Throughout the pre-war decades, the Maskati Cloth Market functioned as an effective barometer of the textile trade and its robustness. A regular *Times of India* newspaper column titled 'Ahmedabad Markets' described the

market as the city's 'principal cloth market' and used it to gauge the health of the textile trade. During a temporary slump towards the end of the 1920s, the *Times* reported, *'Dullness prevails in the Ahmedabad Maskati Cloth Market.'* Later that same month, readers learned that the industry was rallying when they read, *'During this week the Ahmedabad Maskati Cloth Market showed better signs of improvement than the last week.'*

A Maskati Market guild, known as the Maskati Mahajan, was established in the market on the same day as the market opened, and still maintains its headquarters there today. Trade guilds were an integral part of commercial life in Ahmedabad. Before other institutions became available to the public, they provided job training as well as banking and insurance services to their members. They also acted as a collective body to set currency exchange rates and arbitrate in disputes between members or employees and employers, or assist in cases of bankruptcy. As a cloth traders' guild, the Maskati Mahajan administered to the needs of the Maskati Cloth Market tenants, and many hundreds more beyond. The guild prided itself in the fact that trading disputes raised by its members rarely ended up in a court of law as arguments were settled through unbiased and patient negotiations enabled by the guild's arbitration. Today, the Maskati Mahajan has some 1,500 members and remains integrally connected to the Maskati Cloth Market through its location and activities.

Despite his careful preparations, the estate of Abdul Tyeb remained a bone of contention within the family and unsettled issues dragged on for many years ending up, a decade after his death, in the Bombay High Court.

The conflict began with Fatmabai, his daughter from his second wife. Having divorced two husbands her father had arranged for her to marry, Fatmabai had finally settled in a marriage to a third man she had chosen herself. Since Abdul Tyeb's death she had made repeated requests to the family to pay her the share of his estate due to her under Islamic inheritance law. She eventually hired solicitors to ascertain the worth of the estate and to convince the family to hand over her due portion of it. When a letter written by the solicitors demanding immediate payment met with no response, the case proceeded to court. The High Court of Bombay ruled in Fatmabai's favour and called for Nemtullabai, as Abdul Tyeb's widow and principle heir, to pay a share of his estate to his three children from previous marriages. Fatmabai and her sister, Amtullabai, were to receive Rs. 41,000 each, and Haiderbhai, Abdul Tyeb's eldest son from his first wife, would receive Rs. 82,000, as the court put it, *'in full satisfaction of their respective claims as heirs of Abdul Tyeb Maskati.'*

It wasn't until the following year, in August 1909, that the District Judge of Surat granted probate of Abdul Tyeb's legal will to Nemtullabai and the other executors, effectively finalising the protracted debate over his estate.

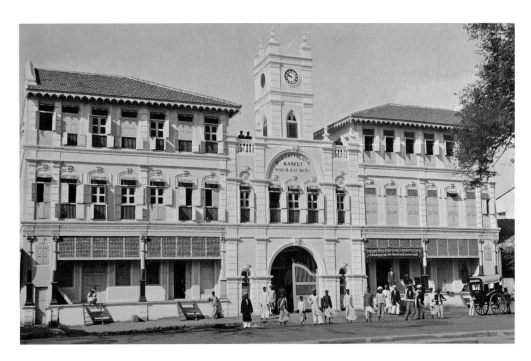

Left: Esmailji Abdultyeb Maskati (1874-1938), who took over the family business after his father's death in 1898.

Right: Front facade of the Maskati Cloth Market, Kapasia Bazar Road, Ahmedabad. The market, established in 1906, is still operating today. In 2010, a portion of this facade collapsed and the clock tower has since been demolished and replaced with a modern-style facade.

THE MASKATI PUBLIC CHARITABLE DISPENSARY, SURAT.
The foundation stone of this building was laid by the late Head Priest of the Bohra Communi Namdar Sardar Saiyedna Abdulla Badrudin in the year 1906 and was declared opened for the public by H. E. Sir George Sydenham Clarke, G.C.M., G.C.I.E., F.R.S., the Governor of Bombay on the 6th of March 1911.

Left: The Maskati Charitable Dispensary, envisioned by Abdul Tyeb Maskati before his death and realised afterwards by his widow, Nemtullabai. The Dispensary opened in 1911 as a non-sectarian establishment using proceeds from the Maskati Cloth Market to provide medical assistance to the needy.

Barrister T.M. Kajiji.

Right: The opening ceremony of the Maskati Charitable Dispensary was held on 6 March 1911 and was attended by Sir George Clarke, Governor of Bombay (standing at the back), with his wife (seated to the right). In his opening address, Sir George generously commended the late Abdul Tyeb Maskati: 'The city of Surat is warmly to be congratulated upon possessing citizens of so noble a public spirit...'

Nemtullabai faced numerous legal battles throughout her life and benefitted from the wise counsel of fellow Dawoodi Bohra, the respected barrister T.M. Kajiji, whose family was intimately linked in marriage and business to the Maskati family.

With the estate of her late husband settled, Nemtullabai could now turn her attention to her second major project, one that was intimately linked to the Maskati Cloth Market and its success.

Just one year after the market was opened, the Syedna, or Head Priest of the Dawoodi Bohra community, oversaw the laying of a foundation stone on a prominent corner of a busy neighbourhood in Surat's Zampa Bazar. Over the following five years, a building built of white stone and Bombay blue stone was constructed with elegant colonnaded corridors and marble-tiled floors. An article in the *Times of India* described the structure as an imposing building executed in *'the classical style with a strong Saracenic and Gothic leaning,'* and also noted that *'the detail carvings are excellent'*.

The building had been commissioned by Nemtullabai as the Maskati Charitable Dispensary, an institution envisioned by Abdul Tyeb Maskati before his death. According to both his and Nemtullabai's wishes, the dispensary would be non-sectarian and provide medical assistance to the needy without restriction as to class, creed, or caste. Administratively, it was devised so that half of the proceeds from the Maskati Cloth Market would be transferred as donations to run the dispensary. The remaining half of the proceeds was to be divided among her children and, thereafter, grandchildren.

On 6 March 1911, Governor Sir George and Lady Clarke presided over the opening ceremony of the Maskati Charitable Dispensary in Surat. While touting the British role in boosting local commerce, the Governor gave a generous speech that described how Nemtullabai

had upheld her husband's charitable plans and designs: *'Mr. Abdul Tyeb's life was spent partly in Muscat, partly in Siam, and partly in India. His foreign trade extended to Singapore and beyond. In India he was a pioneer of new branches of industry in Ahmedabad,'* said Sir George Clarke. *'His public life was marked by enterprise and his private life by charity, which, we are told, was as widespread as his business. He died before he was able to complete the charitable schemes which he had in view, but his widow determined that in no better way could she preserve his memory than by bringing to maturity one of his cherished plans. The result is the dispensary.'*

The Governor noted Nemtullabai's generosity in providing Rs. 50,000 for the building's construction and a sustainable plan for its maintenance, through the proceeds of the Maskati Cloth Market. He concluded, *'The city of Surat is warmly to be congratulated upon possessing citizens of so noble a public spirit, and the Bohra community may well be proud of [the] successful career of Mr. Abdul Tyeb.'* Upon declaring the dispensary open, he took a golden key, opened a silver lock and made a tour of the building.

Within just a few months, the dispensary was up and running, and treating thousands of patients each month.

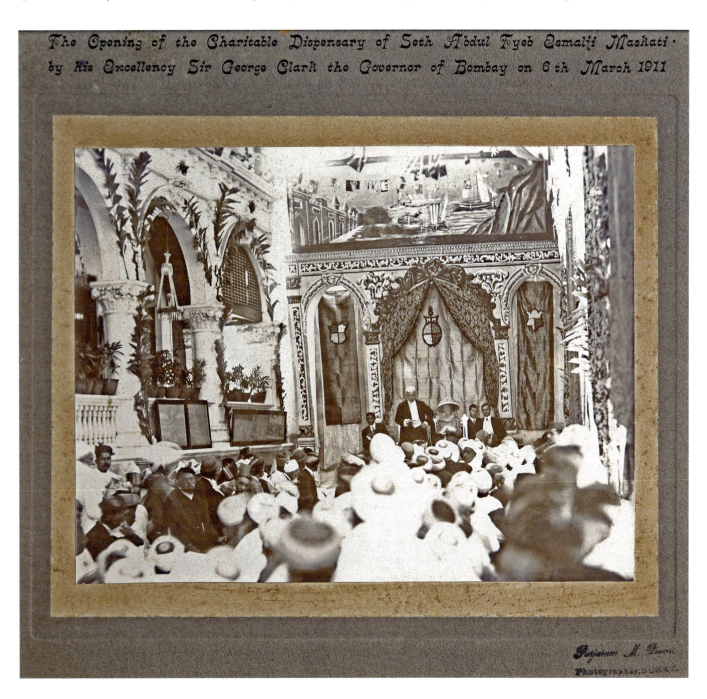

The Times of India reported that in the single month of February 1912, just under a year after its opening, the dispensary treated 5,806 patients.

Life in Surat for a Bohra woman in purdah was filled with various activities. Women from well-off families did not cook, partly because purdah prevented them from shopping in the market, so with fully staffed kitchens, they cultivated numerous distractions to while away the time. Many became expert at embroidering and crocheting. They collected haberdashery items, ordering ribbon, coloured velvet, and golden thread to be delivered to their homes. These were flaunted amongst sisters and female friends, shared or traded, and woven into intricate designs and patterns to adorn their scarves and dresses. Hobbies such as drawing, painting, and playing musical instruments were encouraged with teachers coming to the house to provide lessons. Now over one hundred years old, Shirin Mogul, whose grandfather married one of Abdul Tyeb's daughters, says of her experience growing up and living in purdah in Surat, *'Women were never idle in those days. Though we had cooks and servants, we never sat idle for one minute.'*

Due to her involvement in the Maskati family business, Nemtullabai had a very different lifestyle in her adult life. As was then the custom, she was a teenager when she married Abdul Tyeb and would have had no formal education. While male children were allowed to sit in when menfolk conducted business, she would have been relegated to female activities of sewing and socialising with her female friends. Yet, she stepped out of purdah to set up charitable institutions in her husband's memory and help her son Esmailji run the family business. And neither was she a demure presence. In addition to her work, she wasn't shy about entering into disputes with those she believed had wronged her or the family and there were several instances when she was either drawn into, or herself instigated, legal battles that led to long, protracted court cases in Bombay or Surat.

In one legal case, which took place not long after the estate of Abdul Tyeb had finally been settled in court, she charged a man with abducting her mentally impaired son, Kamruddin. In September 1912, Kamruddin became involved in a curious plot by the proprietor of a theatrical company to marry him off to his wife's sister in order that they might snare the rights to some of his wealth and property. Nemtullabai filed a complaint at the Bombay Police Court and charged the man with abduction. The magistrate convicted him of kidnap under Section 363 of the Indian Penal Code. Given that Kamruddin was unharmed and, once located, swiftly returned home, the perpetrator was sentenced to only a single day's imprisonment with a fine of Rs. 300. His subsequent appeal against the conviction was dismissed.

After Kamruddin's untimely death in July, 1916, Nemtullabai had to petition the court once more for the return of property and inheritance he had been awarded by the 1908 settlement; in accordance with Islamic law she was his sole heir as he died without issue.

Around the same time, Nemtullabai launched another court case, this one against her neighbour in Surat who owned the property adjoining the Begumpura house. The two women shared a by-pass at the back of their properties and had a disagreement as to whether or not Nemtullabai had right of passage to the lane. Nemtullabai believed she did and, when her neighbour began purposefully obstructing the passage to prevent her from using it, she sought a legal injunction that would prevent the lane from being blocked. Nemtullabai was tireless in her pursuit of the cause and launched four successive appeals to the court, once accusing her

From a news article entitled: 'Maskati Hospital Opened'

'Surat cannot now expect to rival Bombay. Its glory has now faded; its trade has been diverted to other natural routes; its industries have been checkmated. ...Though the city is now shorn of all its former splendour and dignity, its people are still true to their traditions. They are enterprising and go far afield in search of fresh pastures. They explore distant regions, and amassing large fortunes return to their native place. ...They have still a warm corner in their hearts for their birth-place and they build beautiful buildings in Surat, and make large charitable endowments. Some of the finest public institutions in the city owe their existence to the philanthropy of eminent citizens.' – The Times of India, 7 March 1911

Right: The Gujarati text beneath this hand-tinted portrait of Nemtullabai reads: 'Respected Lady, Nemtullabai Abdul Tyeb Maskati, 1860-1927'

રોદારણી-સાહેબા
નેમતુલ્લાબાઈ અબ્દુલનૈયાબ મક્કની
(૧૮૭૦ - ૧૯૨૭)

neighbour of submitting false evidence. Her appeals were repeatedly dismissed and, no doubt to her great consternation, she eventually had to acquiesce to her neighbour's assertion that there had once been a wall between their properties and that the residents of her house had no right to use the by-pass.

Neither was Nemtullabai easily intimidated by the religious leaders of her own community. Her great-granddaughter, Ziya Maskati, recalls a story told within the family about a dispute between Nemtullabai and the Syedna, or Head Priest of the Dawoodi Bohras. Though the Head Priest had laid the foundation stone for Nemtullabai's Maskati Charitable Dispensary, the two may have later disagreed over subsequent plans Nemtullabai was putting in place for a maternity ward that would introduce the methods of modern medical science to Surat, where women within the Bohra community were still giving birth at home with the help of traditional midwives and interventions. The Head Priest was displeased enough with Nemtuallabai to effectively excommunicate her by barring her from being buried in the communal Dawoodi Bohra cemetery at Surat. According to family lore, Nemtullabai was unrepentant and responded defiantly: *'It doesn't matter – I'll just tell my children to leave my body on his doorstep!'*

A property chart entitled 'Maskati Estates', completed at the end of 1909, gives a snapshot of Abdul Tyeb Esmailji Maskati's business empire just a few years after his death and demonstrates his acquisition of land in various countries. It lists property in seven locations in five countries: Ahmedabad, Surat, Bombay, Bangkok, Martaban (in Burma), Phnom Penh, and Singapore. Bangkok is the centrepiece of the chart, indicating Siam's importance in terms of the amount of trade conducted there.

Of all the countries, however, the chart shows that the largest amount of property was held in Cambodia; 60 houses are listed, located on 16 separate plots, in the centre of Phnom Penh – purchases that must have been conducted not long after the French decreed land in that country was no longer the sole property of the monarch and could be bought or sold by others.

In Singapore there were seven plots, two of which Abdul Tyeb had purchased from Sir F.A. Swettenham, Governor of the Straits Settlements.

The property chart also records two steamer ships – the SS Khumri in Siam and the SS Madina in Cambodia. Both were used for river transport to send merchandise further inland as roads and train systems had yet to be extensively developed in either country and most transport was still conducted by water.

The chart also lists properties in Burma, where an office was set up in Martaban (today called Mottama), the riverside town located opposite the first capital of British-ruled Burma, Moulmein. Six properties included two houses, two buildings, a doctor's office, a godown, and a plot of open land. Aside from the property chart, there are no surviving documents or any collective family memory of business activities conducted there.

Though Martaban was never one of the great port cities of Asia, it had a long history of global trade and its name was familiar to travellers around the world. As early as the seventh century, Martaban was known for its large earthenware jars produced from the area's alluvial clay. The sturdy jars stood some four feet high and were commonly used by Arabian, Indian, and later European,

Maskati Estates Property Chart

This property chart listing the 'Maskati Estates' was drawn in 1909 and details Maskati-owned properties in seven locations in five countries: Ahmedabad, Surat, and Bombay in India; Bangkok in Siam; Martaban in Burma; Phnom Penh in Cambodia; and Singapore. As the strategic and geographical heart of the Maskati business, Bangkok is given due importance at the centre of the chart. The colour-coded key in the bottom right-hand corner lists the names of Abdul Tyeb Maskati's widow and children, showing how these assets were distributed within the family. Notice that the company motto, *'Honesty is the Best Policy'*, contains a small typo – curiously, the misspelled motto still encapsulates the correct meaning.

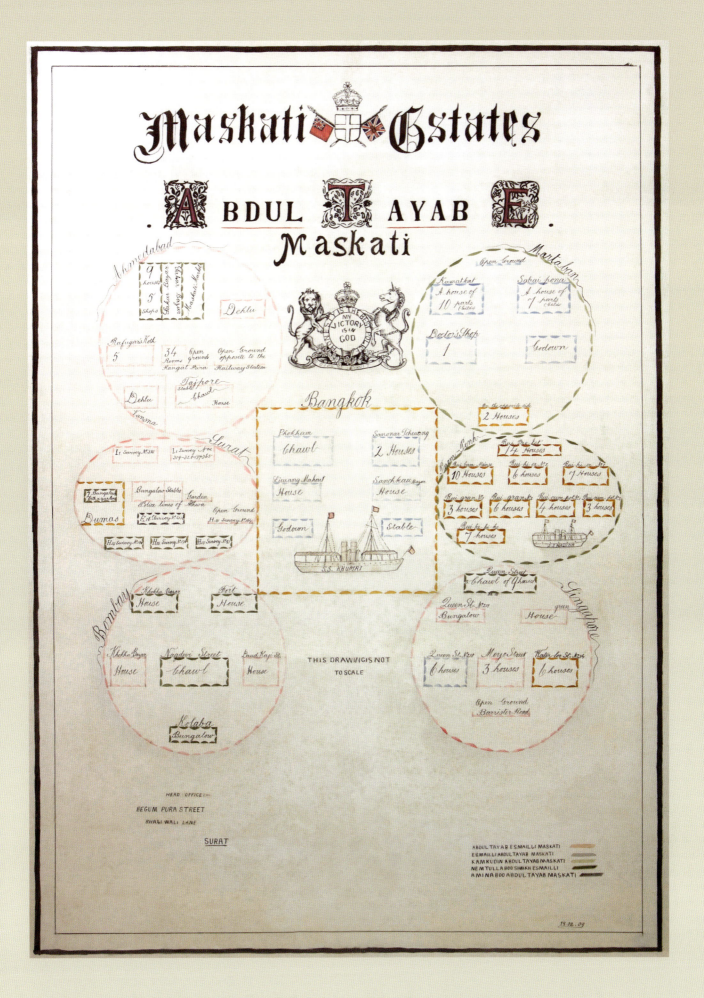

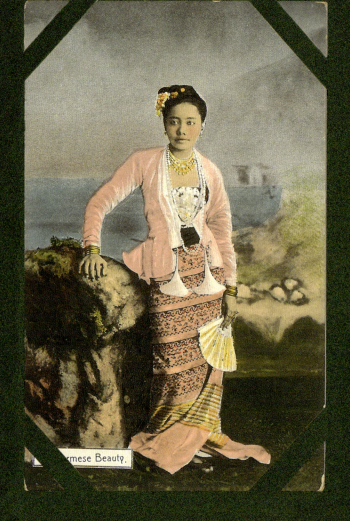

Burmese Beauty.

A Yein Pwe or Burmese National Dance.

travellers to store water, oil, and wine, on long sea journeys. Over the centuries, Martaban – which fell under the control of the Siamese capital of Ayutthaya around the mid-fourteenth and fifteenth centuries – became a key link in the trade between India and China as traders used it as a trans-shipment post to join up with overland routes leading north through Burma to Yunnan or southeast to Ayutthaya, via Mae Sot. Both these overland routes were arduous and time-consuming but, for many traders, they provided a more appealing alternative to making an extended sea voyage through the pirate-plagued waters of the Malacca Straits. By the seventeenth century, there were other reasons to make use of these land routes. Much of the trade between India and Southeast Asia had by then fallen under the control of the English, Dutch, and Danish, and to escape the monopolies of these behemoth trading companies, Indian traders pushed northwards along the Burmese coast to Mergui, Martaban, and Syriam, across the river from Rangoon. They brought textiles from the Coromandel coast and returned with tin, copper, gold, aromatics, and live elephants. They also sometimes returned with new ships as the stretch of Burmese coastline around Martaban became prized for its ship-building skills and its sea-worthy vessels made from teak felled in the vast forests that spread inland towards Siam.

When the British arrived in Burma, this was the first area they colonised. In 1824, they occupied the southern stretch of Tenasserim and established Moulmein as their capital. In 1852, they consolidated their hold over the lower half of the country, and moved their capital to Rangoon. Mass Indian migration to Burma began shortly afterwards as the British initially ruled Burma as part of India, and imported Indian civil servants to help administer the new state. Indian businessmen and moneylenders also flocked to the country in search of the great opportunities provided by a brand new colony that was known to be rich in rice, teak, and oil. Abdul Tyeb Maskati was probably among these traders, expanding to Burma around the same time as he expanded to Singapore and Cambodia, in the 1870s. However, aside from the notations on the property chart, nothing remains of his endeavour in Burma due, probably, to a series of violent events about to be unleashed in the country in the early decades of the twentieth century.

By the 1910s, Bangkok's Bohra community had grown substantially since Abdul Tyeb Maskati first arrived in the city in 1851. Though Chinese and European merchant firms dominated the business scene, the Bohras were now a well-respected part of the business community and were always present at significant public events in the city. When King Chulalongkorn returned from his second visit to Europe in 1907, for instance, Bohra businessmen were among the reception party that met his ship as it docked in Bangkok and presented him with a gift to welcome him home. At the coronation ceremony of his successor, King Vajiravudh (Rama VI, r. 1910-1925), a Bohra representative read an address of congratulations to herald the new reign. In 1913, Esmailji Maskati was among a few prominent members of the Bohra community who pooled their resources to erect what would be the first (and is still the only) Dawoodi Bohra mosque in Bangkok. The elegant teakwood structure modelled on a design from India, served as a gathering point for the Bohra diaspora in Bangkok and Esmailji Maskati sponsored religious gatherings there each Friday as well as special holy day feasts.

The interests of the Maskati firm in Bangkok had been expanded by then. Though one of the early stores opened by the founder and his partners in the 1870s was a general goods store and the business had never been exclusively limited to the textile trade, the Maskati name was inextricably linked to the *saudagiri* cloth it produced and imported to Siam. By the mid-1920s, however, the *Importers & Exporters Directory for Siam* lists the company as doing both wholesale and retail business in other goods. Among textile-related products being imported by the company were dyes, cotton yarn, embroidery, and lace. Other goods included earthenware, chinaware, perfumes, cosmetics, and that most Indian of all cooking ingredients, ghee.

Neither was the Bangkok office solely reliant on trade. Under the Bowring Treaty (see page 28), Indians were treated as British subjects and were among the few

Left: Burmese dress and traditional Burmese dance. Postcard images probably collected by Esmailji Maskati. circa 1905

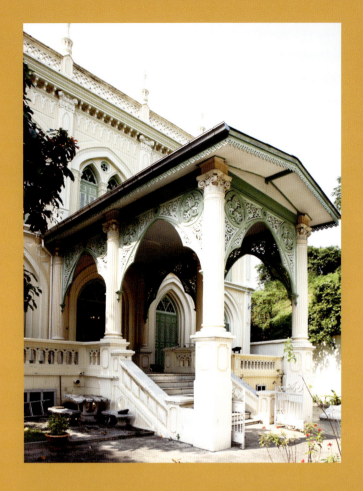

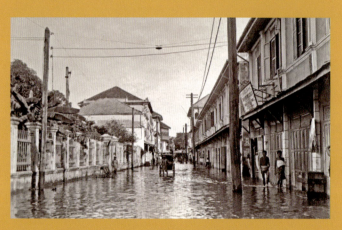

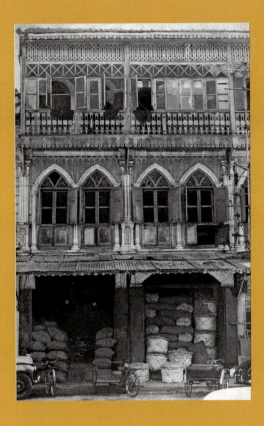

Left: Clockwise from top left: The Masjid Saifee, or Saifee Mosque, Bangkok's only Dawoodi Bohra Mosque, also known as Teuk Khao, or the 'White Building' due to its colour, which was distinct in a neighbourhood of warehouses; Indian Muslim businessmen in Bangkok waiting to present gifts to King Chulalongkorn at a ceremony to welcome the king upon his return from a second visit to Europe, 1907; Bangkok during a seasonal monsoon flood in 1917, with the Maskati office on Anuwongse Road just visible on the far left-hand side of the road; and the beautifully restored interior of the Saifee Mosque, Bangkok.

Above: One of numerous rental properties the Maskati firm owned in Bangkok's Chinatown. The buildings were rented out to other businesses dealing in import and export, including Italian, German, and Chinese merchants.

Right: Abdultyeb Maskati as a young boy. Taken at a Bombay photographic studio, 1900s.

foreigners who had the right to purchase land in Siam. Over the past decades, the Maskatis had acquired numerous plots near the main store in Chinatown, then the city's central business district. The area was near the busy Ratchawongse pier on the Chao Phraya River and the properties were ideally situated for trade. Those that weren't in use for the Maskati business were rented out to tenants, mostly foreign merchants who used them as shops, godowns, and stables. Among these were the Italian Societa Commissionaria, which imported wine, the German merchant firm, Barmen Export-Gessellschaft, which operated in central and south America and traded in Barmen hardware products, and M.T.S. Marican, a well-known diamond dealer who also sold Indian silk as well as English flannels, velvets, serges, and cotton. Another tenant, a Chinese merchant called Thong Soon Chiang, specialised in textiles and textile-related goods and, from his rented shop on Ratchawongse Road, catered to Bangkok's changing fashion demands for more European-style clothes through the sale of poplins, striped satins, khaki & white drills, and felt hats.

In Bombay, the man who would lead the firm through the next half a century was coming of age. Abdultyeb Esmailji Maskati, the only son of Esmailji Abdultyeb Maskati,

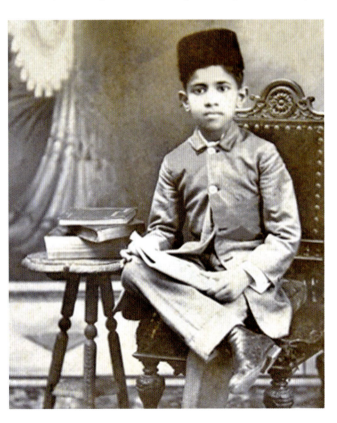

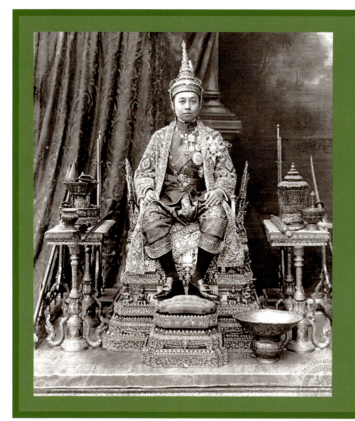

Bangkok Bohras Congratulate the New King

Esmailji Abdultyeb Maskati was the lead signatory on a letter of congratulations presented at the coronation ceremony of King Vajiravudh in 1912. Following is a short extract:

'We the representatives of the leading Mohammedan Indian firms in Bangkok [present] our heartfelt congratulations on this the occasion of Your Majesty's coronation. Some of us came to Siam for the purpose of trading as many as fifty years ago and from that time up to the present we have been happy and prosperous under the rule of His late Majesty King Chulalongkorn, Your Majesty's august father, whose memory will ever remain dear to us. By his death we suffered a great loss but we are deeply grateful to find [in] his successor a monarch worthy in all respects to carry on the great and noble traditions initiated by His late Majesty King Chulalongkorn.'

was named after his illustrious grandfather. He was born in Bombay on 19 July 1899 and spent his formative early years in the city, living at the family bungalow in Colaba (see page 120).

While at the Maskati firm's head office at Nagdevi Street he was in the thick of Bombay's commercial centre. The streets were filled with hawkers selling all manner of goods from fruit, vegetables, and eggs to molasses, candy, sweetmeats, and kerosene. Because it was a predominately Muslim neighbourhood, it was dotted with *tannur* ovens made from brick-and-clay for baking flat naan breads and the comforting smell of freshly baked naan mingled with the more pungent aromas that rose from the sewers. The English poet and writer, Sir Edwin Arnold, described the neighbourhood: '*A tide of Asiatic humanity ebbs and flows up and down the Bhendi Bazar, and through the chief mercantile thoroughfares. Nowhere could be seen a play of livelier hues, a busier and brighter city life…*'

Abdultyeb was the first Maskati to have a formal, if not extended, education and completed his matriculation exams in 1916. He didn't go to business school or pursue further studies but, like his own father, learned how to conduct business from watching the family firm in action. By 1918, at the age of 17, he was already conducting his own transactions. His name is recorded in the public auction of 150 bales of yarn from Elphinstone and David Mills in Bombay and 100 bales of Japanese shirting. By then, his father, Esmailji, was almost completely blind and the young Abdultyeb was probably being encouraged to take charge of the family business.

Abdultyeb was coming to the helm at a precarious time. The future of textiles – the firm's core product and money earner – was not as assured as it had been in his grandfather's time. Though the business was still doing well, having been consolidated by his father, Esmailji, a perceptive mind might have sensed the coming changes and Abdultyeb was well-prepared. Having studied at a public school under the British colonial administration, he was also the first of his family to speak English – thus enabling him to broaden his relationships and negotiate directly with prospective partners around the world. At the age of 20 he was poised to take over the pan-Asian empire his grandfather, Abdul Tyeb, had founded and lead the firm in new and unprecedented directions.

Turbans of Bombay

In 1872, Bombay was home to some 644,000 people. By 1920, that number had risen to more than one million. The city's booming cotton trade attracted traders and speculators from across India, resulting in a multi-ethnic, multi- lingual and multi-cultural city. An indication of the variety of religions and cultures practiced in Bombay is provided in the 1909 volume of the Bombay Gazetteer, which lists 72 different types of turbans worn by city residents. Within the Bohra community alone (which made up about around 1.5 percent of the overall population in 1901) five different types of turbans are recorded as being worn by Sulemani Bohras, and Bohras from Kathiawar, Ahmedabad, Surat, and Ujjain (Malwa). Pictured here, a rare photograph of Abdultyeb wearing the type of turban traditionally worn by Dawoodi Bohras from Surat; it was an outfit he would later eschew in favour of the carefully curated wardrobe of European suits he adopted in his 20s.

Making Bohra Friends

The Dawoodi Bohra community had a custom whereby the parents of small children would select a group of same-sex playmates for their child. This group, known as *saheli* for women and *dozdar* for men, was intended to last a lifetime. Children joined their saheli or *dozdar* at around the age of six or seven. Together, they experienced childhood and, later, all the stages of adult life. In female groups, the women shared experiences of marriage, childbirth, and child rearing, while the men exchanged advice on business ventures, investments, or planned trips. Because relationships within the groups were formed during early childhood and reinforced by scheduled monthly meetings, they tended to last into adulthood. The groups were limited to eight or nine members so they all could fit comfortably around a *thaal*, the large round platter from which Bohras traditionally share their meals (see page 155). Abdultyeb is pictured here, most probably with his *dozdar* group, in the top picture (second from right) and the picture below (third from right).

The Maskati Cloth Market

Throughout Ahmedabad's boom years, in the first half of the twentieth century, the Maskati Cloth Market played a central role in the city's textile economy. This legacy is still recognised today, though the market remains an old-world institution in a fast-changing business.

Originally built to house some 90 commercial properties, the Maskati Cloth Market has around 130 tenants as rooms have been divided and additional storeys added to the original wooden structures.

The market was designed more than a century ago and its amenities are now dated. In keeping with the limited plumbing options available to the original architects, today's tenants make do with shared bathroom facilities and communal water pipes.

The basic footprint of the market remains the same but parts of its street front have been altered, as have many of the shop-fronts and interiors inside the market. When one section of the front facade collapsed in 2010 during heavy monsoon rains, the rest of the structure was declared unsafe and the market's trademark clock tower had to be demolished. It has since been reconstructed in a modern style as have parts of the back facade, which were destroyed by a fire.

The nature of goods sold in the Maskati Cloth Market is changing, too. The market used to be the exclusive domain of wholesale traders who stored their goods off-site, keeping only samples on hand so that clients could assess the thickness, size, colour, and pattern of their cloth. Today, some shops within the market are turning to retail and their wood-shuttered shopfronts have been replaced by neon-lit window displays with tailor's dummies dressed in the latest fashion for sportswear, saris, or tailored suits. In the market's main thoroughfare, the original handcarts pushed by day labourers have mostly been replaced by paddle rickshaws.

Ahmedabad now has many bigger and more modern textile markets that boast better amenities than the Maskati Cloth Market. Though many of the market's traders have opened outlets elsewhere, they still maintain their original branches at the Maskati Cloth Market. The 19 November 2015 edition of the Gujarati newspaper, the *Bombay Samachar*, reports, *'In spite of the sad plight of the mills and textile industry, this textile market built many years back still sees a thriving textile business. Even today many people, especially from rural areas, come [here] to purchase textiles.'*

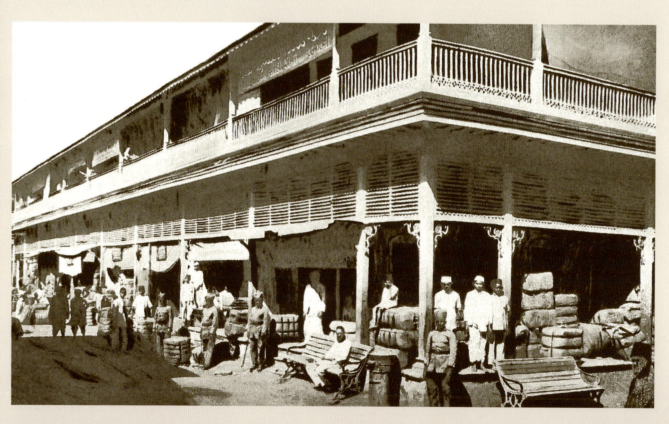

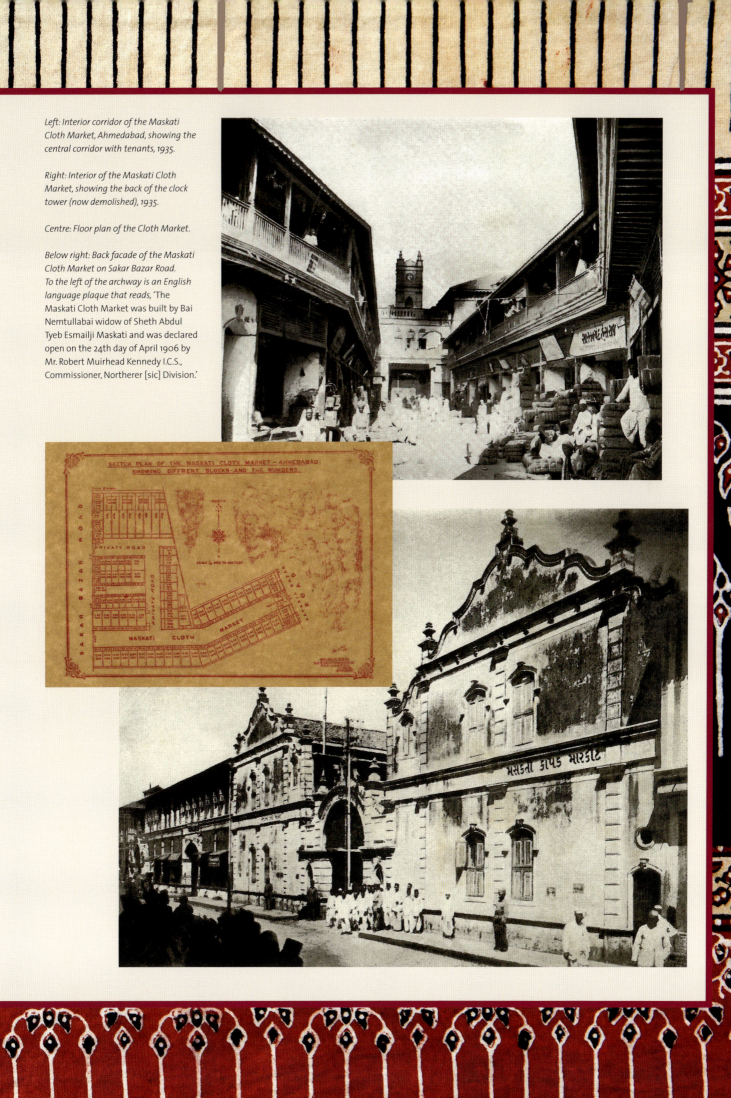

Left: Interior corridor of the Maskati Cloth Market, Ahmedabad, showing the central corridor with tenants, 1935.

Right: Interior of the Maskati Cloth Market, showing the back of the clock tower (now demolished), 1935.

Centre: Floor plan of the Cloth Market.

Below right: Back facade of the Maskati Cloth Market on Sakar Bazar Road. To the left of the archway is an English language plaque that reads, 'The Maskati Cloth Market was built by Bai Nemtullabai widow of Sheth Abdul Tyeb Esmailji Maskati and was declared open on the 24th day of April 1906 by Mr. Robert Muirhead Kennedy I.C.S., Commissioner, Northerer [sic] Division.'

DIVERSIFICATION

DIVERSIFICATION

By 1922, Abdultyeb Esmailji Maskati, then 22 years old, was in charge of the family business. A few years earlier he had become more actively involved in various aspects of the trade and, in 1920, had travelled to Southeast Asia on a tour of the family firm's offices. By the age of 19, he was effectively running the company and the arrangement was legally formalised on 24 March, 1922, when it was announced that his father, Esmailji Abdultyeb Maskati, had donated the business to his only son.

Though Esmailji was not yet 50, he was hindered from further involvement in the family firm by his debilitating blindness. His grandchildren remember him as an affable presence in his retirement – fond of collecting things and evening drives to Bombay's Ballard Pier, where he bought snacks for the children and they would all enjoy the fresh sea breezes as ships loaded with disparate cargo from distant shores came in to dock.

A month before the formalisation of Abdultyeb's business arrangements, on 16 February, 1922, he married Shirin Kajiji, the eldest daughter of the barrister T.M. Kajiji. In keeping with the nature of their life together – during which they would travel far and wide, both for pleasure and work – the couple's wedding was held in their ancestral home, Surat, but was celebrated as far afield as Singapore.

From an Asian perspective, the world appeared to be shifting on its axis in the early decades of the twentieth century. Cracks had begun to show in the established order as nascent movements against colonial rule rippled across the region. Japan's defeat of Russia in the 1905 Russo-Japanese war was powerful evidence that an Asian army could triumph over seemingly invincible European powers. In India, British rule no longer seemed inevitable or as absolute as it had in the previous century. After the unpopular decision to partition Bengal, also in 1905, discontent in that state erupted in mass rallies that evolved into another wave of *swadeshi* nationalism, which swept across the entire nation. Protesting against British exploitation of Indian resources, swadeshi called on all Indians to boycott imported British goods and restrict themselves to buying only home-grown products.

It was around that time that a slight, bespectacled Gujarati lawyer named Mohandas Karamchand Gandhi entered the political arena. Mahatma Gandhi, as he became respectfully known, promoted passive resistance and civil disobedience over violence and led what would

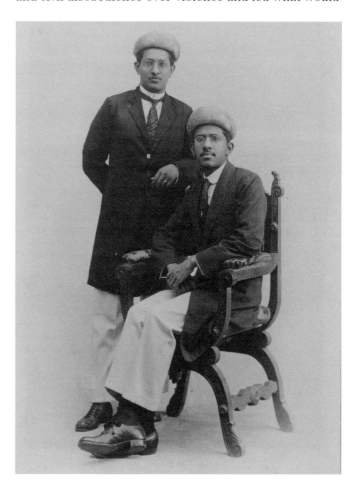

Above: Abdultyeb Maskati (seated). He wears a Bohra turban with a western shirt and tie under a frock coat. The young Abdultyeb was on a tour of his father's Southeast Asian offices in 1920.

Above right: Abdultyeb Maskati (centre) some years later, with his staff in Bangkok, Thailand, September 1935.

Right: Abdultyeb's wife Shirin. The couple married on 16 February 1922 in Surat.

Far right: Abdultyeb Maskati (seated centre) with key Bombay staff and the block printers who produced his family firm's saudagiri, or block-printed cotton, in Ahmedabad, November 1935. In the more conservative surrounds of Ahmedabad, Abdultyeb is wearing traditional Bohra dress.

ABDULTAYEB ESMAILJEE MASKATI
BANGKOK.

Sitting:— Y. M. Makkawala. A. A. Katerawala. Seth A. E. Maskati. E. R. Pulaowala. T. M. Jeewabhai.

Standing:— E. A. Katerawala. K. M. Hassanali. A. Ebramsa. G. A. Khambati. E. A. Kapasi. D. M. Dhorajiwala. S. Mohamedally. Abbassa.

8th September 1935

A group photo of Sheth Maskati, his office staff & his Khorji Kapad Dyers & others engaged in that work.

Ahmedabad, 3-11-35

Silver Miniatures

Despite his failing eyesight Esmailji Abdultyeb Maskati was an enthusiastic collector. He assembled collections of stamps, postcards, and silver trinkets. It was the most tactile of these collections that became the most extensive and still survives today. Collecting silver miniatures was a favoured hobby among Bohra families in Surat. Admired for the intricacy of their workmanship, the exquisite replicas of real-life objects were placed on display in glass cases. Esmailji sent samples, from photographs clipped out of newspapers and magazines, to craftsmen in China who created minuscule three-dimensional silver replicas based on the images. Among his collection were technological innovations of the time that must have intrigued him: an aeroplane, a car, and a sewing machine so small it could be tucked inside a matchbox. Today, these trinkets are miniature examples of the accoutrements of a lifestyle in Surat that is now long-gone. These include a horse-drawn carriage, an abacus, a grandfather clock, a writing desk, and a gas-lit chandelier – all tiny enough to furnish a well-appointed doll's house.

become one of the greatest nationalist movements the world had ever seen.

In the wake of World War I, which lasted from 1914 almost to the end of 1918, general dissatisfaction was rising to the surface in Bombay and Ahmedabad where overworked and underpaid mill workers went on regular strikes. In 1919, widespread and prolonged industrial strikes nearly paralysed Bombay as workers from the mills, railways, docks, and municipality refused to attend to their jobs. That same year, following the massacre in Amritsar during which hundreds of protestors were killed by British troops, Mahatma Gandhi was arrested and riots broke out in Bombay.

For the textile industry, it was a time of instability and uncertainty as much of the political agitation used as a focal point India's all-important manufacture and trade in cloth and cloth-related products. Chief amongst the goods the *swadeshi* movement boycotted were textiles from English mills. Gandhi led his followers in piling up a mountain of foreign cloth, which was set ablaze and burned for days in the centre of Bombay. The 1920s was also a time when labour unions, enthused by the overriding political fervour, rallied workers to claim their rights to better wages and working conditions. Whenever the industry's tens of thousands of workers went on strike, Bombay's mills fell silent, sometimes for weeks at time. Similar upheavals took place in Ahmedabad where the Maskati Cloth Market, as one of the primary conduits for the sale of textiles, was occasionally the starting or end point for political marches or even the target of political anger when its traders refused to adhere to bans on foreign cloth.

Public Notice

'Public notice is hereby given to the public in general, and the constituents of the firm of Abdul Tyeb Esmailji Maskati in particular that our client Mr. Esmailji Abdultyeb Maskati, who was carrying on business in Bombay, Surat, Ahmedabad, Singapore, Bangkok, Martaban [Burma], Phnom Penh and other places under the name, style and firm of Abdul Tyeb Esmailji Maskati has given, assigned and transferred by way of gift the said business with all the goods, stock in trade, effects, outstanding and liabilities, belonging or in anywise relating to the said business to his son Abdultyeb Esmailji Maskati, on Fagan Vad 12th S. 1978, Friday, 24th day of March 1922, and the said Abdultyeb Esmailji Maskati is now the sole proprietor of all the said business and as such is solely responsible and liable for all past and future transactions, dealings and liabilities of the said firm of Abdul Tyeb Esmailji Maskati.'
The Times of India, 28 March, 1922.

Long-distance Celebrations

Abdultyeb's marriage to Shirin was reported in the *Straits Times* newspaper in Singapore where he had made enough friends to merit a long-distance wedding party, hosted by the manager of the Maskati office at the Dawoodi Bohra mosque on Hill Street.

> The wedding of Mr. Abdultyeb Esmailjee Maskati to Miss Shireen Taherali, takes place to-day at Surat, Bombay Presidency. The bridegroom is not only a millionaire, but sole proprietor of the well known firm bearing his name with the head office in Surat, and branches in Bombay, Ahmedabad, Bangkok Battambong, Pnumpenh, (Cambodia) and Singapore. The bride is the eldest daughter of Mr. T. M. Kajiji, barrister-at-law. The bridegroom was in Singapore in 1920 on an inspection of his firm's business, and here made a host of friends by his unassuming manner and genial personality, and he and his bride will have their good wishes in their new life. In honour of the auspicious event the Borah Community will be entertained to-night at dinner at the Borah Mosque in Hill Street.

This picture from the Maskati Family Archives shows an early march led by Mahatma Gandhi, possibly in or near Ahmedabad. The swadeshi movement of the time called on all Indians to boycott imported British goods. Chief amongst those goods were textiles from English mills. In 1921, Gandhi and his followers made bonfires out of foreign cloth. As the Maskati Cloth Market was one of the primary conduits for the sale of textiles it was occasionally the starting or end point for political marches.

Entertaining Siamese Royalty in Surat

On 10 March 1923, a Siamese prince and princess visited Surat and were welcomed at Abdultyeb Maskati's Athwa Lines bungalow. The afternoon garden party was co-hosted by the main Indian businessmen in Bangkok; among them Mohamadali Mogul, E.A. Nana, Abdul-kadaz Vasi, and F.A. Motiwalla. A string band played on the lawn and light refreshments were served to the large crowd of attendees. The *Times of India* reports that *'the Collector, Mr. Macmillan and other [colonial] officers, leading Bohras, and Hindu gentlemen'* were also in attendance and that the royal couple was garlanded by E.A. Nana. The Siamese prince, HRH Prince Bidyalongkorn, was travelling with Reginald Le May, a British adviser to the Siamese Ministry of Commerce, on an inspection tour of India's agricultural industries. In Bengal, he viewed the Calcutta jute mills and Le May told the press there that, though jute was growing abundantly in Siam, there was still no capital to launch a burlap bag-making industry in the country. Having spent some time in Punjab inspecting rice cultivation, he was now in Surat to inspect the cotton-growing districts of Gujarat. *The Times* reports that, before departing, *'The Prince made a short speech thanking his hosts for a pleasant afternoon they had had and assuring them that they would not soon forget it.'*

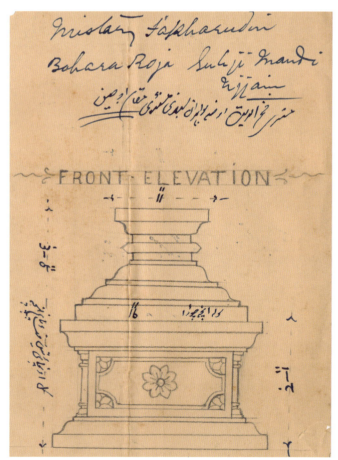
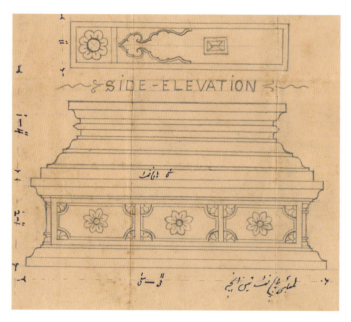

Above left: Nemtullabai (d. 1927), widow of Abdul Tyeb Maskati, the founder of the Maskati business.

Above right: The Maskati Maternity Clinic that was added to the Maskati Charitable Dispensary in her memory and opened by her only surviving son, Esmailji Maskati, in November 1927.

Bottom row: Hand-drawn designs for the tomb of Abdul Tyeb and Nemtullabai Maskati, designed for the Dawoodi Bohra cemetery in Surat, India.

On 20 January 1927, Nemtullabai passed away at the Begumpura house in Surat. The family's notice in *The Times of India* reported that her death was, *'deeply regretted by her family and large circle of relatives and friends'*. In death, whatever dispute Nemtullabai had with the Head Priest in Surat must have been forgiven or forgotten because she was buried in the Bohra community cemetery.

Throughout her life, Nemtullabai had maintained her interest in charity. Among other projects, she had begun working on plans for an addition to the Maskati Charitable Dispensary: a maternity ward that would provide free treatment. It was a forward-thinking, and perhaps controversial, advancement at a time when most women still gave birth at home without medical assistance. One of the reasons men had multiple or successive marriages was that it was not uncommon for women to die in childbirth. Nemtullabai was no stranger to loss and her charitable interest in healthcare, and maternity care especially, may have been generated by her own tragedies. In addition to the loss of Kamruddin at a young age and the death of her youngest surviving son Nomanbhoy, who died of heart disease when he was just 18 years old, she had lost three sons in infancy.

Upon her death, Nemtullabai's commitment to charitable causes – a practice she had learned from her husband, and often conducted in his name and memory – was passed on to the rest of the family, both in spirit and formally through the Maskati Charitable Properties Trust, which she had set up in 1911. Trustees included her son, the company accountant and scribe, Balubhai Lalbhai, and others close to the family and firm.

In November 1927, less than a year after Nemtullabai passed away, the family realised her long-held plan to expand the dispensary in Surat to include a maternity clinic that would provide free prenatal and postnatal care for women. The original dispensary building was extended to include an additional storey for the Maternity Clinic and was declared open on 6 November 1927 by Nemtullabai's only surviving son, Esmailji.

The dispensary was proving of great service to the surrounding community and, just a couple of years after the Maternity Clinic was added, records show that the unit was treating an average of around 7,750 patients per month. The numbers rose steadily and, by the early 1930s, between 9,000 and 10,000 patients were receiving treatment there each month. The gender and age demographic of patients was roughly equal: in August 1938, for instance, the Dispensary and Clinic treated 5,667 men, 6,578 women, and 5,859 children – amounting to a total of 18,100 patients. Curiously, while the number of patients continued to rise throughout the 1930s, the number of women who came to the Clinic to give birth never rose much higher than ten each month – a figure perhaps indicative of the strong influence old-world traditions still had within the narrow lanes and shuttered row-houses of central Surat.

An early photograph of Abdultyeb Maskati taken in his young 20s shows him wearing the traditional white-and-gold Bohra turban on his head. Rather than the crisp white robes that most Surat Bohras wore at that time, however, he is dressed in a European-style three-piece suit. Neither does he have a beard, as was traditional amongst male Bohras. Abdultyeb wasn't raised in the confined by-lanes of Surat's Bohra neighbourhoods but in the family's Bombay bungalow then located on the edge of the city with a view to the open sea (see page 120). Coming of age in the mixed, multi-cultural, multi-lingual environment of Bombay, didn't make Abdultyeb any less of Bohra but it did make him want to instigate reforms that would encourage members of the Bohra community to leave behind their old-world ways and turn towards progress and the changing times.

In 1925, Abdultyeb and 17 other young Bohra men launched the Young Men's Bohra Association (YMBA). The aim of this association was to instigate social reform amongst the Dawoodi Bohras by providing education to a community traditionally adverse to sending its members beyond its confines. Members of the YMBA were known as 'reformists', which was not a complimentary term in more religious or traditional Bohra circles. In a speech given at the association's second annual general meeting in 1927, YMBA president Amirudin Shalebhoy Tyebjee declared that the Bohra community, *'needs, but lacks, educational facilities for their mental improvement and hospitals and dispensaries for their physical welfare'*.

Amirudin argued that while there was plenty of money in the Bohra community, there was little commitment to

educating its members: '[N]obody can maintain that there is any lack of money in our community, which by its innate and inherent qualities of thrift and industry, can hold its own with any other community in business and commerce and profits accordingly thereby, but how does it spend the money it works so hard to make? After providing the essential needs of the individual, such as food, clothing and habitation, whatever remains is most often wasted in large measure in costly but the more or less meaningless and useless religious feasts, glittering processions and ceremonies which do not benefit the community in any way.'

Following this strong condemnation, the YMBA promoted contributing to the provision of schools, colleges, hospitals, and dispensaries. Amirudin, himself quite literally put his money where his mouth was when his wife died. He dispensed with the customary three-day funeral and contributed the money he would have spent on that ceremony to the YMBA for what he called, 'the far more useful employment of the income on it as aids for education to students of our community'.

In addition to being a founding member of the YMBA, Abdultyeb was also one of its most generous donors. His donations were given in memory of the late Nemtulla-bai and he personally supported numerous scholarship students through school. Indeed, Amirudin singled out Abdultyeb in his speech: 'Sufficient praise cannot be bestowed upon our popular young friend and colleague, Mr. Abdultyeb Maskati, who again distinguished himself this year by swelling our funds.'

This group of young and up-and-coming Bohras must have raised the ire of the religious hierarchy back in Surat as it relied on donations and regular taxes received from the community to build and maintain its mosques. Like a certain indomitable woman of the previous generation, Abdultyeb and his YMBA colleagues were unafraid. Their president Amirudin was careful to state that the association had no intention of setting up a rival or hostile camp to orthodoxy but asked that, if it could not be welcomed, that it could at least be tolerated and not hindered in its activities. Then, he concluded with a not-so-subtle warning: 'It is no use trying to suppress our activities,' he said. 'A tennis ball bounces all the higher the more forcibly it is smashed.'

AMIRUDIN SHALEBHOY TYEBJEE PRESIDENT-FOUNDER LEADER OF THE REFORM MOVEMENT AMONGST THE BOHRAS.

It is not the desire of the Young Men's Bohra Association to set up a rival or hostile camp to orthodoxy. They cordially invite co-operation from all the members of the community and all they ask for is to be received in a spirit of toleration, if not cordiality and to be allowed to show without interference the results they have set out to achieve, namely to benefit their community by progress and reform which are now rendered necessary consistently with the times.

It is no use trying to suppress our activities. A tennis ball bounces all the higher the more forcibly it is smashed.

Left: Abdultyeb Esmailji Maskati, formal photographic portrait.

Above: Clipping from an article in The Times of India *about the Young Men's Bohra Association (YMBA), a progressive movement founded by Abdultyeb Maskati and friends in 1925 to promote education in the community.*

An Eclectic Mind

Abdultyeb Maskati kept a commonplace book in which he wrote down thought-provoking quotes and kept clippings he cut from newspapers. Begun in 1927, the book covers such topics as religious tolerance, equality among humans, the value of honesty, and the destructiveness of fear.

Inspired by both the East and the West, Abdultyeb quoted Indian thinkers such as Rabindranath Tagore and J. Krishnamurti as well as Europeans like the French Enlightenment writer, Voltaire, and the nineteenth century Russian novelist, Fyodor Dostoevsky. He picked wisdom from different religions, quoting His Holiness the Pope, Rowland Allanson-Winn or Lord Headley, an Irish peer and prominent convert to Islam, and the Hindu monk, Swami Vivekananda.

Though the book was never filled and Abdultyeb appears to have written in it only sporadically over the course of his life, it demonstrates an eclectic and wide-ranging intellect that was unbound by discipline or geography. Among a list of books he noted down to read are Consequences by Julia Ellsworth Ford, a New York socialite and author of children's books, as well as Modern Civilisation on Trial by the English atheist C. Delisle Burns. Within the notebook's pages, Abdultyeb kept a transcription of a lecture by Jawaharlal Nehru on how to avoid cultural conflict and also a talk given by the first Labour Party leader to become Prime Minister of the United Kingdom, James Ramsay MacDonald, entitled *'What Life Has Taught Me'*.

'Man is held in bondage of fear which destroys the very possibility of fulfillment'
Jiddu Krishnamurti

'We need men and women too great to be clerks and tramwaymen, who are nevertheless unashamedly and understandingly clerks and tramwaymen'
Cecil Delisle Burns

'Enjoy thy youth it will not stay. Enjoy the fragrance of thy prime. For O! it is not always May'
Longfellow

'Avoid everyone, however great and good he may be, who asks you to blindly believe'
Swami Vivekananda

'Where there is intolerance, there the seed of decay has already been sown'
Anon

'Love does not claim possession but gives freedom'
Rabindrath Tagore

'The best way to
find yourself is to
lose yourself in the
service of others'
Mahatma Ghandi

'All man can betray
is his conscience'
Joseph Conrad

'Every man worthy of the name
should learn to stand alone, and do
his own thinking, even in conflict
with the whole world.
Sincere thought, even if it does
run counter to the beliefs of others,
is still a service to mankind'
Romain Rolland

'One of the dangers of our
civilisation it seems to me is
that we have a large
ambitious class who work
only for their wages and
have no thought
beyond amusement'
Dean Inge

'Man may be
the king of all
hearts, but alas,
all the hearts
in him rule him'
John Cournos

'A good day's work
means constant give and
take with the least
possible friction on the
part of all concerned'
Abdultyeb Maskati

'You may have all the softer
and more charming qualities
of life, you may be gentle,
you may be kind, you may
be good company, you may be
merciful, but all these things
are useless unless you have
devloped the habit of regular
industry, which is the basis upon
upon which true manhood rests'
Mr H.B. Lees-Smith

'I slept and dreamed that life was joy.
I awoke and saw that life was service.
I acted and behold, service was joy'
Rabindrath Tagore

'In the present day men
are prone to become atheists
when asked to subscribe to
dogmatic and intolerant beliefs'
Lord Headley

Indo-Siamese Cultural Ties: Rabindranath Tagore Visits Bangkok

The ancient links, both economic and cultural, between Siam and India continued into the twentieth century. In 1927, the world-renowned Indian poet and writer, Rabindranath Tagore, visited Bangkok. He was on a tour of Southeast Asia to look for traces of the centuries-old Indian exchanges with the region in relics and buildings as well as contemporary art, religion, and daily life. Tagore stayed in Bangkok for a week, meeting with Siamese royals, Buddhist monks and thinkers, and literary figures. The visit ultimately led to the establishment of an institution for cultural exchange still in existence today. In 1930, the Bengali linguist, intellectual, and ascetic, Swami Satyanand Puri, came to Bangkok at the behest of Tagore to continue the age-old sharing of Indian knowledge and founded the institute that became known as the Thai-Bharat Cultural Lodge. Today, the lodge is a prestigious Indian cultural organisation and reference library. Its activities include the hosting of functions for important Indian and Thai holidays, displays of Indian dance and music, and assistance for students and research scholars. Rabindranath Tagore is pictured here on his visit to Thailand with Prince Damrong, 1927.

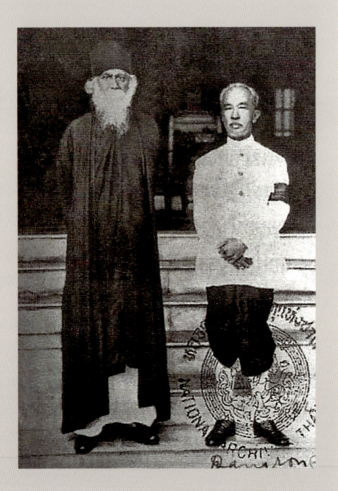

In Bangkok, the Maskati firm was facing increased competition from other Indian merchants shipping *saudagiri*, or *pha lai*, textiles to Siam. Prominent among its competitors were two other Dawoodi Bohra firms from Gujarat, run respectively by the Malbari and Vasi families, the latter of which also had offices in Phnom Penh. This prompted the launch of a new and untried activity for the Maskati business: Advertising. The firm's first advertising campaign was featured in Thai-language newspapers and magazines in the 1930s.

Another way of drawing attention to Maskati's *pha lai* cloth was through labels. By then, the cloth was being sold folded with a large, colourful label attached to the front. Among the images that decorated this label were an all-female Indian dance troupe performing the Gujarati Garba dance most commonly performed during the Hindu Navratri festival and characterised by its colourful spinning skirts. The label's text stated: *'Genuine Indian cloth: Top quality, specially ordered.'* Other labels featured Chinese language script and the name of individual Chinese distributors – an indication of the importance of the local Chinese trade networks for the Maskati business.

Along with these colourful labels came the development of the company logo. Originally, the logo was comprised of the name 'Maskati' written inside a lotus flower. Later, the same lotus flower enclosed the Maskati name above a stylised Indian palace modelled on the Taj Mahal. In 1938, customers were able to visit and walk inside a full-scale model of the palace, which was recreated especially for Bangkok's popular Constitution Fair at Saranrom Gardens.

In 1932, the People's Party, a political group that had been plotting against the monarchy for some years, made its move. In June that year, the king was overthrown in a bloodless coup and Siam's absolute monarchy ended overnight. The resulting nationalism that was roused in the coming decades contributed to the largest competitive force that Maskati cloth had to face in Siam.

When Siamese producers began making their own *pha lai*, Indian importers knew that their long-held position as market leaders was drawing to a close. In an unconscious echo of India's *swadeshi* movement, local Siamese *pha lai* producers used as their key selling point the fact that they were home-grown and local. In 1932, a Chinese merchant known as Ake Seng began experimenting with dying cloth. He soon set up a small block-printing workshop on Surawongse Road, using dyes imported from Germany. The cloth was block-printed on the Indian

'Maskati for All.' *'Maskati cloth is* pha lai *that all levels of society know well. The colours won't fade with washing and the flowers in the patterns will brighten like real fresh flowers.'* Siam Rath *newspaper, 1935.*

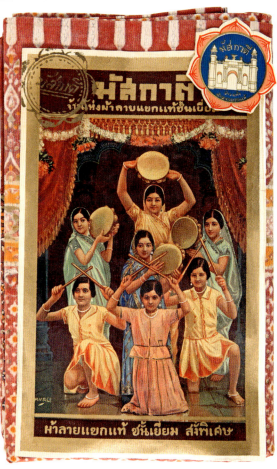

Right: *Labels attached to pieces of* pha lai, *showing how Maskati cloth was branded and sold. These two samples show cloth labelled in both Thai (below), and Thai and Chinese (top). The sample on page 98 is an oleographic print stamped for sale in Phnom Penh, circa 1906.*

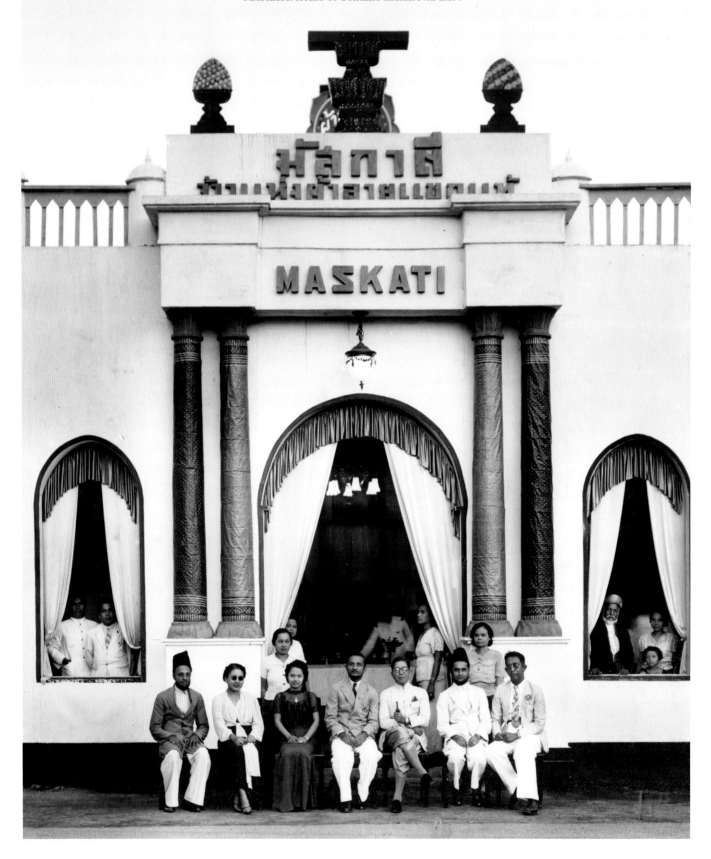

Badruddin A. Kapasi seated centre, Managing Director of the Maskati's Bangkok branch, hosts Thai dignitaries in front of the House of Maskati, a temporary larger-than-life model of the company's brand logo erected for the Constitution Fair at Saranrom Gardens near the Grand Palace in Bangkok, 1938. The pillars are wrapped in *pha lai* cloth and the Thai language words across the top pediment read 'MASKATI: Home of Genuine Indian *Pha Lai*'.

model but from brass blocks by a mostly female team of 20 women. It was an instant success and Ake Seng had trouble keeping up with demand; such a small workshop was only capable of producing around 20 sheets a day. With sponsorship from the importers of the German dye, Ake Seng was able to set up the Thai Arts Factory, a mechanised printing press that could roll out 400 sheets of *pha lai* per day. When the company hit financial difficulties, one of his sons partnered with a Thai entrepreneur who had studied under Ake Seng and set up the Praneet Factory to take over Ake Seng's brand name, Ramasut-Mekhala *Pha Lai*. The Praneet Factory started off printing cloth in just two colours but later invented its own screen-printing machine that could produce large quantities of *pha lai* that was more clear and geometrically precise than its Indian counterparts and, given the rising nationalism of the time, even more popular. One advertisement ran the pointed slogan, 'Siamese women should only wear Siamese cloth.'

In response, the Indian *pha lai* firms began to emphasise Thai cultural values and traditions in their advertisements, and around the time that the Praneet Factory was gaining a name for itself the Maskati firm launched a campaign featuring Miss Siam.

Maskati Marketing (advertisement, above). 'At the market, all you see is MASKATI cloth – it's popular with everyone, regardless of age or rank. The latest designs sport especially beautiful colours and flowers.'

Maskati at the Temple (advertisement, right). 'Going to the temple one should not be too flashy or too dressy. Choose pha lai – it's stylish, well-fitted, and appropriate. But don't forget to look for the MASKATI brand name on the edge of each cloth.'

Miss Siam Wears Maskati

In the 1930s, increased competition between Indian pha lai *merchants erupted in an advertising battle that began with the Maskati firm's Miss Siam campaign.*

As part of Bangkok's Constitution Day fairs, where the Maskati firm erected an annual stall, the new Siamese government began to hold 'Miss Siam' beauty queen pageants. Contestants had to compete over beauty, manner, and dress. The dress part of the competition required wearing three different styles: sporting shorts (that were not immodestly short), gala dinner gowns, and the traditional Siamese *jong krabaen*, which consisted of printed cloth wound between the legs to form pantaloons and then belted with a silver or gold belt. In 1938, the Maskati firm provided *pha lai* to a contestant called Pisamai Chotivudh who went on to win the competition and become Miss Siam.

In Bangkok's increasingly competitive *pha lai* market, the Maskati firm did not miss the opportunity to create a new advertising campaign based on the winning premise that Miss Siam wears Maskati and Pisamai became what would be known today as a brand ambassador. New labels were printed with Pisamai's photograph and her hand-written endorsement, which read, *'I've worn Maskati* pha lai *for a long time now and have worn it in beauty competitions where I won the Miss Siam award. I've always worn it, and continue to do so today. The reason I wear Maskati cloth is because it's soft, strong, and comes in beautiful bright colours with eye-catching patterns and designs. Even after washing and hanging it out to dry in the sun, the colours don't fade. It's better than any other* pha lai.*'*

Additional text was added to entice prospective customers, ensuring them that, *'Maskati* pha lai *has had a good reputation for many decades. It's the one brand of* pha lai *that the more you wash it the brighter the colours become – the patterned flowers will continue to glow until you wear the cloth to shreds.'*

It was a sign of how fierce the competition was among Indian *pha lai* vendors in Siam that this advertising campaign was picked up by one of Maskati's key rivals. The A.K.H. Wasee company ran a corresponding advertisement that showed a drawing of an ordinary-looking woman wearing a *jong krabaen* and a beauty queen crown. The accompanying text reads, *'We're not crazy enough to say that our Wasee* Pha Lai *was the reason that a particular beauty queen achieved her title. BUT, we will say that Wasee* Pha Lai *can make any women more beautiful and eye-catching because Wasee* Pha Lai *is genuine Indian cloth that uses the best material, top dyes, and is created by premium craftsmen.'*

The following year, the country's name was changed to Thailand, making Pisamai the last woman to earn the title 'Miss Siam'.

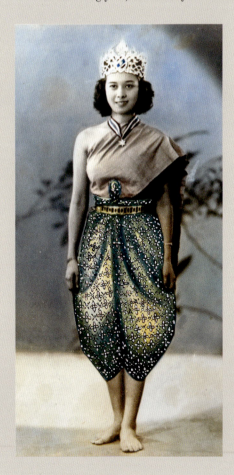
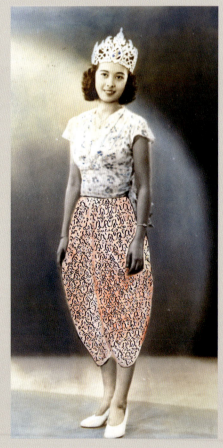
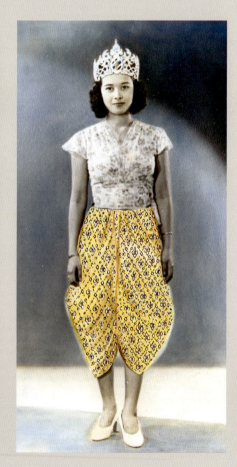

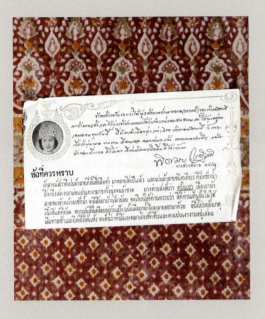

Left: Three hand-tinted photographs of Pisamai Chotivudh, who was crowned Miss Siam in 1938. The beauty queen was a brand ambassador for Maskati pha lai and is shown wearing three different colours of Maskati cloth tied in the Thai style known as jong krabaen.

Above: Miss Siam's endorsement of Maskati pha lai and beneath it a playful advertising retort by the rival Indian pha lai company, A.K.H. Wasee & Co.

It is most likely during the 1930s that the interests of the Maskati business in Burma began to unravel. Like India, Burma was going through its own political awakening and independence struggle. Ruled as part of India since it became a British colony, Burma was finally made into a separate country in 1937. During that decade, anti-Indian sentiments rose to new and deadly heights.

Indians made up the majority of the population in Rangoon, then Burma's capital city. Though some Indians – such as the merchants from Surat (known as Surtis) – had been there since before the arrival of the British, many others arrived after the establishment of British rule and, as a result, became inextricably associated in Burmese minds with the British overlords. This was particularly true of the Indian moneylenders, or *chettiars*, who had managed to gain control of vast amounts of land from debt-ridden farmers. The Indian population in Burma straddled both ends of the socioeconomic spectrum as, in addition to merchants who amassed great fortunes in the new colony, there were thousands upon thousands of manual labourers from India who took on building work or railway construction, and other back-breaking manual tasks that no one else was willing to do.

The first major anti-Indian riots broke out in May 1930 when a group of Indian stevedores in Rangoon went on strike for better pay. When the Burmese workers that were hired to take their place arrived at the ports to begin work, they were attacked by the striking dockers. Reciprocal attacks were launched and rioting broke out across the city. Over the following days, the violence contaminated other port cities along the coastline, including Martaban, where the Maskati office and properties were located. By the time the British authorities were able to quell the riots (using a police force staffed predominately by Indians), around 200 Indians were dead and many hundreds more had been severely injured.

Tensions remained high between the Indian and Burmese population throughout the rest of the decade and broke out once more in 1938. This time, Burmese ire turned against Indian Muslims. Spurred by a hate campaign that had been playing out for some time in local newspapers, Buddhist monks had begun to barricade Muslim-owned shops in order to discourage Burmese from shopping there. After the authorities made a heavy-handed attempt to put an end to one anti-

Muslim march, photographs of Indian policemen beating Buddhist monks ran in the local newspapers and the incendiary images triggered riots that spread across the country. Muslim properties and shops were looted and burned, and more than one hundred mosques were damaged. There are no records to indicate when Abdultyeb decided it was time to relinquish his Burmese office and properties, but it is likely he left either before or after those riots in order to protect his staff and business interests – in such an antagonistic environment there would have been little hope of building profitable networks or loyalties.

The Maskati business in Cambodia continued to thrive. The main office had shifted from its original spot on the riverside promenade at the Quai Norodom into the thick of the Chinese quarter on Rue Ohier, which later became known as Ang Eng Street. To French residents, Rue Ohier was affectionately known as Phnom Penh's Champs Elysees, probably due to the large number of shops selling luxury items. Phnom Penh had by then developed the elegant layout and architectural character of a French provincial town with broad tree-lined pavements and grand chateau-like residences combined with the ceaseless hustle and bustle of a Southeast Asian city with daily wet markets, cyclo (rickshaw) drivers, and street-side vendors. As in Bangkok and Singapore, the Maskatis had purchased property throughout the central commercial area around its Rue Ohier shop. It also owned the SS Madina and SS Mecca, river ships that plied the Tonle Sap River taking textiles and other goods further inland from Phnom Penh, possibly as far as its additional Cambodian outpost at Battambang, which lay across the great expanse of the Tonle Sap Lake and along the Sangkae River.

The Maskati office in Singapore office, meanwhile, had begun to explore alternative sources of revenue. Beyond the import and transit of *saudagiri* cloth from India, the company had been importing Japanese textiles, plain cloth, long cloth for making batik, grey material for printing, and shirting material. In addition, the founder Abdul Tyeb had accumulated numerous well-positioned properties in Singapore and the Maskati office had moved from its initial location on Finlayson Green to Cecil Street, also a highly central business location. As in Bangkok, the Singapore properties were rented out mostly to foreign merchants doing business in the city.

One evening, in December 1934, Abdultyeb Maskati was at the G.H. Cafe in Singapore, famous for its European bakery goods and catering to a high-end crowd of

Europeans and well-to-do businessmen. Abdultyeb was there to host Sir Nowroji Saklatvala, the head of Tata Sons Ltd., a leading Indian industrial concern. Sir Saklatvala was returning to India via Singapore after a six-week trip to Japan with his wife and joined the event in his capacity as the Chairman of New India Assurance Co. Ltd., one of India's leading insurance companies, for which the Maskati firm was the Singapore agent. The *Straits Times* newspaper records that *'The guests of honour were garlanded by Mr. Maskati in true Indian fashion.'*

After tea and cakes, one businessman gave a talk in which he highlighted Japan as the greatest leading example of industrial development. Sir Saklatvala continued the Japan theme, explaining that he had learnt much about Japan's development on his recent visit: *'Japan is one of the foremost nations in the world, as a great power, as a great centre of trade, and as a centre of every sort of industry. I put that down wholly and solely to their one besetting object to do everything possible, even at the sacrifice of their lives, for their country which is near to their hearts. The progress they have made has opened my eyes to an extent which I did not realise before I set out on this trip.'* He concluded that Japan was a great example for India to aspire to.

Providing Protection in Tumultuous Times. In Singapore, the Maskati firm became the agent for the New India Assurance Co. Ltd., which according to its advertising, 'transact[ed] all classes of Insurance business – fire, marine, motor, accident etc.' Known then as India's 'House of Security', today the government-owned enterprise remains one of India's largest insurance companies.

Top left: A scene most probably taken at the residence above the Maskati office in Martaban, Burma. Abdultyeb Maskati is seated third from right.

Above: Rue Ohier (today Ang Eng Street) in Phnom Penh, Cambodia, 1914. The Maskati office (pictured inset) was located on the right-hand side of this street in the row-house just in front of the domed tower.

By the 1930s, the Maskati company had extended its Asian reach as far afield as Japan with an office in Kobe. Historically, Japan had produced its own textiles and had no need to import cloth from elsewhere, but it did have a taste for items of novelty that locals found exotic. When the Portuguese established trade relations with Japan in the middle of the sixteenth century, Indian textiles were among the goods traded with local merchants. The British East India Company also brought Indian textiles when it began trading with Japan in the seventeenth century. Japan was also trading directly with merchants in Southeast Asia and the Siamese capital of Ayutthaya had a Japanese quarter in the seventeenth century. This trade continued throughout the eighteenth and nineteenth centuries. Though it never flourished there was a continuous stream of Indian textiles filtering into Japan and the textile historian John Guy notes that *'historical collections of Indian cloth in Japan display the greatest variety seen anywhere outside the subcontinent'*.

Feeding off existing trade routes, Indian merchants settled in the thriving port cities of Yokohama and Kobe. They imported sheep skins, indigo, and mats from India

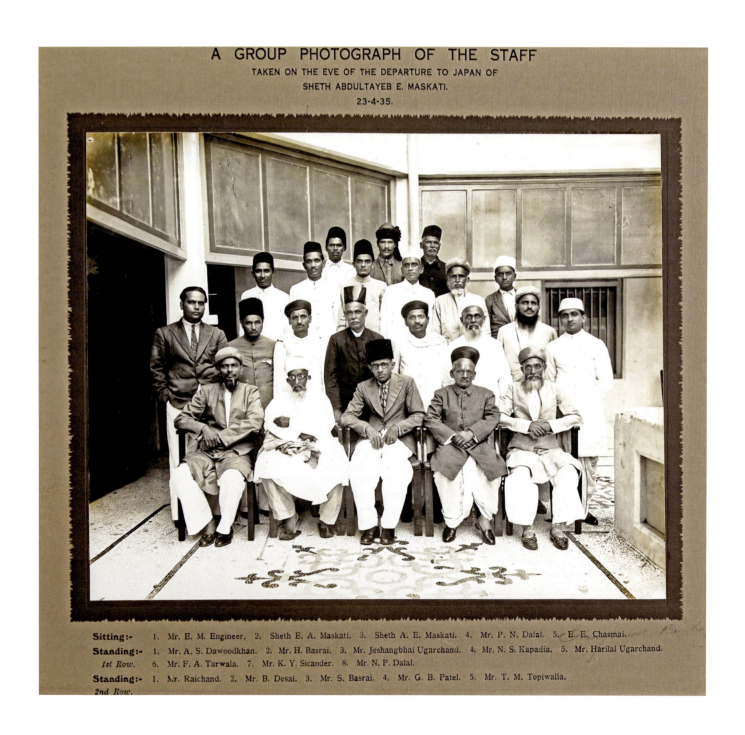

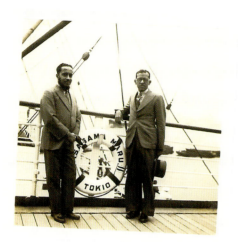

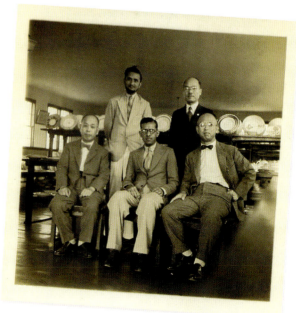

Left: Abdultyeb Maskati is seated front and centre with his father, Esmailji Maskati, on the left. This photograph of the staff at the Maskati's head office in Bombay was taken in April 1935, just before Abdultyeb left on an extended trip to his offices in Southeast Asia and Japan. Esmailji Maskati wears full traditional dress, including pointed slippers.

Above, top row: Abdultyeb Maskati (right) and Y.M. Makkawala from his Bangkok office aboard the Asama Maru bound for Japan. The Asama Maru, which ran a fortnightly trans-Pacific Orient-California service that included a stop in Kobe, where the Maskati office in Japan was located, was later sunk by a torpedo in World War II. Top row, right: Visiting Itami Works, Sumitomo Electric Ind Ltd,. From left to right: I. Fukada, S. Shinohara, Abdultyeb Maskati, K. Kitagawa, S. Saito, Y. Hino, K. Takeo.

Middle row, left: Abdultyeb Masakti (left) and Badruddin A. Kapasi enjoy Japan's famous onsen, or hot springs. Middle row, right: On a later trip to Japan, Abdultyeb and Shirin Maskati stand in front of the residential villa of the Maskati office in Kobe. The office's Indian staff stand on the right side of the picture, from right to left: Abbas Chinwala, Nazim Motiwala, and Abbas S. Dawoodkhan, who can also be seen among the staff at the Bombay office in the photograph opposite, before he was posted to Kobe.

Bottom row: Abdultyeb Maskati (seated centre) visiting a Noritake showroom in Japan, 1935, with the Managing Director of his Bangkok office, Badruddin A. Kapasi, standing to the left behind him.

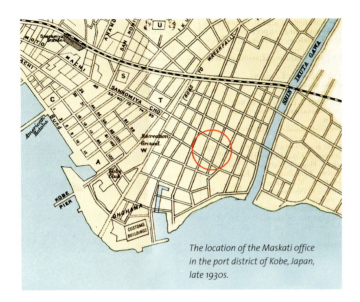

The location of the Maskati office in the port district of Kobe, Japan, late 1930s.

and exported silk goods to other parts of Asia. As exports in silk increased so too did the number of traders. In 1912, there were some 25 Indian trading firms in Japan and by the early 1920s, there were about 50-60 Indian merchants in Yokohama alone. After the great Kanto earthquake of 1923 destroyed much of Yokohama, many of those merchants shifted to Kobe and, in the late nineteenth century, that city emerged as a major Japanese port town for the import of Indian raw cotton. R.D. Tata & Co. Ltd. of Bombay became the first Indian trading firm to establish a branch in the port city in 1891 in order to open a direct trade route to import cotton to Japan from India. At the time there was still no direct shipping route so cotton had to be trans-shipped via Shanghai or Hong Kong. It was Tata's company that led negotiations with Japan to establish a direct shipping line, which was established in 1893. Several more Indian firms, among them some big-name Bohra firms such as those belonging to the Essabhoy or the Motiwalla families, set up offices to trade in raw cotton from India and take back silk goods and sundries.

In the 1920s, a bitter dispute between the two countries resulted in the breakdown of trade relations during which India boosted tariffs on imported Japanese textiles and Japan retaliated by boycotting Indian cotton. It was not until 1934 that the two countries could come to what has been called a barter agreement in which India agreed not to impose tariffs of more than 50 percent on Japanese cotton goods. An exchange was set up whereby Japan agreed to purchase one million bales of Indian cotton annually in return for which India promised to admit 325,000,000 yards of Japanese cotton textiles.

This agreement ran for three years and was renewed in 1937 with some modifications necessitated by Burma's separation from India in that year – Japan would make a separate agreement with the newly administered colony. Raw cotton was by far India's most important export to Japan. India, meanwhile, became a huge and profitable outlet for cheap Japanese textiles; other goods included rayon yarn, rayon tissues, raw silk, silk piece goods, and glassware. For Indian merchants, these trade agreements paved the way for lucrative deals. In April 1936, Abdultyeb Maskati joined a 65-man delegation of the Muslim community led by Sir Currimbhoy Ebrahim, a prominent Muslim businessman, to say farewell to the retiring British Viceroy and Governor-General of India, the Earl of Willingdon, and to thank him specifically for the Indo-Japanese agreement negotiated under his tenure.

As more and more Indian merchants sought opportunities in Japan, and in Kobe in particular, the city became home to the largest number of Indians in Japan by the late 1930s. As of December 1937, 130 out of a total of 176 Indian firms in Japan were located in Kobe. Unsurprisingly, it was in Kobe that same year, that the Indian Chamber of Commerce was established.

With its office in Japan, the Maskati firm achieved its peak in terms of geographical reach and product diversity. From Kobe in the Far East to Lagos in Africa and some 24 destinations in between, the Maskati firm was delivering glassware, chinaware, earthenware, sanitary ware, porcelain, bobbins & mill store articles, hosiery, towels, blankets, cotton, silk, rayon piece goods, corrugated sheets, cement, tiles, paints, varnishes, and enamels, among other products.

From Lagos to Kobe and 24 Destinations in Between: The Maskati Trade Route. An advertisement from the Japan branch of the Maskati business features a map of the world and lists the following destinations on the trade route: Lagos (Nigeria), Durban (South Africa), Port Louis (Mauritius), Mikindani (Tanzania) Lindi (Tanzania), Dar-e-Salaam (Tanzania) Zanzibar (later Tanzania), Tanga (Tanzania), Mombasa (Kenya), Port Sudan (Sudan), Istanbul (Turkey), Aden (Yemen), Bahrain, Basra (Iraq), Lahore (later Pakistan), Amritsar (India), Karachi (later Pakistan), Bombay (India), Colombo (Sri Lanka), Madras (India), Calcutta (India), Rangoon (Burma), Bangkok (Thailand), Singapore, Hong Kong, and Kobe (Japan).

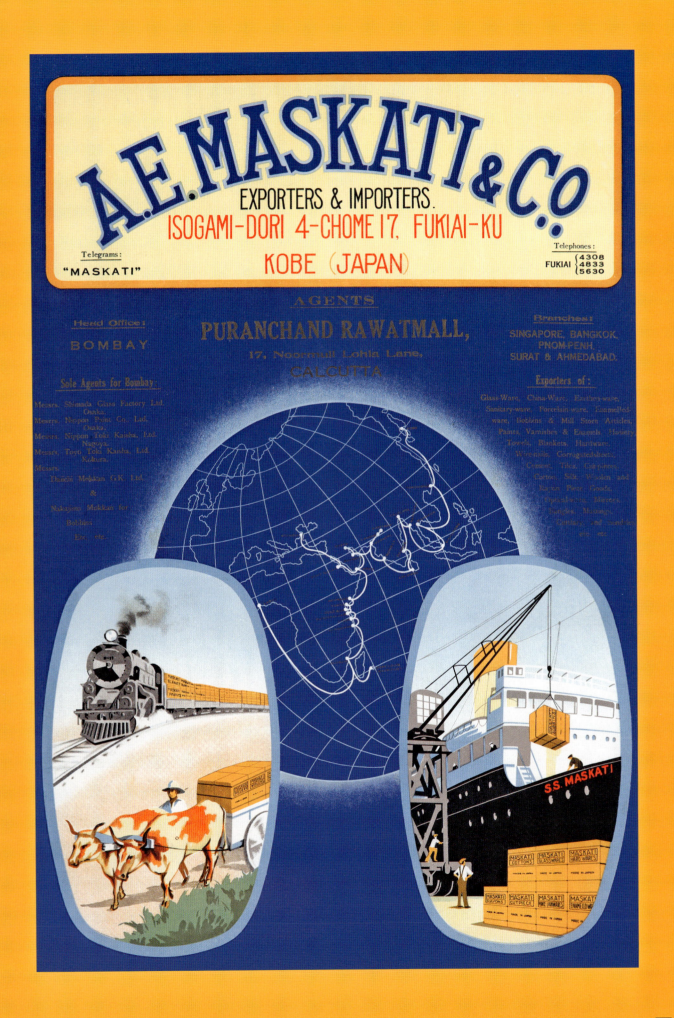

Made for Foreign Markets: Maskati Brings Noritake and Shimada to India

Both Shimada and Noritake bore compelling similarities to Maskati saudagiri. They borrowed from foreign tastes and combined these with local workmanship to produce a unique hybrid product made specifically for distant markets.

Noritake porcelain was modelled on the exquisite fine white porcelains of Europe and created by the Morimura brothers of Japan especially for sale in the United States. Some years after Abdul Tyeb Maskati opened his first store in Bangkok in 1856, the Morimura brothers opened a store in New York city, in the 1870s, selling Japanese antiques and ornaments. There, they noticed a high demand for porcelain and decided to try their hand at producing it in Japan. In 1904, they established a factory at Nagoya though it wasn't until 1914, after years of experimentation, that dinner sets were ready for mass export to the United States. Noritake became Japan's biggest company producing high-quality 'western ware', i.e. dinner sets made for the western market that required specific measurements and uniformity across sets (attributes considered unimportant in 'Japanese ware'). Noritake became world-famous for the delicacy of its floral designs and the luminosity of its glaze.

Shimada glass was created by Magoichi Shimada who apprenticed under a British craftsman to learn European glassblowing techniques. In 1888, he founded the Shimada Glass Factory in Osaka and began producing glass lamps and tableware. His techniques eventually rivalled those used in Europe and his furnace design was patented. Through various innovations, the factory established itself as Japan's top-grade high-volume glass manufacturer exporting its produce to the West and also to India, where Abdultyeb Maskati had the Shimada glass tumbler design patented under Indian law in 1938.

Noritake Stamped for India

Modern-day collectors obsess over the backstamps that mark the underside of any genuine piece of Noritake porcelain. Among the many variations that help collectors date their pieces was the famous green laurel wreath twisted to the left and accompanied by the initials R.C. ('Royal Crockery'), which was registered in 1911. Later, in 1926, this backstamp was transformed into a laurel leaf that twisted to the right and was registered specifically for sale in the Indian market.

TRANSFORMATION

Transformation

The struggle for independence from colonial rule spread across the Asian region. In Indonesia, Burma, and Vietnam movements had formed to sabotage, undermine, and ultimately evict colonial rulers. In 1929 the stock-market crash in New York and the resulting Great Depression, further dampened the colonial spirit. In 1930, Gandhi began his salt march from Ahmedabad to the Gujarat coast and inaugurated the Civil Disobedience Movement that led to widespread non-payment of taxes and rent. Political agitation in India continued to revolve around the textile industry. Shops stocking foreign cloth were picketed in Ahmedabad and merchants were called upon to seal up their existing stocks and, as a result, they sustained heavy financial losses. The Maskati Market Mahajan, or guild, had finally agreed to stop the sale of foreign cloth but others still refused. With local cloth more in demand, Indian mills were thriving; the cotton industry had spread well beyond Ahmedabad into the Punjab and as far afield as Bengal.

The upheavals of the time seem to have had little effect on the Maskati business. Abdultyeb Maskati was adapting to the changing times and appears to have been unperturbed, or at least well-prepared, for the uncertain political and commercial landscape. In India, he was already shifting away from hand-printed cloth – the firm's core product.

In the 1920s, Abdultyeb became involved with and eventually purchased Garlick & Co., a Bombay-based engineering concern founded in 1878 by an Englishman called William Garlick. Garlick & Co. had built the Maskati Charitable Dispensary in 1911 and was known for the manufacture of durable, high-quality tiles and flooring for homes and factories. Garlick offered contracting services for structural engineering and imported numerous tools for factories to modernise their production in keeping with the now irreversible trend towards industrialised and mechanised production lines.

Abdultyeb proceeded to diversify into another sector that veered dramatically away from the textile trade. By November 1927, his first property development, an apartment block in Colaba overlooking the sea, was ready for habitation. The state-of-the-art building was equipped with all the latest in domestic fittings such as geysers, gas stoves, and an electric lift. The apartments

Left: This iconic image shows Mahatma Gandhi beginning his salt march at Ahmedabad, 1930. The march was in protest at the British colonial government's monopoly over the sale and production of salt, and marked a key point in India's struggle for independence from colonial rule.

Right: Newspaper advertisements for Garlick & Co., an engineering concern purchased by the Maskati family. Before World War II, Garlick was perhaps best known for its floor tiles. Many Maskati properties, as well as others in Bombay, still sport the once-famous 'Garlick tiles'.

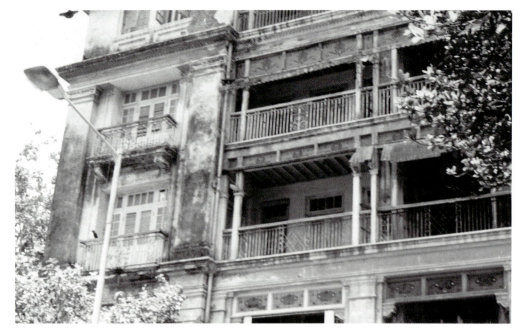

Left and below: Rashid Mansions, Bombay, the first property development built by Abdultyeb Maskati. The building was completed in 1927, boasted a state-of-the-art 'electric lift', and was named after his first son, Rasheed (alternately spelled "Rashid"), who was born in 1926.

Bottom: Rasheed Maskati in his 20s.

within were aimed at the city's burgeoning middle class (or, as one classified ad refers to its prospective inhabitants, 'the best of tenants'). Abdultyeb's first son, Rasheed, had been born a year earlier and he named this, his first property development, 'Rashid Mansions'.

The Maskati business also began to ship agricultural products when demand or opportunity arose; among produce sent from Bombay in the 1930s, Abdultyeb Maskati is recorded as having shipped castor seeds to Kobe in Japan and sandalwood to Ghent in Belgium.

It was amidst the financial and political turbulence of the early 1930s that Abdultyeb decided to build his own headquarters, not far from the existing office at Nagdevi Street. In 1934, he put out a Tender Notice on Maskati House, which was to be constructed at the junction of Mohammedali Road and Bhajipala Lane. The designs had been accepted by the Bombay Improvement Trust, which had recently spent some years laying Mohammedali Road and was very particular about what kind of development was allowed on the new thoroughfare. The Trust requested that buildings should be *'modern as regards constructional details, hygiene and planning, but at the same time in their general appearance would partake more of the traditional architecture of India rather than styles of Europe'*.

The building was designed by the Bombay architectural firm, Adalja & Noorani. Its architects were already known to the Trust and the city – they had designed the new Post Office at the junction of Parel Road and Mohammedali Road. For Maskati House, the firm steered clear of the city's Gothic precedents and the elaborate Indo-Saracenic styles of the colonial government architects and instead devised a modern oriental style with art deco touches that was simple but sleek. Today, the building is classified as a Grade III Heritage structure.

The new building occupied an area of about 600 square yards and had five storeys as it was built up to the full permissible planning height of 70 feet. It was

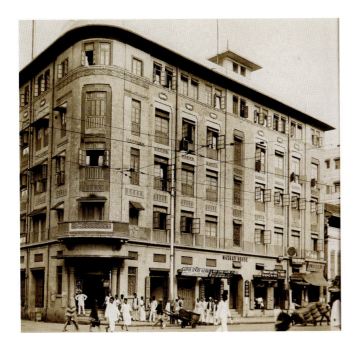

constructed with a reinforced concrete frame – a daring concept at the time, allowing the building to have open-plan interiors that would not require load-bearing walls. The entire facade was lined with Malad stone with special architectural features carved in red stone at the main corner and on the door and window architraves. Malad stone was mined from Kanivali on the main coast just south of Bombay and was a popular light brown stone; used for many of Bombay's grander buildings, it gave the city its distinctive sandy hue. When it came to the flooring, Maskati House used only Garlick & Co.'s tiles. The ground floor of Maskati House was planned for a bank or other business and the first floor was reserved for the Maskati firm's headquarters. The remaining storeys were designed to be let as residential quarters. The cost of the building – considered incredibly steep at the time – came to around 350,000 rupees, including the land.

Above: Maskati House, Mohammedali Road, Bombay, 1935. Work on this new headquarters for the Maskati firm began in 1934. Commissioned by Abdultyeb Maskati, the five-storey building was designed by Messrs. Adalja & Noorani, a well-known architectural firm in Bombay, and built by contractors Messrs. N. Nagindas Gokaldas & Co. The floor tiles were supplied by Garlick & Co.

Treasure of Every Kind

As the Maskati firm entered the world of heavy machinery and engineering, one product on its Thailand stock list contained an unlikely link to textiles.

Godrej safes were renowned throughout India and the Far East. They promised complete protection against fire and criminals for *'valuable books, coins, jewels, and treasure of every kind'*. Mr. A.B.S. Godrej, a Bombay-based Indian lawyer turned locksmith and entrepreneur, personally tested his safes to ensure their contents could withstand extreme conditions such as the intense heat of a raging fire or the inescapable humidity of a tropical climate. In 1904, he devised an experiment to test their fire resistance: pieces of linen, cotton, silk, and flannel were tied to a strip of pinewood and placed inside a Godrej safe. (Other items in the safe included a ten-rupee note, several newspapers, and a coil of electrical fuse wire.) With witnesses of good calibre present, a fire was lit beneath the safe and allowed to burn for hours until the safe's outer casing became red hot. When the fire was put out and the door was opened, one of the witnesses, the editor of the *Indian Textile Journal*, examined the contents and found the cloth samples *'intact and without any sign of deterioration'*. While Godrej safes may not have been an obvious choice for the Maskati firm to stock, given the uncertainty of the times, they may have been the safest bet of all.

Abdultyeb Maskati was a director on the board of Godrej in India and, through his friendship with Mr. Godrej, represented Godrej safes in Thailand.

Dressed to Impress

From garden parties for Siamese royalty in Surat, India, to hosting visiting Indian industrialists in Singapore, Abdultyeb Maskati understood the importance of public appearance. While earlier generations of the family wore the traditional Bohra dress and turban, Abdultyeb went to work in a three-piece suit, tailored from fine European cloth or Japanese wool. He was very particular about the material and fit; each outfit was made complete with a tie and, often a coordinated pocket handkerchief and/or smart felt hat. While plenty of Indian business-men in Bombay wore such garb, inspired by British styles, it was far less common beyond the city in places like Surat or Ahmedabad and, in group photographs with his staff, Abdultyeb is often the only man without a turban or beard. Still, he advised others to follow his lead. When he hired a young up-and-coming accountant (whose son and grandsons continue to audit the Maskati firm), Abdultyeb told him he needed to invest in a good suit. Recalls the accountant's son, Mohsin Contractor, *'He taught my father the importance of dress. In fact, he said there are two things you need to get ahead in the world of business: (1) social functions – you must be seen, and (2) you must be well-dressed, always.'*

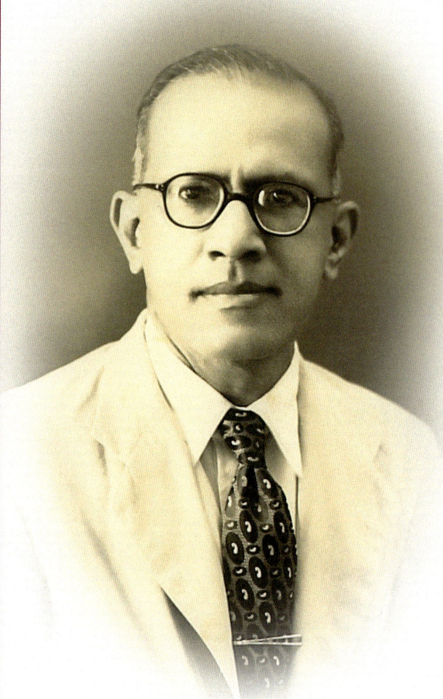

With Nemtullabai's death in 1927, the last remnants of the old world and the old ways were slipping away. Just over a decade later, on 3 September 1938, Abdultyeb's father, Esmailji Abdultyeb Maskati, died at home in Surat. Abdultyeb was now the patriarch of the Maskati family. Not yet 40, Abdultyeb was already a respected and influential member of the Bombay business and social community. His wife, Shirin, had also made her mark. In 1939, she was elected as a Justice of the Peace, eligible to conduct basic legal tasks within the city jurisdiction; she was one of just ten women amongst a total of 150 'JPs', as they were known. The couple lived at Maskati Villa (see page 120), the seafront bungalow purchased by Abdultyeb's grandfather and given to Nemtullabai, together with their three children; Rasheed, Ziya, and Zaki.

Around the World in 1937

In 1937, Abdultyeb and Shirin packed up trunks with fur-collared coats and woollen scarves and set off on a round-the-world trip. Rasheed and Ziya, their two eldest children, accompanied them for the European leg of their tour and were then sent back to Bombay from England in the care of a German governess. The couple continued their tour to the United States, setting sail on the RMS Queen Mary passenger ship, which had just been launched the year before. Abdultyeb carried with him a portable camera and the resulting photo albums show that they took in many of the world's iconic sites: in Europe, they saw the Eiffel Tower, visited the Colosseum in Rome, piled into a gondola in Venice, and took afternoon tea in the lush, landscaped gardens of one of England's great country homes. In the United States, they climbed the Empire State Building in New York, visited Niagara Falls, stood in front of Capitol Hill, home to Congress in Washington DC, and watched a herd of wild buffalo grazing on the open plains.

Aboard the Queen Mary

In a gondola, Venice

Colosseum, Rome

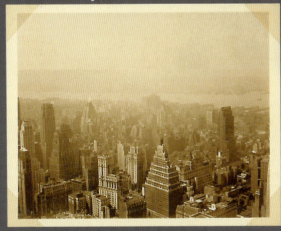

New York City

Tea with a polar bear

Opposite, left: Abdultyeb Maskati, dressed in his characteristic European tailored suit, with carefully chosen tie and matching pocket handkerchief. Circa 1930s.

Opposite, far left: Maskati Villa, the family home in Colaba, Bombay. Abdultyeb is holding his youngest son, Zaki. To the left: his eldest son, Rasheed; daughter, Ziya; wife, Shirin; and father, Esmailji Maskati. Circa 1930s.

A Bungalow in Colaba: Notes from the Edge of Bombay

Purchased in Nemtullabai's name shortly before the death of her husband, Abdul Tyeb Esmailji Maskati, in 1898, the family's Bombay bungalow has remained much the same, though the city around it has changed exponentially.

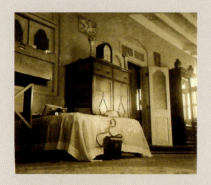

There were few other residences in Colaba when the Maskati family first took ownership of their bungalow. Following the outbreak of plague in Bombay in 1896, the Bombay Improvement Trust had launched a programme of land reclamation to create more liveable urban space and decongest the city. One of the areas that was substantially expanded was Colaba, the southern-most tip of Bombay. The area was then being used by the British as a military cantonment and there was housing only for troops.

At the very tip of Colaba, there was a lighthouse and a lunatic asylum. By the beginning of the twentieth century a number of large, detached bungalows set in spacious gardens with sweeping views of the sea had been erected in the area but Rasheed Maskati, Abdul Tyeb's great-grandson, recalls that it was still difficult to convince guests to come and visit because their house felt so remote to Bombayites used to busier locales.

The Maskati home was equipped with stables and a garden on the sea's edge. The bungalow's design, adapted and expanded from Indian traditional thatched housing, allowed for optimum air circulation in an attempt to alleviate the heat and humidity.

More than a century has passed and, beyond the walls of the Maskati Villa, the city of Bombay has transformed itself. Without having moved at all, the bungalow is no longer located next to the ocean and the view from the top of the garden that once looked out over a rocky coastline to the Arabian Sea is now interrupted by a wall and a sprawling slum where countless makeshift structures have been erected on newly reclaimed land.

The house has partially adapted to fit these new surroundings and the corresponding changes in modern living requirements. Some rooms were partitioned and the balconies were closed in. When the stables were no longer required they were converted into accommodation for servants. The original servants quarters were replaced with a modern kitchen that connected to the dining room. Despite these fixes, the interior of Maskati Villa remains much as it was with art deco fretwork introduced in the early decades of the twentieth century, stained glass windows filtering rose-coloured light into the ground-floor living rooms, and a hushed atmosphere of calm that seems to imply – impossibly – that the house is still located on the edge of Bombay.

To date, four generations of Maskatis have been born and raised in the house; over the course of the twentieth century, the house has witnessed births, weddings, and countless family 'Sunday Gatherings' (see page 143).

An Endangered Species:
'The colonial bungalow is one of those building types which is fast becoming an endangered species... They are so much a part of the environment that we take them for granted, and no one sheds any tears when they are torn down in the name of development. ... As we live in a society of transition, we are just beginning to feel a sense of loss [and preserving such structures] should help us reconnect to our heritage, evaluate the present, and remain a part of the continuum.'
~ Mika and Madhavi Desai, 1998

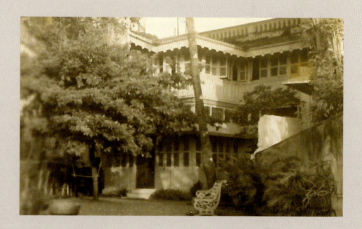

Opposite, left: First floor interior of Maskati Villa, Colaba, Bombay; Rasheed and Ziya Maskati seated in the garden; Ziya on her tricycle in the garden; and the original front of the house, which faced towards the sea.

Right: Japanese Imperial Army tanks at Lumpini Park in Bangkok during World War II. Japan was allied with Thailand from 1941-1945 and Lumpini Park served as the central Japanese army barracks in the capital.

World War II started in September 1939 and lasted six years and one day. Its conclusion would herald massive changes for Asia, as most of the region's battered colonial powers finally agreed to relinquish their colonies. During the war, animosity and allegiances between nations divided the entire globe and spelled a temporary end to global trade. As Adolf Hitler tried to establish the Third Reich across Europe, so Japan's Imperial Army sought control over China and Southeast Asia's mainland and maritime states. In December 1941, the Imperial Army marched into Bangkok and the Thai Prime Minister Field Marshal Plaek Phibulsongkram – who changed the country's name and would later attempt to adjust its fashion sense – acquiesced to Japanese presence. The choice to cooperate rather than fight meant that Thailand became aligned with the Axis powers.

On arrival in Bangkok, the Japanese Imperial Army marched down the Malay peninsula toward Singapore. The British had claimed that its star trading hub was impregnable and no one was more shocked than the British government when the Japanese swiftly captured the city in February 1942. With the fall of Singapore, most of Southeast Asia came under Japanese control – captured British and European civilians and soldiers were herded into prisoner-of-war camps while local populations were forced to live under Japanese rules and regulations. Strict blackouts to avoid Allied bombings and communication embargoes to avoid the sharing of military intelligence ended up silencing radio, postal, telegraph and telephone communications across the region. For almost four years, Abdultyeb Maskati heard nothing from his offices in Singapore, Bangkok, and Phnom Penh.

Bombay was located well out of the way of the main theatre of war and, aside from war-time rationing and the effects of a curtailed global trade, the city was relatively unscathed by World War II. In addition to maintaining his business activities as best he could, Abdultyeb spent most of the war years (1941-1944) serving as president of Anjuman-I-Islam, a prominent Muslim institution in Bombay that was established in 1874 with the aim of supporting, promoting, and providing education for the Muslim community. During Abdultyeb's tenure as president, Anjuman-I-Islam established its first commerce school (today known as the Jan Mohd. Cassum High School of Commerce) as well as its first night school, started on the same premises.

In April 1944, however, the SS Fort Stikine, a freighter docked in Bombay harbour, caught fire. The ship was carrying a mixed cargo of cotton bales that had been loaded at Karachi, nearly a million pounds sterling worth of gold bullion bars, and 1,395 tons of varied explosives, including torpedoes, mines, shells, and munitions. It was a devastating event – nearly one thousand people were killed as neighbouring vessels sank and burning cotton bales tossed from the exploding ship fell into highly flammable slum areas alongside the harbour. Maskati

goods were also destroyed, as the *Ahmedabad Mirror* noted, *'The disaster at Bombay Harbour, in which another Surti Bohra business house, Maskati & Co., lost a lot of goods…'* Though subsequent investigations deemed the blast an accident, the event was a dramatic and tragic reminder that this was no time for trade.

World War II had a far greater effect on life and business in Thailand. There, Badruddin A. Kapasi, the energetic and trusted Managing Director of the Maskati firm's Bangkok office, was a great asset to Abdultyeb during these difficult times. Events in the region were linked to Indian politics as the Indian National Army (INA) was established with the help of Japanese forces that had taken control over much of the Far East and its leader, the Cambridge-educated Bengali, Subhas Chandra Bose, came to Bangkok in 1943. Badruddin put his trading background to good use when he was appointed a Supply Minister in the INA cabinet and put in charge of procuring items needed by the army. Orders to be fulfilled included items hard to find in quantity when trade had come to a standstill such as printing paper, bales of twill, French medicine (to compare its efficacy with its British equivalent), and 20,000 leather boots.

The INA was destined to be a short-lived dream: in August 1945, Subhas Chandra Bose was allegedly killed in a mysterious plane crash, and the independence movement came to an abrupt end. Badruddin was arrested by the Allied Forces and imprisoned for over three months before being released to resume his duties at the Maskati Bangkok office.

Above: The Japanese Imperial Army marches through Fullerton Square after having captured Singapore, February 1942. The fall of Singapore marked a key turning point in the Asian-Pacific theatre of World War II.

Right: T.D.S. Tyebjee and Abdultyeb Maskati leading their victorious racehorse, Mubashshir, after winning the Sargodha Plate, Division II, at Bombay's Mahalaxmi race grounds, 1 January 1945.

How to Dress Like a Thai: Prime Minister Phibul's Fashion Rules

In 1942, Thai Prime Minister Field Marshal Plaek Phibulsongkram led a new drive to modernise Thai fashions. Much of the fashion propaganda was delivered through a radio programme in which Mr. Man & Mr. Khong broadcast nightly dictates of style and colour. The presenters urged women to replace the *jong krabaen* with skirts, dismissing traditional styles as provincial. They also advised people to refrain from dresses that were too bright or colourful. Their effort was part of a nationwide campaign the Prime Minister had launched just before the start of the war that consisted of a series of *Rathaniyom*, or Cultural Mandates. By enforcing these mandates, he hoped to transition Thai society into a new and more modern era. Billboards depicted 'Thai Culture' by showing people the right and wrong way to dress. Men were encouraged to discard their *pha nung*, or sarong, for trousers and collared shirts. Women, many of whom still went topless in the countryside or simply wound a cloth around their torsos, were told to wear *pha sin* (tubular skirt) and tailored tops. A passage from Phibun's

National Cultural Maintenance Act of 1940: *'In public places or areas within the municipality people must not dress in improper manner that will damage the prestige of the country, e.g., wearing loose-ended sarong, wearing only underpants, wearing sleeping garments, wearing loincloth, wearing no blouse or shirt, women wearing only undershirt or wrap-around…'* Though the Prime Minister's Cultural Mandates were unpopular, the new era ushered in after World War II, saw the Indian *pha lai* – once so popular throughout the kingdom – fall out of fashion.

When Jawaharlal Nehru, (fourth from right), made a brief stopover at Bangkok's Don Muang airport in 1935, Badruddin A. Kapasi, (in long grey jacket), Managing Director of the Maskati firm's Bangkok office, organised a reception committee to greet him. Though the famous Indian nationalist leader was travelling from Indonesia to China and spent just an hour in Bangkok, thousands of Indians came to the airport to show their support.

Above right: A propaganda poster published when Field Marshal Plaek Phibulsongkram launched his Cultural Mandates. Entitled, 'Thai Culture', it clearly demonstrates how the government prohibited old-style dress (pictured on the left) and encouraged Thai citizens to wear more modern clothes (pictured on the right).

The day after new years day in 1945, Abdultyeb Maskati was at Bombay's Mahalaxmi race grounds. The horse he owned together with his friend, Amirudin S. Tyebjee was racing in the Stewards Cup. While the triumph of the day went to the Maharaja of Baroda, whose horse, Flashing Prince, won the Cup, Abdultyeb's horse pulled off a surprise victory. Aptly named Mubashshir (meaning the bearer of good news), pulled off a great performance for the Sargodha Plate, a one-mile second division race. Mubashshir was in sixth place when, just a furlong from home, the horse raced past the lead, Gold Mohar, to cross the finish line by one-and-a-quarter lengths.

Later that year, the war ended when an atomic bomb was dropped on Hiroshima on 6 August 1945 and resulted in an official surrender on 14 August and a formal signing on 2 September. Over the following weeks, the Japanese surrendered in Singapore, Burma, and elsewhere. As war-time restrictions on communication and travel were lifted, Abdultyeb began to hear news from his offices in Southeast Asia.

Badruddin A. Kapasi was able to send his first letter back to India on 17 September 1945, and Abdultyeb was thrilled to hear from him. He had been waiting anxiously, collecting titbits from returning Indians and trying to piece together the course of events in that region. Communications had already been established with Singapore and he knew that his offices and staff there had survived intact but was still waiting for news from Phnom Penh or, until Badruddin's letter, from Bangkok.

'*My dear Badruddin,*' begins Abdultyeb's reply. '*It was a great relief to get some news from you after a very long time. Thank God that you all have come out of the ordeal quite safely & feel happy that you will now soon be able to return to India and once again join your friends & relatives. I am glad to learn & I thank God for that [and] that all of you have done your best under the difficult times to safeguard the interest of the firm. I convey to you & to all our staff my thanks & appreciation of the way in which you have all shouldered the great responsibility and pray that in the final adjustments also we shall be overcoming such difficulties as would come in our way.*'

Turning to work, Abdultyeb writes, '*I think it will still take a very long time for business to start – unrestricted Export & Import is both controlled and under many restrictions.*' But he asks Badruddin to check whether the demand in Bangkok still exists for a large stock of cloth that the firm was unable to ship in wartime. He notes that rivals, Wasee and Malbari, were less patient and sold off all their remaining stock. Badruddin's reply is unrecorded but, if he responded affirmatively to the shipment of *saudagiri* to Bangkok, it would have been among the last such sales in Thailand for the Maskati company.

Keen to regenerate trade, Abdultyeb sent his stockpiled goods out of India as soon as it became feasible; he had accumulated bales of textiles that couldn't be transported from India during the war or sold in-country due to local restrictions imposed by the Textile Commissioner of the Government of India on the supply and sale of cloth in Bombay and Ahmedabad. In November 1945, he sent numerous bales of cloth to Suez and a month later, ten more bales went to Muscat and Aden. By January 1946,

Left: Letter to Badruddin A. Kapasi in Bangkok from Abdultyeb Maskati in Bombay, dated 29 October 1945. This letter was written in response to the first contact Abdultyeb received from Badruddin and his Bangkok office after being cut off during World War II.

Above: Singapore was the first stop on a tour Abdultyeb Maskati made of his Southeast Asian offices after being incommunicado for the duration of World War II. He is pictured here with his Singapore staff on 30 December 1946. Seated from left to right: H.A. Malbary, Abdultyeb Maskati, H.T. Attaree. Standing: T.G. Sarela, H.A. Khapra, T.R. Nair, A.H. Khirkiwala.

Right: Abdultyeb Maskati hosts Prime Minister Thawan Thamrongnawasawat (served as Prime Minister of Thailand from August 1946 to November 1947). The Prime Minister wears a black armband, probably marking the death of King Ananda (Rama VIII) in 1946, and is thought to be attending an event to mark 90 years of the Maskati business.

trade systems were beginning to recover as the total number of exports from Bombay reached a new high that had not been seen throughout the war years.

As affected countries around the world started to repair and rebuild damaged structures, ships were loaded with goods that had been missed while trade routes were blocked. Linseed dealers in Bombay supplied linseed to paint and varnish manufacturers in Hull, England, and Sydney, Australia. Bales of raw cotton were shipped to Liverpool in England and to Hong Kong. Machinery parts from Europe were shipped to India to fix machines that had worn down over the intervening years; one ship from Glasgow offloaded engineering parts and more than 18,000 fire bricks in Bombay. Abdultyeb continued to distribute his textile stocks but also added other goods to his trading roster. He sent 50 bags of turmeric to Mombasa in Kenya and 50 bags of dried chilli to Singapore. The Bombay shipping rosters – channeling trade from across the globe – was a concrete indicator of post-war recovery.

Abdultyeb focussed on reinvigorating his company in Southeast Asia and soon made a tour of the region's offices. Though his interests in the region had survived the war, India was about to face its own upheavals.

Over 14-15 August 1947, British India was divided into two independent countries: India and Pakistan. Created on the basis of religion, the division had tragic consequences as it spurred some 14 million people to flee in either direction, creating the greatest exodus in recorded history. Clashes broke out between Hindus from the regions that became West and East Pakistan (later Bangladesh) and Muslims travelling to those areas. Mass atrocities were committed on both sides and hundreds of thousands died. Bombay's sea-bound location and resulting cosmopolitanism saved the city from the worst violence of partition but many Muslims chose to leave and build a new life in Pakistan.

Abdultyeb Maskati was active in Muslim cultural

and charitable circles and had met the leading politicians of the day, such as Morarji Desai (Home Minister of Bombay, who became Prime Minister of India in 1977) and Muhammad Ali Jinnah, leader of the All-India Muslim League and architect behind the creation of Pakistan. According to family lore, Jinnah personally extended an invitation to Abdultyeb to move to Pakistan. Though Abdultyeb had a business in Pakistan, he had built his life and livelihood in Bombay – he had land, homes, and an office there, and he had no intention of giving all that up to start afresh in another country. Along with many among the city's Bohra business leaders, he planned to stay put. His son Rasheed Maskati remembers that his father flatly refused the offer, telling Jinnah, *'I'm not going to Pakistan. I am an Indian and I'm going to stay right here, in India!'*

In the years following World War II, the production of *saudagiri* – so dramatically interrupted by the global conflict – came to an end. The war had broken down the supply chains and Thailand's own production of *pha lai*, which had begun just before the start of the war, was quickly resurrected. With the changing mechanisms of trade and production, and modernising fashions, it made little sense for the Maskati company to continue producing *saudagiri*. In Cambodia, where there was as yet no local production facility and fashions had yet to change substantially, there was still a market for *saudagiri* (or *kien* as the cloth was known in the Khmer language), but soon this, too, died out in favour of Thai-produced varieties or more modern outfits.

In 1948, the Bangkok arm of the family firm was formalised and two private limited companies were established. A company was set up under the name A.T.E. Maskati Ltd., with a mandate to purchase, acquire and take over as a running concern the firm of Maskati, 'general merchants, importers, exporters and commission agents'. One of the Maskati shops, which had been known as the Gujarat Store of Bangkok, became the Thevaraya Co. Ltd., a companion company mandated to continue the business of general shop-keeping and retailing of both local and imported produce and products. From its original headquarters at Anuwongse Road, Bangkok, the company began its major shift into agricultural goods. The Memorandum of Association, drawn up in 1948, describes the items that replaced *saudagiri* and set the standard of trade for the coming decades. Key products listed included jute, maize, kapok, timber, ground nuts, seedlac, and cotton.

The company's staffing and management was still conducted in accordance with the habits and practices of an old trading firm. Many staff members became lifelong employees. One such employee was the company's Managing Director, Badruddin A. Kapasi, who had steered the company safely through the perils of World War II. He had come to Bangkok in his mid-20s to work for the Maskatis and had committed himself to bringing the company to the fore of Thai society; he became the first president of the India-Thai Chamber of Commerce and a member of the Rotary Club. When he died an untimely death in 1949, from bronchitis at the age of 45, his son Husamuddin B. Kapasi travelled from India to see to his father's affairs and later joined the company as well. Husamuddin, known as 'Mr. Kapasi', worked for the company until his retirement in the year 2000. The position of Managing Director was taken up by Tayebbhai M. Jeewabhai.

When Mr. Kapasi began working in Bangkok, the company was already quite a different concern to the one his father had overseen as its unique core product, *saudagiri*, had been replaced by agricultural produce such as rice, pulses, timber, raw jute, betel nut, dammar batu (a tree resin) and seedlac. Of these, one in particular supported the company through its transition from textiles to broader fields of trade. Raw jute was then indispensable in trading circles as it was used to make sacks that transported goods around the world. As Mr. Kapasi put it, *'Without jute [bags] we traders could not have done any business!'*

Left: Abdultyeb Maskati (second from left) with Muhammad Ali Jinnah (centre), the leader of the All-India Muslim League and architect behind the creation of Pakistan. Family lore has it that when Jinnah invited Abdultyeb to move to Pakistan, Abdultyeb responded, 'I am an Indian and I'm going to stay right here, in India!'

Jute: The Fibre of Trade

In 1955, the Maskati's Bangkok office began exporting raw jute to Europe and America. It was an industry that would become a substantial source of foreign exchange for Thailand, amounting to Baht 1.6 billion in 1966.

Jute was a quintessentially Indian product. It was grown in, and exported from, India under British rule. According to the *Hobson Jobson*, a dictionary of Anglo-Indian terms, the word jute is derived from the Sanskrit *juta* or *jata*, which referred to the matted hair of an ascetic or the fibrous roots of trees such as a banyan tree. It is a fibre of the bark of *Corchorus capsularis, L.*, and *Corchorus olitorius, L.*, which proved to be ideal for packing goods for transportation due to its durability and dimensional stability. Before the development of synthetic fibres, jute was the world's primary packaging material, used to make sacks and bags as well as backing carpets.

Jute proved to be another well-timed choice for the Maskati firm as 1955 marked the year that the worldwide market for jute began to grow by around 5 percent annually and global demand for jute peaked over the following decade. During those years, jute became a leading economic crop for Thailand and reached its peak in 1966 when 473,269 tonnes of jute was exported from Thailand.

A.T.E. Maskati Ltd. was among the first ten companies to set up the Thai Jute Association in 1960 and its then Managing Director, Zoyeb T. Kajiji, became a director of the association.

In the 1960s, the development of the synthetic resin polypropylene led to the decline of the jute market. As polypropylene was adapted for use in packaging, jute was gradually substituted by synthetic options.

Even with jute in decline, the country still claimed a large chunk of the global market: in 1970, Thailand was projected to supply an estimated 325,000 out of 845,000 tonnes of the world's jute, making it the second largest exporter in the world.

By the middle of the 1970s, the global market had fallen dramatically. With lowering demand and decreasing prices, Thailand's domestic production slowed further over the 1980s;

reduced from 203,000 tonnes at the beginning of the decade to 139,100 tonnes by 1991. By then, most jute was being produced for the local market and only 1,100 tonnes was exported that year.

Planted primarily in the northeast of Thailand, jute was laborious to grow and farmers ended up shifting to more profitable crops such as sugar cane, rubber trees, orchard fruit, and tapioca.

The Maskati business no longer exports jute, but has now become a consumer of the product. For some of the company's products – namely betel nut and seedlac – jute's organic nature and breathability still make it the best possible packaging material. Filled jute sacks piled high at the Maskati's Bangkok warehouses stand as a testament to old world ingenuity in the company's modernised supply chain.

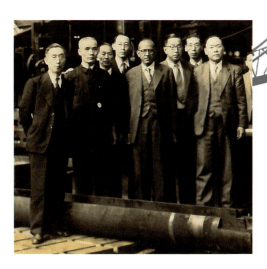

Under Abdultyeb Maskati, the founder's grandson, the family firm had experienced a period of gentle but definitive transformation; Abdultyeb had foreseen the coming changes in world trade and knew the business could not survive on textiles alone. In India, he modernised the company in preparation for the industrialisation that would sweep across Asia in the decades following World War II by incorporating engineering facilities and the supply of mechanical tools.

World War II had put a temporary halt on Maskati activities in Japan. Immediately afterwards, Japan was occupied by Allied powers led by the United States and it was not until 1952 that trade relations were re-established with India. While the Maskati's Kobe office was not maintained during the interregnum, the Japanese contacts Abdultyeb had established before the war were sustained and, on trips to Japan in the 1950s, he formed additional relationships with companies like Sakai Works (today Sakai Heavy Industries Ltd.), and Sumitomo Electric Industries Ltd., which would collaborate with Garlick & Co. to design engineering machinery for use in India.

The Singapore office, now based at Cecil Street, was also diversifying further by shifting its business interests from textiles to timber and other trading opportunities. It would later shift again, from trade to investments. When Abdultyeb visited the Singapore office in February 1951, a buffet party was held in his honour at the Raffles Hotel and the *Straits Times* newspaper reported that those in attendance included, *'legislative councillors, municipal commissioners, prominent local Chinese, European and Indian business magnates, the Representative of the Government of India, and their wives'*.

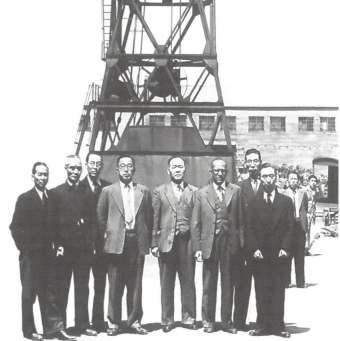

Opposite, left: These black-and-white photographs of jute being harvested, drying in the sun, and transported by boat were taken by Zilika Maskati's grandfather, Ariyant Manjikul, a professor of agriculture, while on a study trip in Chantaburi, Thailand.

Below & left: Though the Maskati office was not reopened in Japan after World War II, the Maskati firm continued doing business there after trade relations between India and Japan were resumed in 1952. Abdultyeb Maskati is pictured here with Japanese colleagues third from right beneath the crane and, inside the factory, he can be seen in the centre of the picture.

One Hundred Years in Business

In 1956, the Maskati family business celebrated its centenary in Bangkok, marking one hundred years since Abdul Tyeb Maskati first launched a small-scale venture that would eventually become a pan-Asian trading empire encompassing six countries and include a production line for hand-printed saudagiri in Ahmedabad. Celebrations were held at all Maskati branches. In Bangkok, the celebration was held on 22 January 1957, at Lumpini Hall in the city centre.

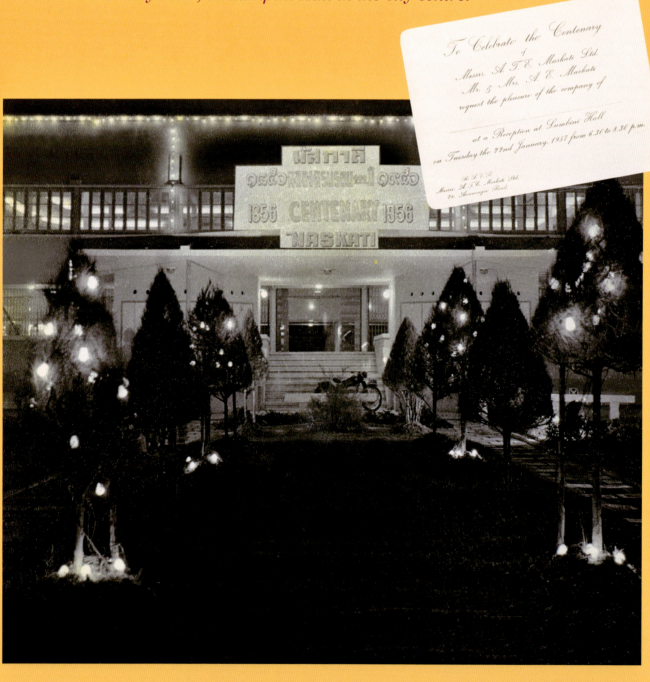

Opposite: The centenary celebration venue, Lumpini Hall in Lumpini Park, Bangkok, decorated for the occasion, and an invitation to the event.

Top left: A congratulatory letter from staff at the Bombay office, Maskati House.

Top right: Abdultyeb Maskati greeting guests upon their arrival at the Bangkok centenary celebrations.

Above: Maskati family members at another event in Singapore. From left to right: Shirin Maskati, a guest, Zaki Maskati, Ziya Maskati, Abdultyeb Maskati, Mrs. Attaree (wife of the Managing Director of the Maskati office in Singapore, H.T. Attaree), Zubeda Basrai, and Rasheed Maskati.

Left: At the centenary celebrations, Lumpini Hall, Bangkok. From left to right: Rasheed Maskati, Zoyeb T. Kajiji (Managing Director of the Maskati firm in Thailand), Shirin and her sister, Zubeda Basrai, Ziya Maskati, Zaki Maskati, and Abdultyeb Maskati.

PRUDENCE

PRUDENCE

The next generation of Maskatis was now ready to join the family firm. As Abdultyeb Maskati had done with his father, his own children went one step further than him in their education and all obtained college degrees. His eldest son, Rasheed, studied at the prestigious Doon School at Dehradun under its first headmaster, Arthur E. Foot. Rasheed's schooling was interrupted by World War II when the ship carrying his year's Senior Cambridge exam papers for marking in England was sunk en route. He later had to complete his matriculation at the Bradley Night High School and, despite spending more hours at Bombay's old Capitol Cinema watching movies than in the classroom, he went on to India's first college of commerce, Sydenham College of Commerce & Economics, and graduated second out of his class of 180 students.

Abdultyeb began taking Rasheed along with him on his business trips to Southeast Asia. By then, air travel had made the journey from Bombay much quicker and more convenient but it still involved multiple flights that landed first in Calcutta and Rangoon, Burma, before arriving in Bangkok. In 1950, Rasheed spent nearly half a year learning the ropes at the Bangkok office on Anuwongse Road. At that time of transition for the company, much of its business was being generated by the Cambodian office, where the textile trade was still going, but was also being expanded to include agricultural products such as rice and pulses. Rasheed would eventually take on the job of overseeing the Maskati interests on mainland Southeast Asia, travelling two or three times a year to Bangkok and Phnom Penh to meet with staff and do an annual audit of the accounting books.

Rasheed and his younger brother, Zaki, shared responsibilities for the family firm. Though Zaki often accompanied Rasheed to Southeast Asia, he also followed developments in India at Garlick & Co. and Rane Pvt. Ltd. (another company the family was involved in, dealing in auto parts), and managed investment portfolios for individual family members as well as the family's investment firm, Maskati Investment Pvt. Ltd.

Far left, above: Portrait of Rasheed Maskati, taken in Lucerne, Switzerland, 1937. Far left, below: Rasheed's younger brother, Zaki Maskati.

Left: Four generations of the Maskati family represented with portraits of the founder Abdul Tyeb Maskati and Esmailji Maskati on the wall. Abdultyeb Maskati is seated (centre) with Rasheed Maskati to the right. Maskati House, Bombay, circa 1950s.

Below left: Rasheed Maskati's graduation portrait. Rasheed graduated from India's Sydenham College of Commerce & Economics and was the first member of his family to obtain a college degree.

Below: Abdultyeb Maskati visiting his office in Phnom Penh, 1953. From left to right: A transporter who arranged for goods to be sent from Phnom Penh to Saigon and vice versa, Mr. Hu (Secretary), Essabhai Chinwala (Accountant in charge of property rent collection), Yusufbhai Khapra (Manager), Abtultyeb Maskati (seated), Imran Garari (Clerk, standing), Ahmedali Garuji (Assistant Manager), Fida-ali Khumri (Cashier), and Abbas Janati (the clerk whose story about daily life at the Phnom Penh office is featured on page 146).

A Traditional Bohra Wedding: Rasheed & Zahra

Over the period 11-15 January 1959, a traditional four-day ceremony was held for the wedding of Rasheed Abdultyeb Maskati and Zahra Dawoodbhoy Zaveri (top right). Reminiscent of grand weddings hosted by Abdul Tyeb Esmailji Maskati for his sisters and daughters in the nineteenth century, the ceremony involved numerous rituals designed to cement relations between members of the two families such as a meeting of four aunts, represented by one sister from each of the bride and groom's parents. Various family members supplied the elaborate clothes worn by the couple. Both the bride and groom separately paid respects to their new in-laws. In accordance with tradition, the bride was absent for the central nikah ceremony at which Zahra's father and Rasheed sealed the wedding vows (top left); in Islam, a marriage is viewed as a contract with the bride's father acting on behalf of the bride. Final festivities took place at Maskati Villa, the family home in Colaba, Bombay, where the couple still live today. Below left: Zahra with her new mother-in-law, Shirin Maskati. Below right: Abdultyeb and Shirin Maskati with the newlyweds.

At its peak, Garlick & Co. Pvt. Ltd. had a total of 1,300 staff, a foundry and factory in Bombay, and representative branches in Ahmedabad (at the Maskati Cloth Market), New Delhi, Hyderabad, Coimbatore, and Madras (now known as Chennai).

As a newly independent India explored and started to fulfil its post-colonial architectural identity, new construction and investment abounded. Garlick & Co.'s structural engineering department was well-positioned to take on large-scale projects. Among the machinery Garlick & Co. imported and assembled for large-scale industry were Electric Overhead Travelling (EOT) cranes capable of lifting up to 100 tonnes and, in technical collaboration with the British company, J.H. Carruthers & Co., single girder cantilevered monobox cranes used on construction sites. Additional products are shown in these images from a company diary (right). As new roads were laid across India, many were compacted by Garlick-Sakai vibrating road rollers, made with the Japanese heavy industries firm, Sakai. At the docks of the Bombay Port Trust, cranes provided by Garlick & Co. and mechanical hoists shifted heavy cargo on and off ships. The company's expertise and equipment help to establish new industries and to modernise the production lines of old ones, such as sugar, soap, and oil production. At the municipal level, Garlick & Co.'s foundry churned out manhole covers and fire hydrants that dotted the streets of Bombay. Garlick & Co. engineers designed structural steelworks that still hold up many of Bombay's buildings; among them the city's iconic art deco Eros Cinema.

In Bangkok, the company was also exploring mechanical and engineering opportunities. The office was now being run by the charismatic Zoyeb T. Kajiji, part of the closely linked Kajiji clan. Zoyeb was a trained engineer who had been a manager at Garlick & Co. in Bombay, along with his younger brother Abdemannan Kajiji, who became the Managing Director at Garlick. He later worked at Raziki, a Karachi-based trading firm Abdultyeb had named after his children (**Ra**-sheed, **Zi**-ya, and Za-**ki**). The company imported Noritake porcelain and other high-end items to Karachi but became impractical to run from Bombay during the bilateral tensions that followed partition. Abdultyeb handed the business over to a senior employee and Zoyeb moved to Bangkok where his engineering

background would guide the company in new directions.

As Abdultyeb's interests in India and Southeast Asia adapted to the uncharted post-war, post-colonial, and industrialising landscape of those regions, he maintained the early practices his grandfather had used to establish and expand the business. Though new technologies like the telephone meant that communication between countries was now instantaneous, he continued to maintain the practice of regular visits to all his offices, eventually passing the task on to his sons, Rasheed and Zaki. As his grandfather, Abdul Tyeb, had learned, establishing and maintaining trust between himself and his staff was essential to the company's prosperity. The offices in Southeast Asia were still divided along the old models with mostly rented shop fronts on the ground floor, a Maskati office on the first floor, and residences for staff and manager on successive floors. When Maskati family members visited, lunches were cooked and served in-house and the staff would gather for long sessions of accounting, business talk, and plenty of *got-pit sot-pit* (the great Gujarati tradition of endless chit-chat).

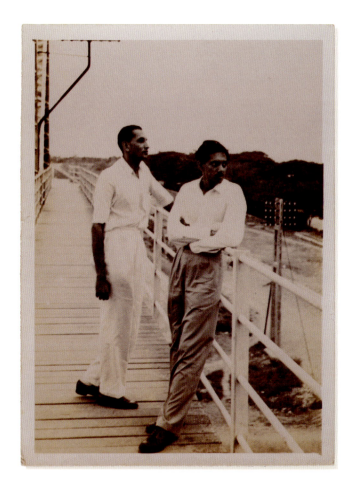

Opposite: A Garlick & Co. advertisement from the early 1960s and Zoyeb T. Kajiji with Rasheed Maskati in the field.

Above: Rasheed Maskati (second from left), Zoyeb T. Kajiji (second from right), and Zaki Maskati (far right), with employees of Garlick & Co.

Top: The inauguration of Garlick & Co.'s Alandur factory, Madras. Seated sixth from left is P. Jacob Peters (Regional Manager). To the right: Zarina Kajiji, Abdultyeb Maskati, Shirin Maskati, Abdemannan T. Kajiji (Managing Director), and Mrs. Peters. While Emran Kanthawala (pictured on page 141) managed the technical side of Garlick & Co., Abdemannan Kajiji managed commercial and administrative matters. He remained at Garlick for a few years after it was sold and then went on to manage Rane Pvt. Ltd.

Abdultyeb Maskati's reformist beliefs were applied both to wider society and to his own household. While his daughter, Ziya Maskati, was growing up, the Bohra community in Surat was very traditionalist in its interpretation of female roles within the family and the family car had 'purdah curtains' installed in the back seat, which female occupants drew closed when they travelled through certain neighbourhoods where purdah was maintained. Abdultyeb, however, did not uphold such constraints and, having been a long-time supporter of education through the Young Men's Bohra Associaton (see pages 93-95), treated men and women as equals and ensured that Ziya received the benefits of a full education.

Ziya completed her Senior Cambridge exams at Queen Mary's High School and spent a year studying the arts at Sophia College before spending two years at the Le Manoire finishing school in Lausanne, Switzerland, alongside girls from England, Italy, Germany, and the United States. She completed her studies at the Siddharth College in Bombay where she graduated in Philosophy and French. After her graduation, Ziya became interested in social work and joined the Bombay Presidency Women's Council (now known as the Maharashtra State Women's council) and later the Women Graduates Union, which celebrated its centenary in 2015 and is one of the oldest women's organisations in India. Ziya went on to become President and Trustee of both organisations. Ziya was also Secretary of the School Board at the Anjuman-I-Islam Girls School in Bombay. Her father had been president of the Anjuman-I Islam education institution from 1941-1944 and, in keeping with his belief in education for women, had supported the Anjuman-I-Islam Girls School during its early years. When the school started in 1936, it had just three pupils. Within two years, it was teaching 40 girls and needed larger premises, which were realised through funds provided by the Nemtullabai Trust for a new leasehold property. As Secretary of the School Board, Ziya oversaw the school's continued expansion; by 1956, the Anjuman-I-Islam Girls School was capable of holding 20 classes simultaneously and had 1,000 girls enrolled in primary and secondary education.

The Maskati Charitable Properties Trust continued to provide medical assistance to Surat through contribuutions for the construction of a new building for the municipal hospital, then known as the C.F. Parekh Dispensary. The new building was opened on 26 June 1954 by Morarji Desai, then Bombay's Chief Minister.

Far left: Ziya Maskati, the only daughter and middle child of Abdultyeb and Shirin Maskati, often accompanied her father on his business trips to Southeast Asia. She is pictured here with him and his colleagues in Phnom Penh, Cambodia.

Left: The Maskati family at Maskati Villa, Colaba, Bombay. From left to right: Rasheed, Ziya, Shirin, Zaki, and Abdultyeb Maskati, circa early 1950s.

Opposite, below right: Morarji Desai (right) presides over the opening of a new building funded by Abdultyeb Maskati (left) for the C.F. Parekh Dispensary, a municipal hospital in Surat (pictured below), 1954.

Garlick & Co's Chief Engineer

In the 1960s, the engineering side of Garlick & Co. was run by one of its joint Managing Directors, Emran Kanthawala, a grandson of the founder, Abdul Tyeb Maskati, and cousin of Abdultyeb Maskati. Emran studied electrical engineering at Faraday House in London and, during his time at the helm of Garlick & Co., oversaw significant achievements, such as: building the infrastructure and framework for India's sugar industry; numerous turnkey projects to install complete air-conditioning and cold storage systems; and the provision of 90 percent of mobile cranes operated on rail systems at the Bombay Port as well as the introduction of the first heavy-lift floating crane in India for use by the Bombay Port Trust. He also designed and oversaw the construction of the company's main factory at Ambernath near Bombay. He is pictured here giving his farewell speech in 1972, with his glamorous wife, Rehana Kanthawala (nee Mogul), who is descended from both Abdul Tyeb Maskati (through his second wife) and Abdulali Mogul, who first urged Abdul Tyeb to venture to foreign shores.

In September that year, the President of the Surat Municipality, Gordhandas Ranchhoddas Chokhavala, described the hospital in the *Times of India*: '*The municipality has an up-to-date and well equipped hospital called Maskati Charitable Hospital with 42 beds and special rooms for inpatients. It was constructed out of a magnificent donation of Rs. 3 lakhs' securities by the Maskati Charitable Properties Trust and municipal funds at a cost of Rs. 4,22,000. It is extensively taken advantage of by the inhabitants of the city and the district and it has proved a blessing to the ailing patients. It has established its reputation as one of the leading hospitals on this side of the country.*' The hospital remains operational and continues to be run by the Surat Municipal Corporation.

Meanwhile, the building that housed the nearby Maskati Charitable Dispensary and Maternity Clinic has fallen into disuse. Unable to keep pace with larger hospitals and increasingly professionalised medical services, the Clinic was gradually wound down, functioning for some years only as a homeopathic dispensary to administer medicines, advice, and referrals to patients from the surrounding community.

In the 1960s, Abdultyeb Maskati was diagnosed with Parkinson's disease and his health began to deteriorate. On 21 June 1972, he passed away at his home in Bombay.

Abdultyeb's career spanned the first three quarters of the twentieth century, during which time he transitioned his family's firm from an old-world trading company and producer of hand-printed textiles to a conglomeration of companies able to meet the changing demands and relentless industrialisation of a very different world. He had weathered many storms and steered the firm through challenging periods that included the region-wide upheavals of World War II. It was said among his contemporaries that he had the ability to turn dust into gold. His success was attributed to his uncanny business acumen – his knack of knowing the right people to hire, the right import licenses to procure, and the right time to launch new products or businesses.

Mohsin Contractor, Senior Partner of the accountancy firm CNK & Associates, LLP (the successor of H.M. Contractor & Co., founded by his father, Huseini Contractor, a contemporary of Abdultyeb), whose family has advised the Maskatis for three generations, says that, while Abdultyeb's astute business sense was indispensable, it was his honesty and integrity that assured the longevity of his company: *'First and foremost, he was highly trustworthy and – in a world where this is not true of everyone – it was a highly appreciable value.'*

Abdultyeb held several directorships, including at one of the Godrej companies, Cipla (one of India's leading pharmaceutical companies), and Western India Vegetable Products (today known as Wipro and now a major IT company).

The values Abdultyeb practiced in the business world also extended to how he treated his staff. When Garlick & Co. suffered a setback in the mid-1950s, the company listed the names of staff who would have to be laid off on its notice board. Abdultyeb went immediately to the headquarters at Jacob's Circle and ordered that the lists be taken down. Jamil Merchant, who worked at Garlick & Co. later says that staff members at the time recalled Abdultyeb announcing, *'These lists aren't necessary. Until we make a profit again, all those staff salaries will be paid from my own account.'* It was an echo of the steps taken by his grandfather, Abdul Tyeb, to redress any errors in the company accounts with money from his own pocket and it showed that the bonds of trust ran both ways.

When the *Times of India* reported Abdultyeb's death, the newspaper described him as a *'well-known businessman and industrialist'* as well as a *'reformer and a prominent member of the Dawoodi Bohra community, known for his many charities'*. Like his grandmother before him, Abdultyeb had maintained a lifelong commitment to charitable causes both in India and abroad. He was

Adventures Amid the Ruins

In 1951, Ziya Maskati accompanied her father, Abdultyeb Maskati, on a trip to Indochina. They flew via Calcutta on the now defunct airline BOAC (British Overseas Airways Corporation). Ziya had recently read *Le Roi Lépreux* by Pierre Benoit, a French novel set in the ancient Cambodian kingdom of Angkor, and insisted on visiting the ruins of Angkor. Her father acquiesced despite the fact that the First Indochina War had spilled over from the borders of Vietnam into Cambodia and the road from Phnom Penh was plagued by guerilla fighters. Due to the dangers, they had the luxury of being among the only visitors at Angkor.

Sunday Gatherings: Family Get-Togethers

At Maskati Villa in Colaba, the extended Maskati clan – Abdultyeb Maskati's children, cousins, in-laws, and close friends – assembled each week for get-togethers known as the 'Sunday gatherings'.

Instigated and perpetuated by Shirin Maskati, wife of Abdultyeb Maskati, the Sunday gatherings were a regular event at Maskati Villa in Colaba. While Shirin ran the household, these were semi-compulsory events for the immediate family and close friends. Beginning late morning each Sunday, the Sunday gatherings at Maskati Villa often started with drinks in the living room and shifted to the garden where participants reclined on mats beneath the *chikoo* (sapodilla) tree. On rare occasions, a small fire was lit beneath a flat, black stone upon which thin slices of meat were grilled; the fragile stone, procured from Jeddah, provided a particular smell and flavour that made it worth the effort and the wait. The gatherings, held since the 1940s, petered out after Shirin's death on 13 January 1994 and now happen rarely.

Opposite, left: The Maskati family at the causeway to Angkor Wat with Abdultyeb Maskati sitting centre. Opposite, right: Family members at the royal city of Angkor Thom, Cambodia. From right to left: Ziya Maskati, her mother Shirin Maskati and Shirin's sister, Zubeda Basrai.

Above: Zahra Maskati is pictured right of centre bending over to organise the food. Seated to the left is Shirin Maskati, circa 1960s.

Left: 'Sunday Gathering', early 2000s. Seated back row, left to right: Bilkish Bhatri, Abdemannan Kajiji, Zarina Kajiji, Rasheed Maskati, Ziya Maskati, Pushpa Sethna, Zahra Maskati, and Rachani Kajiji. Seated on the floor, left to right: Rezoo Joseph, Niloufer Kajiji (front), Shabbir Basrai, Azra Goriawala, Nabil Shamoon, Aidoon Kajiji, and Rahil Bhatri.

Bottom left: family members gathered around an informal thaal meal (see page 155). Bottom right: 'Sunday Gathering', July 1969. From left to right: Emran Kanthawala, Dr. Nakhooda, Hasani Bhatri (front), and Abdemannan Kajiji.

> **A Wonderful Life: Homage to the Late Mr. Maskati from the Baha'i Centre of Thailand**
>
> 'Mr. Maskati detested publicity and refused always to attend any meetings wherein people wished to express their gratitude for his magnanimity, yet today under sad circumstances we have to gather and express our admiration for the wonderful life he led, benefitting those who he thought needed his help. We offer our heartfelt condolence and request that his Bangkok Office convey our deep sympathy and prayer to Mrs. Maskati and her sons and daughter and may God give them courage to bear this irreparable loss and guide them to further his aims and objectives and carry on and multiply the noble work he did. Since all good actions are rewarded into Eternity we envy the spiritual wealth Mr. Maskati is now endowed with in the world beyond.'

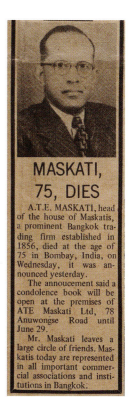

president of the Anjuman-I-Islam, or the Association for the Service of Islam, for two years, and served on the committee of the Muslim Educational Service League.

The list of sponsors for his memorial service in Bangkok, which included both business and cultural entities, shows just how wide his interests and commitments stretched. Among business sponsors were the Bangkok Stock Exchange, the Board of Trade of Thailand, and the India-Thai Chamber of Commerce together with trade associations like the Thai Jute Association, the Thai Lac Association and the Thai Maize & Produce Traders Association. Religious and cultural charities included the Foundation for Islamic Centre of Thailand and the Hindu Samaj as well as the Thai-Bharat Cultural Lodge and the Thai Muslim Women Foundation of Thailand.

Rasheed Maskati continued to visit the Phnom Penh office during the 1960s but, towards the end of that decade, the visits became increasingly dangerous. The United States was enmeshed in the Vietnam War and Cambodia had been drawn in to its theatre of war. Aboard one BOAC plane that landed in Phnom Penh, Rasheed and other passengers were ordered to kneel in the aisles when shooting broke out around the airport. On other flights, the pilot barely took the time to idle on the runway and passengers had to dash across the tarmac to the terminal building.

By 1973, the war had come to Phnom Penh. The American bombing of Cambodia, aimed at breaking the north Vietnamese army's supply chains, built up huge resentment in the rural population and strengthened the communist forces of the Khmer Rouge that were massing in the countryside. Indian residents of Phnom Penh began leaving Cambodia and in early 1974 India closed down its embassy there. The Maskati office stayed put on Ohier Street, maintaining a nightly blackout with all staff inside the office by sundown and through the night.

Then, on 17 April, 1975, the black-clad army of the Khmer Rouge marched into Phnom Penh and declared Year Zero. Businesses and homes were abandoned overnight as the Khmer Rouge forcibly evacuated the city and marched its inhabitants into the countryside to set up communal labour camps and rebuild the country according to the extreme vision of its leader, Pol Pot.

The new rulers made it clear from the beginning that foreigners had no place in Cambodia. Along with

Opposite: This late portrait of Abdultyeb Maskati (19 July 1899-21 June 1972) is thought to have been taken by his son Zaki, who had a great passion for photography.

> ### *Recalling Indochine*
>
> *Abbas Janati began working at the Maskati firm in Phnom Penh, Cambodia, in 1948. He saw Maskati textiles replaced by other textile products such as blankets, cotton yarn, calico muslin, and white linen. Later, the company's importation stock list was expanded to include electrical equipment – radios, light bulbs, refrigerators, televisions – and exported Cambodian agricultural products like white & black sesame and mung beans. By chance, Abbas happened to be on home leave in India when Phnom Penh was taken by the Khmer Rouge.*
>
> 'Life in Phnom Penh in the 1950s and early 1960s was very quiet and very pleasant. The city was so peaceful back then. We lived and worked in the shop-house [on Ohier, later Ang Eng, Street], had a siesta at midday that lasted till 2:30, and then worked again from 3pm until the evening time. We were wholesale traders. Our imported goods were sold to smaller Chinese traders who distributed them in shops around the country. They came to our office and ordered whatever goods they wanted; we kept samples for them to look at in the office but most goods were stored in a godown. We were successful because we had the license for products that were popular in Cambodia. We never took any loans from the bank. We always maintained good capital. The Maskati business also had many properties rented out to the French. There were not many other Bohras in Phnom Penh and during Ramadan, they would gather at our shop for evening meals. Everything changed when the troubles started. After 6pm, we couldn't turn any lights on and we couldn't go out [due to a nightly curfew]. We often heard shooting on the other side of the river. In 1974, I left on home leave to India and while I was there the Khmer Rouge cleared out the city. After that, it was all over. I never returned to Cambodia.'

other remaining foreigners, 33 Indian nationals sought refuge at the French embassy and were evacuated to Thailand. Four remaining members of the Maskati staff were among those who took shelter at the embassy and arrived safely at the office in Bangkok some days later.

The Khmer Rouge takeover of Phnom Penh had been so sudden that the staff had been unable to pack up the office, though they emptied the safe and carried as much remaining cash as they could. In Bangkok, they handed the cash – all that remained of the company's assets in Cambodia – to Zoyeb T. Kajiji. As Pol Pot's Year Zero marked the complete destruction of Cambodia's economy, the notes were ultimately worthless and Zoyeb later handed the cash to family and staff as a memento. One member of staff dutifully locked up the office building in Phnom Penh and later presented the key to the Maskati family in Bombay. As the Khmer Rouge confiscated all properties and shutdown all business, the key would be the last remnant of the Maskati business and properties in Cambodia.

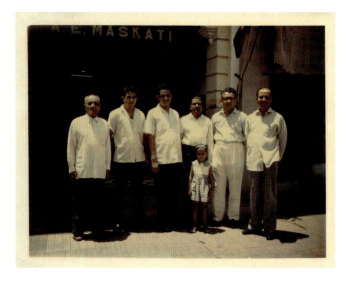

One of the last remaining pictures of staff taken outside the Maskati office in Phnom Penh, Cambodia, circa the 1950s. After the Khmer Rouge seized Phnom Penh in April 1975, the staff fled to safety in neighbouring Thailand and the firm was unable to salvage any of its assets. Abbas Janati, whose story is highlighted above, is pictured third from left.

The year Abdultyeb Maskati died, the family decided to sell Garlick & Co. Pvt. Ltd. Rasheed Maskati invited his good friend, Satish C. Malhotra – a former Doon School graduate and Chairman of Empire Industries Ltd. – to take over the company. There was no protracted negotiation; the two men struck a deal, the company changed hands, and Rasheed was appointed a director of Empire Industries Ltd.

By then, Garlick & Co. had moved its main foundry from Jacob's Circle to a large plot of land at Ambernath, just outside Bombay. To meet changing demands and technologies, Satish Malhotra ended up closing down the foundry, which was then still operated manually. After streamlining operations, the main division of Garlick & Co. to be developed, and that still survives to this day, was its goods trading division, which imported machine tools from Europe.

At the time, licenses to import goods into India were hard to come by. Under Prime Minister Indira Gandhi's socialist policies, severe restrictions were placed on imports and the activities of all businesses were greatly curtailed. Her government nationalised the country's major banks and insurance companies and imposed wealth taxes. In 1970-71, there were 11 brackets of personal income tax with the tax rates progressively rising from 10 percent to 85 percent. When a surcharge of 10 percent was taken into account, the maximum marginal rate for individuals was a mind boggling 93.50 percent. In 1973-74 the highest tax rate applicable to an individual could have gone up to an astronomical level of 97.50 percent. In this economically constrained environment, the black market flourished and inflation rose over 30 percent within the five-year period of 1969 to 1974.

The Maskati firm still operated some licenses via its companies, Kosmochem and Rane Pvt. Ltd. Kosmochem was founded in the 1970s by Rasheed Maskati and his friend and contemporary, Tyebjee Anik. Initially linked to the German pharmaceutical firm, German Remedies, Kosmochem later imported medical supplies for distribution to hospitals in India. Rane was an auto spares and parts trading firm, in which T.M. Kajiji (father of Shirin Maskati) had invested along with the Rane family. Rane imported various spare parts from a few key sole agencies (such as the Ucal Group and the Pentafour Group) that were required to keep a vehicle on the road, from brake liners and mechanical hydraulic jacks to garage tools. Business was especially good in the years following World War II, as Aidoon Kajiji, whose father, Abdemannan Kajiji, ran Rane for some time, recalls, *'It did well because that was the time when India only had two cars – the Ambassador and the 'Fiat' so if anyone wanted spare parts they had to come to us!'* In its heyday, it had branch offices in Delhi, Madras (now Chennai), Ahmedabad, Secunderabad, and Bombay (now Mumbai). Today, the Kajijis have exited Rane and the business is run by the current Managing Director, Jamil Merchant (who is descended from the founder of the Maskati firm, Abdul Tyeb Maskati, through his first marriage), and the Maskatis.

During these difficult years, prudence and preservation of capital were the watchwords, though Rasheed Maskati tried his hand at various other small businesses: Sarnaz Dairy and Cattle Breeding Farm based in Gujarat; Dye Sento Ltd. set up at the industrial township of Udhna, near Surat in Gujarat, to manufacture chemicals and dyes; Favourite Tex Dyes, Plynet Traders Pvt. Ltd., and another proprietorship by the same name, Plynet Traders, that traded in plywood, wood products, and zinc sheets. Tyebji Anik, who founded Kosmochem with Rasheed, recalls that Rasheed was always open to new ideas and suggestions from friends: *'He was always doing favours for his friends and he liked to help them out by investing in their companies.'* While most of these businesses failed, the venture into plywood succeeded for a while. Rasheed later acquired the agency to market ply products from Bhutan Board Products Ltd. of Bhutan and the firm also did well manufacturing plywood drums for specialised uses.

Meanwhile, Abdultyeb Maskati's youngest son, Zaki, took a controlling interest in a venerable old company called D.C. Oomrigar & Co. Pvt. Ltd. The company had been started by the Oomrigar family and at the time Zaki took ownership control, the main business of the firm was its licence to import fine alcohol, such as Remy Martin, for hotels and retail consumption. However, in the late 1980s, the Indian economy began to liberalise and, when Prime Minister Narasimha Rao removed the requirement of licences for numerous businesses in the early 1990s, these included the importation of alcohol. As international spirits companies were then able to supply directly to hotels and the retail trade, D.C. Oomrigar became a dormant company.

In the late 1970s, Rasheed and Zaki supported Huned Karwa in starting Mascom Electronics. Mascom started with an agency to market dot matrix printers manufactured by Godrej & Boyce. The business later grew to include dumb terminals (to connect to mainframes and mini-computers – the personal computer not yet having arrived) and modems. With the introduction of personal computers by IBM, Mascom started selling unbranded, assembled PCs. As business grew, it was spun off into a separate private limited company. However, in the mid-1990s, the Maskatis divested themselves of this business and the firm was taken over by Huned Karwa.

The Maskati brothers stuck to a well-established daily routine. At 10am, Zaki would drive with Rasheed to the office at Maskati House on Mohammedali Road and monitor the investments, while Rasheed worked on incubating his various businesses. At 2pm they both returned home to Maskati Villa for lunch and a short afternoon siesta. Later in the afternoon, Zaki drove over to the Rane office while Rasheed either returned to Maskati House or attended board meetings of companies in which he was a director (in addition to Empire Industries, these included the Bombay Mercantile Cooperative Bank and Forbes Forbes & Campbell, a Tata Group

The 'Socialist' Lifestyle

The 1970s and 1980s in India, marked by severe economic restrictions, resulted in a very particular lifestyle; one that was characterised by queues and by waiting.

Cars: Buying a car could involve a ten-year wait. Sakib Maskati recalls going with his uncle, Zaki, to take delivery of a Fiat Premier Padmini car booked for purchase about a decade earlier. On the drive home, Zaki remarked that he had better make a purchase booking for the next car so that it would arrive before one in his fleet had to be scrapped.

Telephones: Applying for a landline could take up to five years. Once connected, service was unreliable and the telephone repairman became a necessary "friend" to cultivate with Divali and other festive *baksheesh*.

Televisions: A television was considered a luxury and the first one at Maskati Villa was a nine-inch black-and-white Sony portable. Reception was poor; to get a clear picture the antenna had to be adjusted and pointed in different directions depending on atmospheric conditions. Even then, the picture was never especially clear; watching cricket was a challenge as the ball was barely visible and the cricket players could be identified only by the way they walked on the field. Upgrades were few and far between, and the Maskati's first colour television only arrived in time to watch the Asian Games held in New Delhi in 1982.

company). He was also the Managing Director at Kay Distillery, a subsidiary of Forbes, and travelled on the Punjab Mail train once a week to the distillery at Nasik. At the end of each working day, Zaki would invariably end up at the Cricket Club of India (CCI) for an evening drink with his friends, before returning home for dinner.

Though the Thai economy was still overwhelmingly driven by agricultural pursuits, with agricultural produce amounting to some 90 percent of total exports, between 1965 and 1990 it became one of the fastest growing economies in the world. Over the short span of just a few decades, the country was transformed from a traditional, rural-based economy to a modern, industrial economy.

In addition to the natural produce that the Maskati firm was exporting from Thailand at that time, such as rice, betel nut, and timber, the company imported cotton bales from India and Pakistan to supply raw cotton to the burgeoning Thai textile industry.

During those years, many Indian enterprises were also interested in expanding to Thailand and Maskati House in Bombay became an obvious starting point for establishing a commercial link between the two countries. With more than a century's worth of experience and connections in Thailand and across mainland Southeast Asia, the Maskati business made introductions and provided assistance to numerous Indian companies including the Thai-India Steel Company with the Patel Group, Usha Siam Steel with the Jhavar Group, and the Aditya Birla Group, which set up the publicly listed companies Thai Rayon and Thai Carbon Black, as well as the synthetic textile company, Thai Acrylic Fibre. The Maskati's Bangkok office also imported familiar Indian brands to Thailand, namely, Emery India, Usha Wire Rope, Texmaco, and Godrej safes (see page 117).

Above right: Cover of Business in Thailand *magazine, August 1977. The Maskati firm is one of the oldest in Thailand; launched in 1856 it is still operating today.*

Right: Advertisement for the Maskati business showing how the company's core business was transformed from its early days of importing pha lai. Business in Thailand, *August 1977.*

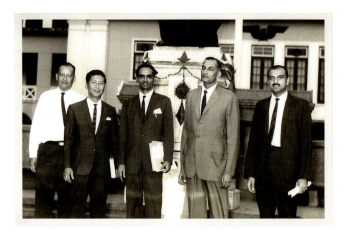

Alongside Thailand's industrialisation came the need to provide comprehensive and consistent connectivity between distant parts of the country through the provision of more roads, railway lines, and electricity. Making use of Zoyeb T. Kajiji's engineering background, A.T.E. Maskati Ltd. began bidding for power trans-mission line projects with the Electricity Generating Authority of Thailand (EGAT). To convince Thai author-ities to use Indian manufacturers, EGAT representatives were invited to witness demonstrations that proved the reliability and tenacity of equipment provided by the EMC Company. One such tender was secured after a demonstration showed how a transmission tower would withstand stormy conditions; to simulate the extreme winds of a monsoon storm, the transmission equipment was placed on a large vibrating platform and continued to work despite being violently jolted around. Other infrastructure projects taken on at this time included the provision of electrical equipment to provincial electricity authorities, road-making machinery to the Royal Irrigation Department and Royal Highway Department, and the procurement of railway tracks and track components.

Nanda Basu, who has worked at the Maskati firm in Thailand since the 1970s, recalls that adaptability was key during this period of modernisation for the country, and for the company. Though the company could see the huge potential for all kinds of machinery in a fast-industrialising society, not all efforts were successful; a later project to import textile machinery overestimated its market and was eventually shut down. Other endeavours proved more enduring, such as the establishment of a department to supply the chemicals – ferrous and non-ferrous alloys – needed by foundries and steel mills as well as other products required for the optimal operation of specialised machinery such as insulating oil for transformers and rubber lining for ball mills. As Basu says, *'We were traders then, not manufacturers. We examined the market carefully and we assessed the current needs. When a product went down, we simply thought of something new. If it went up, we were happy!'*

All this was achieved against the backdrop of the Vietnam War, which had repercussions for countries across Southeast Asia. As the war spilled over into Cambodia and Laos, Thailand experienced the rise of a communist insurgency active in the north and northeast. Political pundits predicted that Southeast Asian countries would fall to communism one by one, like a pack of dominoes. This, in turn, had serious repercussions for the Maskati business. After losing all its assets and properties in Cambodia when Phnom Penh was taken over by the Khmer Rouge, the company was cautious in its dealings in Southeast Asia and chose that time to sell many of its properties in Thailand and Singapore. The shop-houses in Bangkok that had been rented out to other traders were sold and today only one row of three connected shop-houses remains (see page 152). Though Thailand's communist insurgency ended in the early 1980s and the country never did succumb to communist forces, the spectre of Cambodia's tragedy loomed large over business decisions made during that time.

A Legend in Bangkok

Managing Director of A.T.E. Maskati Ltd., Zoyeb T. Kajiji, (pictured far right), is credited not only with overseeing the introduction of an engineering arm to the Bangkok firm but also with raising the company profile beyond the close-knit community of Muslim Bohra traders. Zoyeb was Managing Director from 1953 until the late 1980s, when he assumed the role of Chairman. He was a dedicated, hardworking and charismatic man who, like his cousin, Abdultyeb Maskati, was active in many businesses and cultural and service associations in the Thai capital. Following in the footsteps of Badruddin A. Kapasi, he joined the Rotary Club of Bangkok (a membership continued today by his son-in-law, Ateeb Maskati). Yunus Mogul, great-grand-son of Abdulali Mogul who began the business with Abdul Tyeb in the 1850s, observes, '*He was the right man for the job – the name Kajiji was a legend in Bangkok.*'

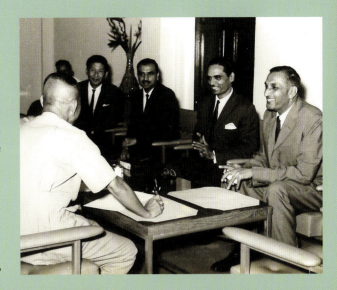

Blessing the Account Books

As long as can be remembered the Maskati firm maintained the tradition of old trading houses and businesses to bless the new account books of each fiscal year during India's annual Divali festival, also the start of the Hindu New Year (known as Chopadi Pujan, literally, '*blessing or praying over the account books*').

Maskati family members, together with their cousins from the Kajiji and Kanthawala families, visited the office to perform a Hindu ritual over the new account books that involved offerings of dried coconut, betel nut leaves, and betel nut. The tradition was adopted because the financial year was originally set to the Hindu calendar and the accountants employed at the firm were Hindu; Muslim participants did not follow the actual Hindu tradition of blessing the account book but wrote a blessing in Arabic from the Koran. For the first entry of each book, a family member wrote down an amount of money to be donated to charity, and so the financial year began with a conscious act of kindness.

The ceremony was attended by all employees and it was traditional to serve ice-cream after the snacks (a much-anticipated treat). Afterwards, each attendee received an envelope with a token amount of 'good luck' cash. For the youngsters,

the highlight came after the ritual was over and they went over to Maskati Villa in Colaba to light Divali fireworks.

The dates of the financial year no longer coincide with Divali and, in recent years, the tradition has faded out in India though it is still conducted at the Maskati's Bangkok office.

Opposite, left: Zaki Maskati (left) and Zoyeb T. Kajiji (behind right) greet an official at the Railway Ministry of Thailand, Bangkok.

Opposite, right: Zaki (far right) and Zoyeb (second from right) photographed with colleagues in front of the Ministry.

Above: Ziya Maskati is pictured blessing the account books, Bombay, India, circa 1960s.

A Short History of Number 45 Anuwongse Road

The original office-cum-residence of A.T.E. Maskati Ltd. stood at 45 Anuwongse Road in Bangkok's Chinatown. The wood and mortar structure had space for shop-houses rented out on the ground floor and maintained offices and residences for staff on the first and second floor. In the 1970s, the original building was demolished to make way for a more modern eight-storey structure (pictured right) that would serve as a residential complex for staff and family members. The Managing Director, Zoyeb T. Kajiji, lived with his family on the 7th floor. When Rasheed and Zaki Maskati visited the Bangkok office, they would stay on the 8th, or top, floor. In 1987, when Rasheed's son, Ateeb Maskati, moved to Bangkok, he also inhabited the top-floor residence, and was later joined by his wife, Zoyeb's daughter, Zilika, and their young family.

Managers who came from India to work for the company were provided with accommodation in the building and a Thai cook was trained to make favourite Bohra dishes.

The main office had for some decades been located at the nearby site of 78 Anuwongse Road (pictured above, with Zaki Maskati in the foreground). Built on land rented from the Crown Property Bureau it was replaced with a new building in 1997, with permission from the Bureau. Always crowded, Chinatown has become even more congested and the company had to lease warehouses elsewhere to hold its stock. Unsatisfied by his ability to control quality and safety from a distance, Ateeb Maskati decided to integrate warehousing and offices at a new and much more spacious site at Nakorn Pathom, on the western outskirts of Bangkok. The Maskati family has also since left its Chinatown residence in favour of a riverside condominium and, with staff now hired locally, 45 Anuwongse Road awaits a new purpose. One floor of the building remains in use by Zilika Maskati for her company, Flavours of the Orient; the ground floor continues to be rented out.

Shop-houses of Old Bangkok

This row of three shop-houses on Rajawongse Road was purchased by the Maskati firm in 1915. Part of a longer line of identical shop-houses and located just around the corner from the Maskati offices at Anuwongse Road, the shop-houses were rented out to local businesses and traders. Though neighbouring buildings have been transformed into taller and more modern structures, the company has renovated the shop-houses and restored their original facades.

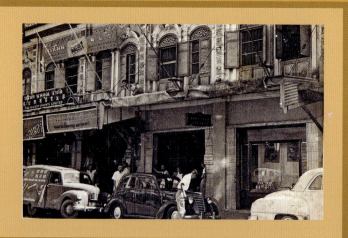

Life on His Own Terms: Zaki Maskati

When friends and family describe Zaki Maskati, the youngest son of Abdultyeb Maskati, they all use the same phrases: fun-loving, uninhibited, adventurous, out-going, charismatic. Zaki died 16 September 2000 but the way he lived his life is unforgotten by the Maskati family.

Even as a young boy Zaki was a voracious reader of magazines. His father subscribed to *Life* magazine when it was a news weekly and Zaki was a regular visitor at the United States Information Service (USIS) library in Bombay, borrowing other magazines to feed his insatiable curiosity. Later in life, he subscribed to *Popular Mechanic*, *Time*, *Newsweek*, *National Geographic*, and *Architectural Digest*. He also consumed business magazines that helped him make astute decisions about the family's financial investments and, each week, he devoured *The Economist* magazine cover-to-cover. 'He was well-read and very, very smart,' says his cousin Bashir Karachiwala. 'He was always learning about new things going on in the world. He was always finding things out, and he could talk to anyone about practically anything.'

Throughout his life, Zaki socialised with people from all walks of life – he was as comfortable talking to a labourer as to a CEO. For this reason, he was popular with staff at the Maskati family firm as well as with a broad swathe of Bombay society. A life-long bachelor, when he wasn't travelling for business he could be found most evenings chatting with friends on the lawn of the Cricket Club of India (CCI).

Zaki studied engineering at St. Xavier's College in Bombay and, through regular office visits, kept abreast of developments at the Maskati's engineering firm, Garlick & Co., and the family investment in the automobile parts supplier, Rane. Says his cousin, Bashir, '*He knew everything about engines and was able to take a car engine completely apart and rebuild it.*' In addition to his passion for cars, Zaki had other diverse interests. He collected sculpture and art, and was especially fascinated with miniature paintings. He loved photography and its evolution, from 8mm movies to polaroid cameras, Pentax SLRs, and the first Sony handycam. He also had a great passion for flying and became a qualified pilot at the Bombay Flying Club.

Well-dressed when necessary, with a cravat and matching handkerchief, Zaki was most often seen in casual dress and he rarely missed a chance to exercise his sense of humour. Another word that recurs frequently when people recall Zaki is 'Fiat'. Due to restrictions on the importation of automobiles to India, Zaki's fondness for cars led to his having a fleet of automobiles that consisted almost entirely of 'Fiat' cars. He had a particular penchant for the Premier Padmini 'Fiat' and his nephew, Sakib Maskati, recalls that when he was teased by those friends of his who had managed to acquire a much-coveted imported car he would retort, '*So what? I have a different coloured Fiat car to match each of my suits!*'

Zaki Maskati (1934-2000), the youngest child of Abdultyeb and Shirin Maskati. Pictured here clockwise from the top: In his 20s in Bombay; travelling in Europe; with Jamshed 'Jimmy' Fozdar (centre) and Narottam Vanmali (right) at Jimmy's home in El Cerrito, California, USA, December 1973; and on one of his many road trips.

Mahabaleshwar: Another House of Memories

Abdultyeb Maskati purchased another holiday home at Mahabaleshwar where members of his family and relatives could escape Bombay. If there were too many visitors, hammocks were hung out on the covered verandah. The fourth generation of the Maskati family has fond memories of spending entire months of their summer vacations at this home in the hills of the Western Ghats.

Getting to Mahabalaleshwar was always an adventure. The last 50 kilometres of the drive from Bombay is winding and climbs over 4,500 feet. When Abdultyeb first bought the house, the journey took two days by horse and carriage and was broken overnight at Pune (then known as Poona).

Later, during the 1950s and 1960s, the trip was made in one of the family's Premier Padmini, or 'Fiat', cars. It was a hot and exhausting drive – the 'Fiat' had no air conditioning and had to stop several times while ascending the Western Ghats to let the steaming water in the radiator cool down. Rasheed Maskati and his friend Homi Mehta, who also has a holiday home at Mahabaleshwar, often preferred to drive up in Homi's Buick Wildcat – a comparatively luxurious ride as the Buick had air conditioning, an automatic gear shift, and the capability of making the journey without having to stop for cooling breaks. But the car came with its own hazards as it was a lefthand drive vehicle imported from America and Homi had to drive with a companion in the passenger seat who could check the narrow road for on-coming traffic.

But the cool, fresh air of Mahabaleshwar rewarded and revived most who made the journey. Days at Mahabaleshwar were spent outdoors – hiking through the surrounding forest, picnicking at the Lingmala and Dhobi waterfalls, or rowing on Venna lake. Other entertainments included magic shows performed by itinerant magicians and collecting the fresh fruits that grew wild around Mahabaleshwar. The family would pick mulberries by the bowlful as well as *jamun* (Indian blackberries), which were collected by spreading old bedsheets out beneath the *jamun* trees and beating the branches to dislodge the succulent fruit.

Rasheed Maskati was an avid hiker and, over the decades of visiting Mahabaleshwar, came to know every shortcut and twisting path across the hills. But today, as more and more holiday makers pour into the area, he recalls a quieter, wilder Mahabaleshwar where you were more likely to bump into sambar deer, monkeys, boar, or even the occasional panther.

Top: From left to right: Rubabbai Bandukwala, Zahra Maskati, Abdultyeb Maskati (behind), Shirin Maskati, and Shirin's sister, Banu Karachiwala on the terrace of the Mahabaleshwar house.

Above: Seated front, left to right: Rasheed, Azmat, and Zahra Maskati. Standing behind: Ateeb Maskati, Aneesh Manohar, and Sakib Maskati.

Opposite, top row: The Mahabaleshwar house and the cousins who frequented it, from left to right: Bashir Karachiwala, Shahib Kanthawala, Sakib Maskati, Aidoon Kajiji, Shariq Kajiji, Shabbir Basrai, Nadeem Kajiji, Yusuf Goriawalla, Zaki Maskati, and Rahil Bhatri, 1987.

Opposite, centre: Cigar smoking sisters, from left to right: Bilkish Bhatri, Shirin Maskati, Zubeda Basrai, and Zarina Kajiji (seated in front).

Opposite, below left: Abdultyeb Maskati on horseback at Mahabaleshwar.

Opposite, below right: A traditional thaal in the Mahabaleshwar house, from left to right: Bilkish Bhatri, Rezoo Joseph (nee Karachiwala), Memuna Kanthawala, Shirin Maskati, and Zarina Kajiji, circa 1950s.

Left: Postcard of Mahabaleshwar, circa 1913.

The Traditional Thaal

The custom of shared meals has always been a focal point of Bohra community gatherings. The traditional *thaal* meal is served on a round silver-coated copper *(kalai)* or stainless steel platter large enough for eight or nine people to gather round and eat together from shared serving bowls.

The meal began with a pinch of salt reminding diners of a time when the prophet Mohamed was so poor all he had to eat were chapatis flavoured with salt. Zahra, wife of Rasheed Maskati, likens this tasting to a small and silent prayer conducted before the meal.

To cleanse the palate, the salt was followed by a taste of something sweet; a mouthful or two of a favourite dessert such as caramel custard or *khir* (a pudding made with rice and milk mixed with dried fruit and saffron). The main meal comprised mutton or chicken, grilled or stewed with almonds, or served with a cashew-nut sauce. There were also helpings of meat and vegetable curries cooked with spices, and steamed rice or hot chapatis. The meal was finished off with fresh or dried fruits.

For most Bohra gatherings, the *thaal*, a meal traditionally eaten on the floor and without cutlery, has since evolved into a more modern form with round tables and individual plates but the idea of well-prepared meals shared among close friends and family remains.

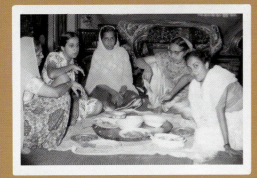

CONTINUITY

CONTINUITY

The fifth generation of Maskatis began to come to the fore in the 1980s as Rasheed and Zahra Maskati's three children completed their education. Their daughter, Azmat, studied at Wellesley College in the United States, went on to gain a Master's degree in Public Health at Harvard University followed by a medical degree from McGill University in Canada. Azmat now lives in the United States with her American husband, Geoffrey Alperin, and their two young children. She works as a doctor specializing in internal medicine and HIV medicine, and treats under-privileged patients at the Brockton Neighborhood Health Center. Geoffrey works at Millennium Pharmaceuticals Inc., now part of the Takeda Pharmaceutical Company Ltd. Meanwhile, Rasheed and Zahra's two sons, Sakib and Ateeb, went on to join the family businesses.

When Ateeb Maskati arrived at the Bangkok office in 1987, the city would no longer have been recognisable to his great-great-grandfather, Abdul Tyeb Maskati, who first experienced it in the 1850s. Then, the Golden Mount had not yet been completed and Wat Arun, the Temple of Dawn, was still the tallest structure in the city. Bangkok covered just a few square kilometres along the riverside and had more canals than roads. By the time of Ateeb's arrival almost 140 years later, the Thai capital had become a sprawling urban metropolis covering more than 330 square kilometres. The city's skyline was studded with an ever-increasing number of towering buildings and most of the old canals had been paved over for traffic-clogged roads.

Ateeb had completed his Master's degree in business at the Amos Tuck School of Business Administration, Dartmouth College, in the U.S. but the textbooks he used only partially equipped him for the hands-on challenges that lay ahead. The Thai side of the family business had been run independently from India-based business operations since the 1950s, and Ateeb took charge of Thai operations on the cusp of the ICT revolution that was about to connect the entire world. As a result, he faced the task of modernising not only the office systems and ways of doing business but the staff, many of whom had been with the company for decades. While the products the Maskati firm had dealt in had adapted and changed over the past century, its way of doing business was still firmly rooted in the tried-and-tested methodologies and mentality of an old-world trading company.

There were no computers on the desks at the Anuwongse Road office. Communications were generated through a stenographer who took dictation and typed up letters on a mechanical typewriter that could only be signed and sent after they had been checked, corrected, re-typed, and checked again. Trade deals were mostly conducted through Chinese middlemen. But different circumstances demanded a new, more effective way of working. In a globalised and connected world, the old-style trader and his carefully cultivated supply chain was becoming obsolete as direct links between clients and suppliers would soon be made at the click of a computer key. Realising this, Ateeb set about reinventing the company.

Key to this process of modernisation was retaining the business ethic his forefathers had so successfully upheld during their respective periods at the company's helm – trust, honesty, and reliability. Says Ateeb, *'The fundamental question became how are we adding value for our customers and, in many cases, it turned out we were not; we were just functioning as middlemen in a world of increasing connectivity.'*

Ateeb's answer to the question of how to add value was developed over the years as he streamlined the company's operations and focussed on areas in which he and his staff knew they could provide improved services and goods for their clients. Many of the previous departments were maintained with the addition of integrated services. Ateeb began supplying a sourcing, selection, and quality control process to the existing agro-forestry products, which included betel nut, dammar, and seedlac. The trade in these products had generally been conducted through Chinese suppliers.

Right: Company employees at A.T.E. Maskati & Co., Ltd., Bangkok, gathered for the arrival from India of Ziya and her mother Shirin Masakti, 1982. Seated in the middle row, from left to right: Ziya Maskati, Shirin Maskati, Zoyeb T. Kajiji, and his wife Rachani Kajiji.

Below left: Sakib and his younger brother, Ateeb Maskati, in the garden at Maskati Villa, Colaba, Bombay, 1970.

Below right: Azmat, youngest child of Rasheed and Zahra Maskati, is a doctor and lives in the United States with her husband Geoffrey Alperin and their two children.

Today, a more direct chain has been established that directly links the company with growers. To establish and solidify these links, Ateeb travelled across Thailand inspecting sources and building the necessary relationships with representatives of small-scale farmers. Through links he made in the south of Thailand, for instance, betel nut from selected suppliers is now driven straight from growing areas to on-site warehouses at the Maskati office in Bangkok where it is sorted, graded, and prepared for shipment to clients. The company moved out of Chinatown to a newly constructed and integrated warehouse-cum-office facility on the edge of Nakorn Pathom, bordering Bangkok. To create value in production, the company invested in processing machines.

To further integrate the supply chain, Ateeb established a seedlac factory in Lampang under the new company Atem International Co. Ltd., promoted by the Board of Investment of Thailand. Seedlac is a seasonal product, which requires proximity to the raw material source, processing, and careful handling to ensure the end quality and competitiveness. The factory is one very concrete answer to the question of how to add value; it enables the company to transform the raw material and extract the seedlac resin, and also to provide quality control throughout the entire supply chain, from the source all the way to the client.

While the company still provides the chemicals and products needed by steel foundries and the ceramics industry, it has expanded into an area essential to almost all trade – packaging. The company's packaging arm began with the importation of stretch film wrapping from Australia and progressed to the provision and design of specialised wrapping machines. At one stage, simple semi-automatic stretch wrappers were being designed and manufactured at the Nakorn Pathom office. Soon, the company provided a comprehensive end-of-line packaging solution through the purchase, distribution, and service of fully automatic systems with conveyor belts, robot/wrapping machines, and pallet inverters that could be made to each client's specific needs. Sold under the brand-name Atemac (an evolution of the initials for Abdul Tyeb Esmailji Maskati standing for A.T.E. Machinery), the machines have built up a solid client base in Thailand that includes BP Castrol, CP Group, Dole, Electrolux, F&N, Nestle, Siam Cement Group, Singha, and 3M.

Essentially, the process of maintaining continuity while consolidating the business so that it can survive, and thrive, in a contemporary environment, involved grouping the company into three distinct entities – agroforestry products, industrial supplies, and packaging. *'Ultimately,'* says Ateeb, *'my plan is to spin these off into three separate companies and let them each grow under their focussed management teams. It makes sense to let each of them evolve down its own, natural path.'* Looking to the future, Ateeb has also instigated a research project with a leading research institute in Thailand with the hope of discovering new ways to use natural resources and diversify into other natural ingredients.

The original office and residence at 45 Anuwongse Road, Bangkok, meanwhile, no longer serves as a residence but is still home to a business. There, Zilika Maskati, daughter of Zoyeb T. Kajiji and wife of Ateeb Maskati, continues the family's long tradition of trade with her company, Flavours of the Orient, which procures spices and dried fruits for clients. To meet the demands of chefs at some 50 hotels around Bangkok, Zilika has worked with food scientists and sources produce from suppliers across Thailand.

In India, meanwhile, Ateeb's older brother, Sakib Maskati, led the family firm in a very different direction.

Sakib graduated with a Bachelors of Commerce degree from the Sydenham College of Commerce and Economics, Bombay, in 1981. By then, a decade after the sale of Garlick & Co., the Indian operations had shrunk considerably, a decline aided by the so-called 'Licence Raj' and business-unfriendly socialist policies of the Indian government. Built on international trade, the Maskati business in India was severely hamstrung by import restrictions and capital controls. A closed economy resulted in poor-quality manufacturing in India, making it difficult for a trading outfit to sell Indian goods on the world market.

Rasheed and Zaki Maskati had helped Huned Karwa launch Mascom Electronics, and this was the first venture Sakib became interested in. The business started with marketing dot matrix printers manufactured by Godrej & Boyce and then expanded to selling 'dumb' terminals (terminals without a CPU that connected to a mainframe computer enabling users to access a centralized computing facility). The personal computer was just beginning

Above: Management team at A.T.E. Maskati & Co., Ltd., Bangkok, Thailand, 2017. Left to right: Satit Piyamaikongdej, Rungsima Wongjirapaitoon, Samart Termsettajalern, Rungrat Onsub, Kanokwan Innurak, Ateeb Maskati, Zilika Maskati, Nanda Basu, Niraya Marasri, Kaewchira Kaewsuwan, Thidarat Lapawong, and Anucha Woramaris.

Below right: While the Maskati business family stands together as one, the actual family is also close knit. This picture shows the Maskati family gathered in Phuket, Thailand, to celebrate Ateeb Maskati's 50th birthday, 2011. Standing back row: Ateeb and Zilika Maskati, Sakib and Sharmeen Maskati, Zanita Kajiji, Geoffrey and Azmat Alperin, with their son, Noah. Seated middle row: Pushpa Sethna, Zahra and Rasheed Maskati, Ziya Maskati, Rachani Kajiji. Seated front row: Panisa (Beam), Panalee (Dew) and Palinee (Rose) Maskati, daughters of Ateeb and Zilika; Aalia and Liyaan Maskati, daughters of Sakib and Sharmeen; and Talia Alperin, daughter of Geoffrey and Azmat.

Above: The Atem International Co. Ltd. seedlac factory, Lampang, Thailand, 2017.

Below: Opening of the Maskati seedlac factory, Lampang, Thailand, on 30 November 2007. Rasheed Maskati (centre) is cutting the ribbon. To the left of Rasheed is Direk Konkleeb (Governor of Lampang Province), Ateeb Maskati, and Rachani Kajiji. To the right of Rasheed stands Zahra Maskati, Zilika Maskati, and Zilika and Ateeb's three daughters.

to make its entry into India. The next product launched was a modem to communicate between computers over telephone lines. The modems were imported in CKD (Completely Knocked Down) kits from Taiwan, assembled locally, and sold by Mascom. As the 1980s progressed and personal computers were being introduced to offices, Mascom began selling generic assembled computers. In the mid 1990s, however, the Maskatis sold their stake in Mascom to Karwa, as the two parties were at variance over the company's operations.

During the time the family was still involved in Mascom, it had become clear that some small businesses could not afford the outright purchase of this new technology. Rasheed, with his banking background, encouraged Sakib to start a finance company that would provide leasing and hire purchase financing to Mascom customers, and so Atem Finance Pvt. Ltd. was launched. The business did not take off as most of its customers were small businesses that rarely paid their lease rentals on time; with the clogged-up courts and legal system in India, it was not commercially viable to file law suits for relatively small-value claims. With their exit from Mascom, the Maskatis also exited the leasing and finance business, though Atem Finance was continued and functioned as a kind of family holding company to launch other business ventures.

Mascom's business had included the sale of terminals (manufactured by Pycom Industries Pvt. Ltd.) to the Tata Institute of Fundamental Research (TIFR) in Bombay and the Maskatis ended up going into business with the two men who helped to install and debug the terminal software at TIFR, K.S. Kane and S. Nagarajan.

The owner of Pycom Industries, Kishore Kapadia, had managed to obtain a licence to import a PDP-11 series mini-computer manufactured by Digital Equipment Corporation; in those days Indian companies could not freely import goods into the country without a valid licence.

When Kane and Nagarajan decided to set up their own computing facility utilizing Kapadia's licence, they approached the Maskatis for finance and funding; Rasheed and Sakib agreed. It was a sign of the creaking bureaucracy of the period that by the end of the two years it took the relevant government departments to process the licence, the model had been discontinued and a new one launched.

The licence had to be amended, papers re-submitted, and, finally, in 1984, the VAX-11/730 was imported into India through a company called Syseng Data Techniques Pvt. Ltd., which was co-owned by Kane, Nagarajan, and the Maskatis.

Syseng housed its mini-computer in the premises of Hindustan Dorr-Oliver Ltd., at the latter's office in Saki Naka, Andheri. The arrangement was that Hindustan

Dorr-Oliver had exclusive use of the computer for a certain number of hours daily and Syseng could use it for the rest of the day to process electronic data for its various clients. In the early days, before the onset of the personal computer, Syseng counted among its clients Hindustan Lever Ltd., a local branch the State Bank of India, and Parke-Davis Ltd. Syseng personnel wrote the software (generally in COBOL), entered and processed data, and generated printouts and reports for clients. Syseng did well in the early years but was caught offguard by the swift induction and spread of the personal computer. The rapid growth in computing power and fall in computer prices, coupled with the launch of operating systems and applications software that made computers easy to use, enabled customers to do tasks themselves such as processing payrolls, invoicing, and statistical analysis, that had hitherto been outsourced.

Seeing the precipitous drop in its outsourcing client base, but the growth in demand for computer literate personnel, Syseng sold its VAX to Hindustan Dorr-Oliver and, in 1995, took up a Datapro franchise for imparting computer education and providing computing and programming courses. This business operated out of the Maskati's first-floor office at Maskati House, Mohammedali Road. About half the premises was utilized by Syseng and the other half by another company called Kosmochem, with Zaki retaining a small room for looking after his investments (Rasheed had by then moved his office to Maskati Court at Churchgate). However, the computer education and training business did not last very long; as schools and colleges quickly incorporated courses into their regular academic curriculum, the demand for basic computer training and programming collapsed. In 2005, Syseng closed operations and ceased doing business.

Sakib, meanwhile, had entered into a new venture with two friends, Sandeep Bakhshi and Lalit Shahani. Their plan was to develop software for the personal computer and they started Atemsoftw, a division of Atem Finance Pvt. Ltd. Bakhshi and Shahani developed various application packages based on customer requirements; the most successful of these was an accounting package developed in Foxpro that was used by the Maskati family office to manage their personal accounts, Trusts and a few small businesses still run by Rasheed. After Bakhshi, and later Shahani, left for better prospects abroad Sakib ran Atemsoftw with hired staff for a few years. Finding that the company failed to grow with reasonable traction, he shut down its operations.

In the mid-1980s, Mahesh Walke, a college friend of Ateeb's, approached Sakib with a business proposal for shrimp farming. Sakib and Mahesh scouted the coast north and south of Bombay looking for a suitable location and finally narrowed the choices down to a spot a little beyond the small village of Murud in the Raigad district, south of Bombay. But when Ateeb asked a business friend experienced in shrimp farming in Thailand to survey the site, he noted the lack of infrastructure, terrible roads, irregular electricity supply (power outages occurred 6-8 hours a day), and concluded, *'Don't even think about it.'*

Though the shrimp farm never materialised, Sakib's travels along the coastline did produce an unexpected outcome: a real estate operation in the Alibag-Murud region, located on the mainland across the harbour from Bombay. In the second half of the 1980s, this scenic, rural locale was not yet sought after by many Bombay residents; a few intrepid Bombayites had only just begun to brave the poor road and transport infrastructure to buy plots of land on which to build 'farm houses' to escape the noise, pollution, and frenetic pace of the city. Mahesh Walke roped in Mark Selwyn, another friend of Ateeb's from college, and asked Sakib to help fund a company called Uniland Estates, which was set up as a division of Atem Finance Pvt. Ltd. Sakib remembers driving his Maruti-Suzuki 4-wheel-drive Gypsy over paddy fields and bullock cart tracks with Mahesh and Mark (alternately) bouncing in the rear seat while they scouted out prospective properties. Coincidentally, Uniland's very first customer was the daughter of the ex-Chairman of Hindustan Dorr-Oliver, where Syseng's computer had been located.

Business was slow in Uniland's early days. Mark kept himself occupied during slack times as the bass guitarist of Rock Machine, then India's premier rock music band (later renamed Indus Creed). Mahesh, meanwhile, approached Sakib with another business idea. On family land at Devgad near the Maharashtra-Goa border, Mahesh had set up a small mango processing plant that canned mango pulp under the brand name Golden Orchard to sell through retail outlets. Mahesh and Sakib went on to set up Atem Exports (as another

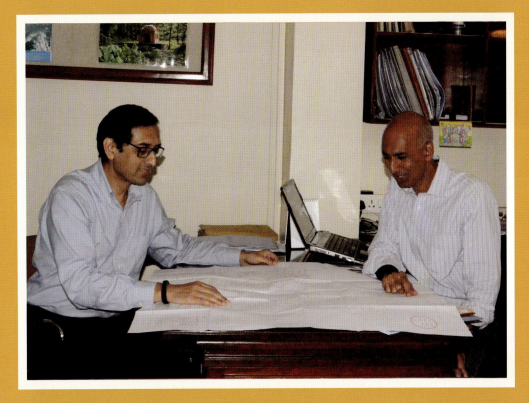

Maskati business partners in Mumbai, 2017. Left: Sakib Maskati with Mark Selwyn, Managing Director of Uniland Estates.

Below left: Sakib Maskati with Jamil Merchant, Managing Director of Rane Pvt. Ltd.

Below right: Sakib Maskati with Munaf Presswala, Managing Director of Kosmochem Pvt. Ltd.

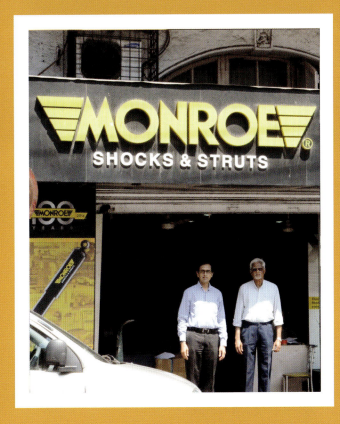

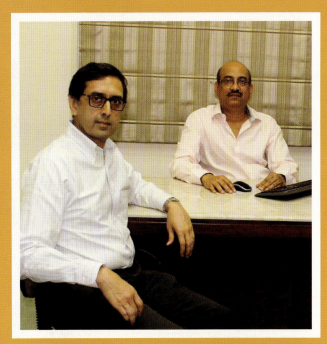

From A.T.E. Maskati to ATEMS

This logo was embossed on envelopes of Abdultyeb Esmailji Maskati. It is a modernised version of the original logo used by his father and probably also his grandfather, the founder Abdul Tyeb Maskati, which can be seen in the monogram on the first two letters on the left.

A century of letterheads and logos demonstrates the evolution of communications technology and shifting aesthetic of the Maskati family firm. The first letterhead predates telephone communications; it would have been handwritten in ink from the Begumpura House in Surat, India, and sent to overseas destinations by ship. The final letter displays the present-day logo for A.T.E. Maskati Co. Ltd. Bangkok, and, through the company's email and website addresses, invites instant methods of communication that would have been impossible to imagine one hundred years ago.

division under Atem Finance Pvt. Ltd.) to market and sell mango pulp and a variety of jams (mango, banana, pineapple, and papaya) under the brand name Indian Harvest. Around this time, Sakib and Ateeb's cousin, Husain Dawoodbhoy, in Colombo, Sri Lanka, visited Bombay and encouraged Sakib and Mahesh to sell tea and coffee in gift packs. Husain was already successfully marketing gift packs of flavoured teas in Sri Lanka as well as for export. Through Atem Exports, Mahesh and Sakib duly launched the Indian Harvest range of Darjeeling, Assam, and Nilgiri teas, as well as Indian coffee in wood and cloth gift packs. Their largest customer was Air India (then, still India's premier airline), which used these attractive items as corporate gifts.

In the summer of 1989, Sakib travelled with the family to Boston for his sister Azmat's graduation from Wellesley. There, he met up with his old school friend, Aneesh Manohar, who dragged him to a physics lecture at MIT. Inspired by this brief taste of American academia, Sakib decided to do an MBA programme. He did his GMAT in 1990 and gained admission to Cornell's Johnson Graduate School of Management for the fall of 1991.

While studying in the United States, Sakib still returned to Bombay every summer and winter break to stay in touch with the family business. At the beginning of the 1990s, the Maskatis were involved in multiple and varied business activities: electronic data processing at Syseng with K.S. Kane and S. Nagarajan; real estate at Uniland with Mahesh Walke and Mark Selwyn; personal computer software at Atemsoftw with Lalit Shahani (Sandeep Bakhshi having just left India); and computer hardware at Mascom with Huned Karwa. The family investments were looked after by Zaki while Rasheed oversaw the old family businesses (namely A.E. Maskati & Co., Plynet Traders, and Buildboard Distributors). The other key business interests of the Maskatis were Kosmochem Pvt. Ltd., managed by Rasheed's friend, Tyebjee Anik, and Rane Pvt. Ltd., which was run by Abdemannan Kajiji, with Rasheed and Zaki overseeing both companies as part of the Board of Directors.

Sakib felt there was something missing in these business operations; while some were profitable, others were not, and none were really growing. When he completed his studies and returned to Bombay in 1993, Sakib decided to focus the family business on a few key areas rather than allow it to be spread thin over multiple small enterprises. Atem Exports was perhaps the first to be shut as it was not profitable and Mahesh Walke had diverted his attention into another venture (Mahesh also exited Uniland around 1995 so Sakib and Mark continued the firm on their own). The closing of Atemsoftw followed soon after, and the family moved their accounting package from the in-house one developed by Bakhshi and Shahani to the popular off-the-shelf package, Tally.

The Maskatis exited Mascom Electronics Pvt. Ltd. in the mid-1990s, selling their stake to their partner Huned Karwa. Syseng was finally shut down in 2005 as the business was only marginally profitable. In the late 1990s, Sakib pushed his father, Rasheed, to wind up Plynet Traders and Buildboard Distributors as they had only a nominal sales turnover; initially reluctant, Rasheed relented after Zaki's death in 2000, and these companies were also shuttered early in the 21st century.

During those years in the mid-1990s, Sakib pushed through key changes that would transform the face of the Maskati business operations in India. Uniland Estates was then a subsidiary of Atem Finance Pvt. Ltd., which was, in turn, fully owned by the Maskati family; Sakib offered Mark Selwyn the opportunity to spin off the 100-percent-owned division as an independent entity, with Mark gaining majority ownership control if the business could stand on its own feet.

Kosmochem Pvt. Ltd. was then a 50:50 venture between Tyebjee Anik and Rasheed Maskati, with both families holding equal ownership stakes. When Tyebjee retired from active business and Kosmochem shifted from a loan licence operation to an importer and distributor of surgical supplies, Tyebjee's young accounts assistant, Munaf Presswala, proved indispensable to the continued business operations.

Sakib convinced Tyebjee and Rasheed to make Munaf the Managing Director and offer him a roughly equal equity stake (30 percent) in the company.

Some years later, when Tyebjee expressed his desire to retire completely and offered his shares to the Maskatis, Sakib again convinced Rasheed to let Munaf acquire the stake in order to take majority control as he was successfully growing the company more rapidly than it had grown in the past.

Kosmochem had been incorporated in 1972 by Rasheed and his friend Tyebjee Anik. The business started as a 'loan licence' operation with German Remedies Ltd., itself a joint venture in India between premier German pharmaceutical companies such as Schering and Boehringer Ingelheim. The loan licence policy was offered by the Indian government to promote small-and medium-sized industries (in pursuance of the then prevalent socialist policies favouring small business). Since small companies could not afford state-of-the art manufacturing facilities, the policy allowed them to take on loan the modern manufacturing facilities of larger companies and manufacture under the larger company's licence. The relationship was mutually beneficial to both the small and large companies as the larger companies were otherwise subject to controls on the price at which they could sell their products, while small-scale businesses were not subject to such price controls. Around 1986, it finally dawned on the government that the loan licence policy was not achieving the desired results and the facility was withdrawn. Kosmochem was suddenly left without a business and, for the next three years, experimented with importing and marketing various odd items, including pen-knives. Around 1989, Kosmochem tied up with Becton-Dickinson, USA, to import and market the latter's range of needles and disposable syringes. The product range later expanded to IV canula, catheters and insulin syringes. It was during these days that Munaf gradually took over operational charge from Tyebjee. Kosmochem became one of the two largest distributors of Becton-Dickinson products in India and was totally dependent on this one principal. As Sakib became more involved in Kosmochem's business upon returning to India from his studies in the U.S., he coaxed Munaf to represent other agencies in order to reduce the firm's dependence on a single principal and Kosmochem developed agencies with Nipro, Bard, Hudson-RCI, and 3M's surgical product division. Kosmochem supplied these products directly to key hospitals in Mumbai as well as to the wholesale surgical market. However, competition became cut-throat and the regional marketing managers of the principals, in their desperation to achieve sometimes unreasonable targets, divided their distribution businesses among more and more distributors. This effectively put a cap on Kosmochem's growth so Munaf and Sakib decided to directly reach out to a principal abroad; one that did not already have a presence in India and would therefore be willing to work with Kosmochem on a longer-term partnership basis. The first of these tie-ups took place in 1999 with adult incontinence products from the U.S. company, First Quality Inc. As this business model proved more profitable and did not engender the unreasonable 'product dumping pressures' from the surgical supply principals, the focus of Kosmochem's business shifted from hospital surgical supplies to products required by end-user customers, particularly senior citizens. The agencies of Nipro, Bard, Hudson, and 3M were gradually given up (other agencies from that time included Smith Medical, Convatec, and Rusch). Kosmochem began to import products direct from abroad and sell some items under its own brand, Kosmocare.

Today, Kosmochem imports a wide range of wheelchairs (manual and powered), walking sticks, walkers, rollators, shower wheelchairs, shower commodes and benches, grab bars, safety frames, hospital beds, antidecubitus (air and foam) mattresses, memory foam pillows and air cushions, and a range of miscellaneous home and hospital healthcare products. Kosmochem has perhaps the widest range of adult incontinence products in India, including disposable adult diapers, disposable protective underwear, bladder control pads and pant liners, underpads for bed and linen protection, washable underpads, hygiene protective sheets, and washable/reusable protective underwear. Kosmochem also represents Tanita, Japan (with their range of weighing scales, body fat monitors, and body composition monitors) and Omron and A&D Medical, Japan (with their range of blood pressure monitors), and markets Johnson & Johnson's blood glucose monitoring kits. After Munaf's son, Tyzoon, joined the business in 2012, on-line marketing was launched both through Kosmochem's website (www.kosmochem.com) and Amazon, India.

After Zaki's death in 2000, Sakib took charge of the family investments in India and was shortly thereafter inducted as Trustee in the family's charitable Trusts. Zaki had also been overseeing the Singapore office and, in 2002, Sakib relocated to Singapore with his wife Sharmeen Datoobhoy (a solicitor by education, whom he had married in 1997) and their young daughter, Liyaan,

Above: The Maskati office in Mumbai, India, no longer resides at Maskati House on Mohammedali Road but is now housed at Maskati Court, Churchgate, an apartment block built by Abdultyeb Masakati in the 1940s.

to attempt to revive the Singapore operations. By then, the Singapore business had dwindled to sales of a few bales of textiles and bunting cloth – a far cry from the days of his great-great-grandfather, Adul Tyeb, and those of his grandfather, Abdultyeb. However, Sakib felt his attention being diverted to the continuing opera-tions in India, which were then emerging from a period of anaemic growth. After reforms and the opening of the Indian economy by Prime Minister Narasimha Rao between 1991 and 1995, and the relatively liberalised, business-friendly policies continued by subsequent governments, the Indian economy was growing at a healthy rate. Towards the end of 2003, Sakib and his family returned to India. The Singapore trading opera-tions were shuttered and the Singapore companies now operate only as investment companies.

By 2010, there was no longer any business fully owned and run by the Maskatis in India. The operational business entities were Uniland Estates (in partnership with Mark Selwyn who now had a majority stake in the firm), Kosmochem Pvt. Ltd. (in which the partner Munaf Presswala held a majority stake), and Rane Pvt. Ltd. (in which the Maskatis also had a minority stake, the rest being held by various descendants of T.M. Kajiji and a few original members of the Rane family). The Maskati head office at Bombay was substantially downsized and is now run from Maskati Court, an apartment block in Churchgate, constructed in the 1940s. From his ground-

Giving Back in India and Thailand

The Maskati Charitable Properties Trust was established in 1911. Along with other charitable foundations set up by the family, the Trust continues to contribute to various charitable causes in India. With a focus on helping the underprivileged through support for educational scholarships and hospital/medical treatment, the Maskati Trusts disburse about 10 million rupees (approximately US$155,000) in charitable activities and causes each year. Some sample donations, pictured here: a bus to help transport girls from nearby villages to Dr. A.R. Undre Women's Degree College, which is located near Raigad in Maharashtra, and a shelter built by the Trust and the Rotary Club of Mumbai Downtown at J.J. Hospital in Mumbai for parents whose children are hospitalized.

The Maskati Foundation Thailand was founded on 2 August 1974 and has been providing partial scholarships to promising students from under-privileged backgrounds for more than 40 years. While some of the Foundation's funding supports primary and secondary education at the Sathya Sai Foundation School and Thai Muslim Women Foundation School, the majority is spent on higher education.

Administered through universities across Thailand, from Chiang Mai University in the north to Prince of Songkla University in the south, as well as at the country's leading institutions such as Chulalongkorn, Mahidol, and Thammasat universities in Bangkok, the scholarships help students defray expenses and the cost of learning.

Riverside Legacy

During his lifetime, Abdultyeb Maskati contributed to numerous charities and causes in the various countries where he conducted business. To help residents of the Muslim neighbourhood in Thonburi commute across the river to Bangkok, he funded the construction of the Charoenphas riverside pier in Thonburi. In this picture, Ateeb Maskati, Abdultyeb's grandson, stands on the pier together with his wife, Zilika.

Top: Opening of a shelter for use as a bus stop and rest stop, donated by the Maskati Foundation, Thailand. Located opposite the Banglaen District office in Nakorn Pathom province, the shelter was built in 1982 for Bangkok's bicentennial. Left of centre is Ziya, wearing a green sari, with her mother, Shirin Maskati on the right.

Middle left: A bus donated by the Maskati Charitable Properties Trust, India, to Dr. A.R. Undre Women's Degree College, Maharashtra, to enable women in rural areas to more easily attend the college.

floor office, Sakib manages the family's investments, administers the family Trusts and its properties, and monitors the few joint ventures in which the Maskati family still has a stake. Uniland Estates also operates from here, while Kosmochem has taken over the entire premises of the erstwhile Maskati HQ at Maskati House, Mohammedali Road.

In recent years, Sakib has also acted as an 'angel investor' in a number of startups. Aquasail Distribution Co. Pvt. Ltd., promoted by Ateeb's friend, Shakeel Kudrolli and Shakeel's wife, Zia Hajeebhoy, was the first such investment. Aquasail is the first – and perhaps still the only – company in India to teach a wide range of water sports activities in a professional manner with uncompromising safety and quality standards; it consistently gets 5-star ratings from its customers on the TripAdvisor website. The company teaches sailing, powerboating, windsurfing, ocean kayaking, and kite surfing at its centres in Mumbai, Mandva, and Goa. Aquasail also offers team-building exercises to its corporate customers, organises regattas, and provides time-share yacht ownership as well as advice on outright yacht sales.

Together with TUI Travels, they offer global sailing holidays, including yacht charters at a range of exotic international locations.

Sakib also made a small angel investment in Systemantics India Pvt. Ltd., a Bangalore-based company attempting to develop fully indigenous, low-cost robots for use by manufacturing units (especially in the automotive sector) in India. Systemantics has raised subsequent funding from Accel Ventures and Nandan Nilekani (of Infosys fame), but has yet to launch a fully functional and saleable robot.

In 2014, Sakib invested in Seven Islands Craft Brewery Pvt. Ltd., which was about to launch Mumbai's first microbrewery, the Barking Deer Brewpub. Sakib was among a group of investors that helped bail out the company when it ran into financial distress due to delays in obtaining the microbrewery licence. After a good first 18 months, the company began to struggle again and, as of April 2017, Sakib and a group of investors were evaluating whether to buy out the other shareholders and try to revive operations or sell the company to another investor.

In India, where Abdul Tyeb Maskati launched his first business venture in the mid-nineteenth century, all businesses wholly owned by the Maskatis have now been shut down. As Sakib says, *'While the Maskatis are not running any businesses in India, they are still invested in many running businesses.'*

The story of the Maskati firm spans five generations and straddles the old world and the new. Built on the success of Abdul Tyeb Maskati's early venture exporting Indian textiles custom-designed for the Siamese market, which began in 1856, the business stretched from India to Siam, Singapore, Cambodia, and Burma. Decades later, his descendants followed the shifting commercial landscape and expanded into the import and export of agricultural products and other in-demand items, eventually extending the reach of their business interests as far as Japan. With the wave of industrialisation that swept across Asia following World War II, the company bolstered its existing engineering concern to contribute to modernisation efforts taking place in India and Thailand. The family business is now run as two separate entities, steered in India by Sakib Maskati and in Thailand by Ateeb Maskati, with each exercising different methods for meeting the challenges of doing business in the new millennium.

Despite the vagaries of these past 160 years, some old habits remain unchanged. Rasheed Maskati, now more than 90 years old, still wakes each morning and reads the *Times of India* newspaper with a cup of tea. Afterwards, he heads to his office at Maskati Court where he sits at the same large, teakwood desk used by his father, Abdultyeb Maskati. There, he oversees the donations he makes to various charitable causes, which include – as they always have done – medical and educational charities. When Rasheed was born in 1926, the Maskati name was inextricably linked to the *saudagiri* textiles that were being block-printed by hand in Ahmedabad, dried on the banks of the Sabarmati River, and packed onto ships for sale in Siam, Indochina, and elsewhere in Southeast Asia. Maskati *saudagiri* has been largely forgotten by the wider world and successive generations of the family have transformed the company in ways it would have been impossible to imagine back then. As Rasheed is fond of saying, *'The world turns.'*

Friends and Family Gather for Rasheed Maskati's 90th Birthday

On 12 August 2016, the Maskati family hosted a dinner for Rasheed Maskati's 90th birthday that brought distant family and old friends to Maskati Villa in Colaba, Mumbai. Among those who travelled furthest to attend were Rasheed and Zahra's daughter, Azmat, who now lives in the United States, and her husband Geoffrey Alperin and their two young children. Cousins Nabil Shamoon and Shabbir Basrai also travelled from the US. Rasheed's closest friends gathered for the occasion, including Homi Mehta, Munis Varawalla, Satish C. Malhotra, and Rasheed's long-term bridge partner, Tyebjee Anik. His childhood Doon School friend, Paul Gupta now lives in Canada but was represented at the event by his son Rahul. Remembering boyhoods spent in a more genteel, less congested Bombay, they all had warm words to share about Rasheed. Homi Mehta first met Rasheed in a railway carriage on the 24-hour journey from Bombay to Doon School, Dehradun; they became, and remain, fast friends and spent many happy holidays together at Mahabaleshwar (see page 154). Munis Varawalla's friendship goes back to pre-World War II days and he remembers first meeting Rasheed when he went with his father to bid farewell to the Maskati family as they set off by ship on their round-the-world trip in 1937 (see page 119). Satish C. Malhotra, another Doon School graduate, became friends with Rasheed during their bachelor days when they hung out together in prohibition-influenced Bombay in the 1950s, drinking coffee at Bertorelli's coffee house and partying in people's homes. He describes Rasheed as *'a great gentleman who never says a false word and never bears ill-feeling towards anyone'* and succinctly sums him up as, *'One hell of a good human being!'*

Above: Rasheed Maskati's 90th birthday celebrated at his home, Maskati Villa, Colaba, Mumbai, 12 August 2016. Rasheed sits at the head of the table. From left to right: His close friend, Homi Mehta, his wife, Zahra Maskati, with his son, Ateeb Maskati, and his younger sister, Ziya Maskati, standing alongside.

Top right: Close friends catching up at Rasheed Maskati's 90th birthday. From left to right: Satish C. Malhotra, Rasheed Maskati, and Himmat Khara.

Below right: The next generation. Upon the occasion of Rasheed Maskati's 90th birthday, his children and grandchildren – who live in Mumbai, Bangkok, and Boston – gathered at his home in Colaba, Mumbai. Seated, left to right: Sharmeen and Sakib Maskati, Geoffrey and Azmat Alperin, Zahra Maskati with her grandson, Noah Alperin, Rasheed Maskati, Ziya Maskati, Ateeb and Zilika Maskati. In front, left to right: Aalia Maskati, Palinee (Rose) Maskati, Panisa (Beam) Maskati, Liyaan Maskati, Talia Alperin in the foreground, and Panalee (Dew) Maskati.

The Art of Saudagiri

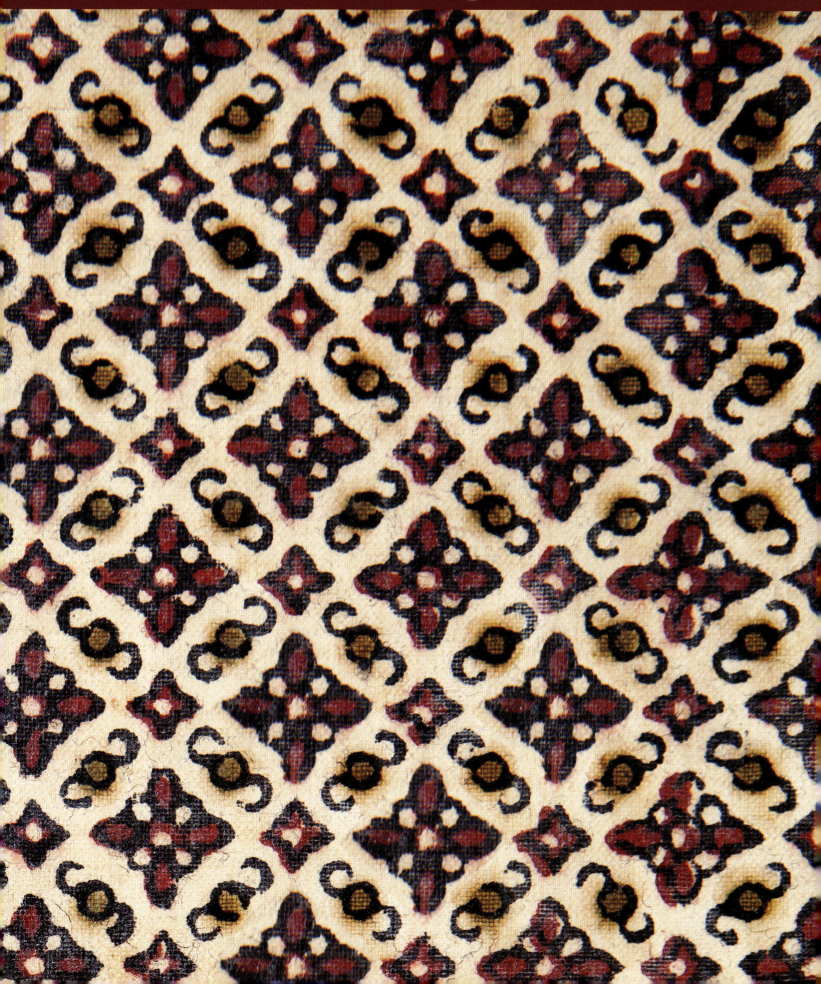

THE ART OF SAUDAGIRI

The Art of Saudagiri *or* Pha Lai *Textiles*

From the initial drawings of designs made in Siam to the carving of intricate patterns onto teak wood blocks in the village of Pethapur, Gujarat, and the hand block-printing process in an Ahmedabad workshop, the production of just one sheet of saudagiri cloth involves a wide variety of labour, expertise, and skill.

In India, the cloth known as *pha lai* in the Thai language is called *saudagiri*, from a Persian word meaning 'goods for sale'. It is a piece of cotton that is typically about 1 yard wide and 3 to 3.2 yards long. It has a fine floral and geometric motif printed in three or four colours. *Pha lai* was produced in varied grades, according to the quality of the printing and the material used, which included both crude and fine cotton. Good quality *pha lai* printed on fine machine-made cotton was called *yamawad* in the Thai language; the name was probably derived from *Amdavad*, the local name of Ahmedabad, the former capital of Gujarat where these textiles were produced, and was featured on some labels of the Maskati cloth. The trade in *saudagiri* – in which the Maskati firm played a leading role – took place between Gujarat and Siam, as Thailand was then known. It flourished for about one hundred years and ended around the 1940s.

Why the Siamese Market Favoured Saudagiri:
Brilliant colours
Long-lasting colour that didn't fade
Fineness of weave from machine-woven cotton
Quality of design due to skilled block-makers at Pethapur

Saudagiri *Motifs*
Saudagiri cloth has two main design components, namely the centrefield (*tong pha* in Thai) and the cone-shaped border panel (*cherng* in Thai). The centrefield motifs feature grid designs based on Islamic geometric patterns; possibly inspired by the intricate latticework of Mughal architecture in Gujarat. The designs are similar to those used in *ajrakh*, a style of block-printing cloth with symmetrical patterns and motifs that is hundreds of years old and is still practiced today, mostly in the districts of Kutch, India, and Sindh, Pakistan. However, the *saudagiri* grid is comparatively smaller than that of the *ajrakh* grid; its geometric motifs vary within the grid and have been

The Colours of Saudagiri

This photograph of *saudagiri* cloth from a collection at the Victoria & Albert Museum in London shows the wide variety of colours used in *saudagiri* design over the course of the century in which it was produced.

© VICTORIA & ALBERT MUSEUM, LONDON (Photograph by John Guy)

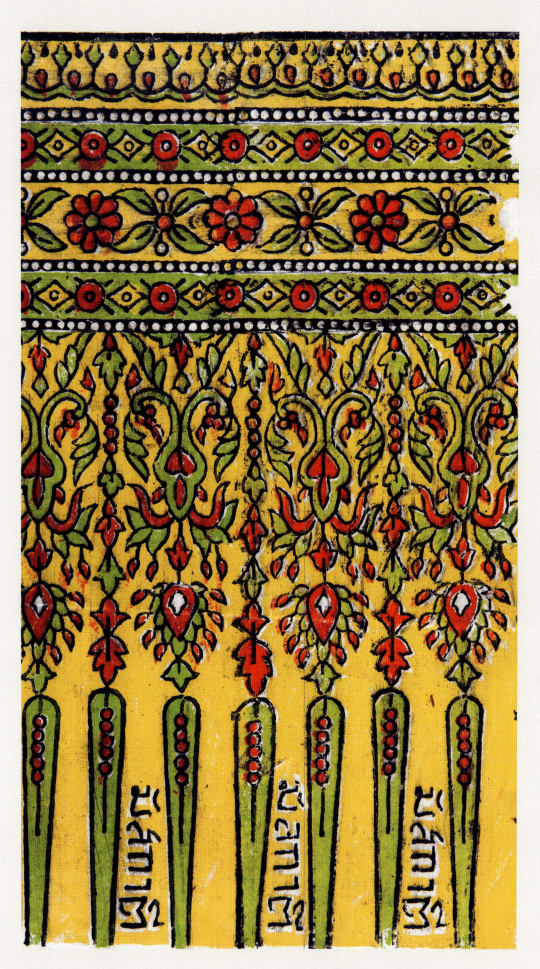

Maskati Saudagiri or *pha lai* block print. Up to five different blocks were required to print a four-colour pattern such as this one. Drawn in Siam (now Thailand) and produced by hand by artisans in Ahmedabad, India, these patterns resulted in every individual cloth being utterly unique.

modified to include more patterns derived from nature such as flowers, leaves, and creepers. Some scholars have compared aspects of the *saudagiri* floral motifs to those on *sanganeri*, another type of block-printed cloth from Sanganer in Rajasthan, India, which incorporates small floral patterns that are, like *saudagiri,* set in either a semi-repetitive motif or one with connecting creepers and lattices. The end border motif is very characteristic of *saudagiri* and each piece of *saudagiri* cloth is finished off with a cone-shaped motif. This motif has gone through a variety of stylisations, with more than one hundred different styles documented to date.

Floral Representation

The geometrical grid forms of *saudagiri* were often based on floral patterns composed of dots that would represent flowers such as jasmine, champa (plumeria), tisi (the linseed oil plant), or the tuberose.

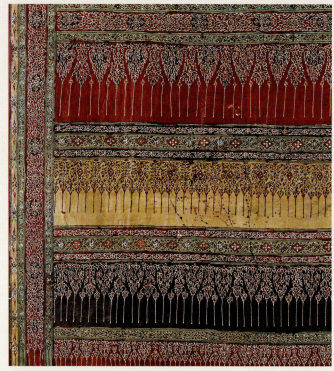

Saudagiri *Samples*

Sample books of *saudagiri*, or *pha lai*, designs for the Siamese market of the type sent by the Maskati firm and other Indian textile agencies in Bangkok, such as Malbari and Wasee. These books belonged to the late Maneklal T. Gajjar, a block-master whose family was commissioned by the Maskati company. After he passed away in 2012, his collection was purchased by a Gujarati collector who plans to set up a *saudagiri* museum.

Making Saudagiri *Blocks*

Each new design for *saudagiri* cloth must begin with the carving of the blocks that will be used to print it. For this, the pattern is first drawn on a sheet of paper. The basic design grid is traced onto tracing paper, which is then folded to check the symmetry. Another tracing is made to include all the curved points in the pattern. These points are marked with a circle, arc, or pattern that closely resembles the design. Before the grid is traced onto the block with pencil, the surface of the teakwood block must first be made completely smooth; this is done by rubbing it with a file, sandstone, and water. The perfectly levelled surface is then placed at a right angle and coated with a mixture of chalk and gum arabic (from the sap of the acacia tree), which makes the traced grid clearly visible. This grid is never chiselled on the block and only

Saudagiri *End Motifs*

The cone-shaped motif is characteristic of *saudagiri* fabric, as can be seen in these folios from a pattern book used in the production of *saudagiri* textiles for Siam. Block printers tended to specialise in certain patterns as they built experience and perfection through endless repetition; their names are recorded in these books to indicate the printer affiliated with each particular design.

Above: Sample books for Masakti designs. The top book shows designs for the geometrical grid patterns that formed the main body of the cloth. The bottom book shows end motifs with the name 'Maskati' repeated in Thai along the border.

Right: Maskati order book, 1930. Attached to the book are sample swatches showing colours, printed patterns, and cloth quality. These had to be approved in Siam before large orders were made from India.

Printing Saudagiri

Printing *saudagiri* cloth involved the application of dyestuff or pigment to the surface of the fabric. This was done in various ways. Maskati *saudagiri* began with plain cotton known as 'grey cloth' that was produced in Indian mills and sent via the Bombay head office to the Maskati workshop in the Astodia neighbourhood of Ahmedabad, where mostly Muslim printers known as *chippas* transformed the plain cloth into brilliantly coloured and intricately patterned *saudagiri*.

Before printing, the cloth was washed and bleached with water and soap. The exact dyestuffs used are not known. Though very early *saudagiri* would have been printed using vegetable dyes, the cloth made by the Maskati firm may have been made with chemical dyes, which became available in India in the early part of the nineteenth century. The printers worked by hand, applying the dyestuff to the blocks and the blocks to the cloth. A colour tray was prepared to provide just enough dye to colour a single block, which was then pressed onto the cloth. The next block of the design repeat was positioned by matching the registration marks with the corresponding points on the block.

Block printing was used to create both continuous lengths of yardage and pieces of cloth with predefined layouts such as *pha nung* (or hip wrappers worn by Thais) and handkerchiefs. For the latter, borders were printed first and the centre portion was filled in afterwards.

Once the dye was dry, the cloth was rinsed in running water for about ten minutes to remove excess dye and enable better absorption of dyes as the process developed. Rinsing was done very carefully in the Sabarmati River, which runs through Ahmedabad, to ensure that no black colour spread from the alum base. The cloth was placed in the water back-side up so that the printed side was completely submerged. The rinsed cloth was then laid out to dry in the sun for about half an hour on the sandy banks of the river, a process that was believed to facilitate the absorption of colours.

The final step of the process was to starch the material with wheat flour using a calendaring machine (to flatten the cloth) after which it was sent back to Bombay and readied for export to Bangkok.

the original design is chiselled, using the pencil grid as reference points.

There are three types of *saudagiri* blocks, namely *rekh*, *gad*, and *data*. The *rekh* block is used to create the outline of the cloth. As it is a large block covering the entire design, it contains holes to release air pressure while it is stamped onto the cloth and also to prevent any dye from clogging the block. The *gad* block is used to create the background colour and the data blocks are used for filling in colours in the motifs.

The blocks are sometimes stuffed with wool between the pattern lines so that more of the dye is absorbed and a more precise imprint is left upon the fabric. A dot at the corner of each block provides a registration mark for the next repeat.

The number of different blocks needed for each piece of *saudagiri* is dictated by the number of colours being used in its design. When more than one colour is used in the motifs, the number of data blocks used will increase accordingly. On average, a typical *saudagiri* cloth with two-to-four colours in its overall design, like those of the Maskati brand, requires three-to-five blocks.

Shelf-life of a Block
Pictured above is the late master blockmaker, Maneklal T. Gajjar, who lived and worked in Pethapur, Gujarat. According to the late John Irwin, Keeper of the Indian Section at the Victoria & Albert Museum, who conducted a tour of Gujarat's key block-printing workshops in the 1950s, saudagiri blocks were made from teak wood, with carvers often favouring repurposed pieces of wood from old buildings because these were ready-weathered and would not become warped. A single block could be used to produce around 1,000 pieces of cloth before it was worn out. Due to religious beliefs against destroying an object that had been used to earn a living, old blocks were either sold to lower quality printers in the village or tossed into the river.

Diary Notes

On 19 February 1957, John Irwin, Keeper of the Indian Section at the Victoria & Albert Museum, visited the office of the Maskati firm at Astodia, Ahmedabad. This is his account, taken from his *Diary Notes on a Brief Tour of Block Printing Centres in Western India*:

'Since 1852, this firm has played a leading role in the export of a certain type of cotton print to Siam. These cloths are known as 'Sodagiri' [sic]. They are especially worn in Siam by dancers. The main features of the design consist of a hybrid concoction of basically Siamese motifs, much Indianised… This trade was still flourishing in 1939 but was killed by World War II, whence the [Japanese] made a determined effort to capture it by exporting mill-imitations of the Indian cloths. It seems, however, that the Indian cloths are preferred because this trade is now being revived. The retail price of such cloths is about Rs. 8 and the best are of good design quality. The smooth stiff finish of the cloth is explained by Siamese ladies' wish for a crinkly sound when they walk!'

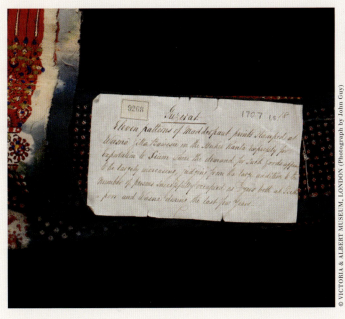

Saudagiri at the Victoria & Albert Museum, London
Handwritten label on the sampler reads: 'Guzarat, Eleven Patterns of Madder-punt *(type of coarse cotton)* prints stamped at Wasna Zilla *(district)* Bawesee *(town name)* in the Mahee Kanta *(banks of the Mahee river)* expressly for exportation to Siam where the demand for such goods appears to be largely increasing, judging from the large additions to the number of persons successfully occupied as Dyers both at Peethapoor and Wasna during the last few years', c. mid-to-late 1800s.

Artistic Inspiration
The designs featured on saudagiri reverberate across Siamese art forms, with Bencharong pottery being one fine example. The repeated geometric design of saudagiri was based on an Islamic grid adapted to include more natural patterns such as flowers, leaves, and creepers; similar floral grid designs can be seen on the five-coloured Bencharong ware – an art form that flourished during the same time period and was commissioned for the exclusive use of Thai royalty.

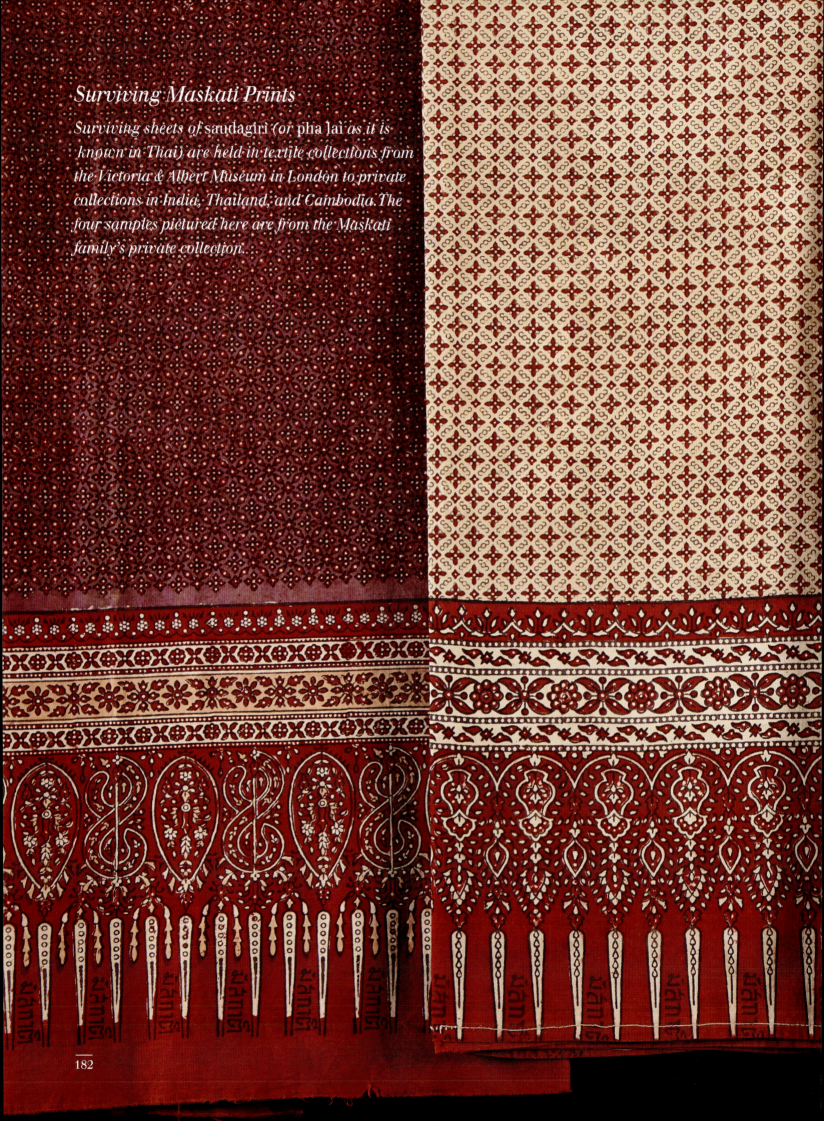

Surviving Maskati Prints

Surviving sheets of saudagiri (or pha lai as it is known in Thai) are held in textile collections from the Victoria & Albert Museum in London to private collections in India, Thailand, and Cambodia. The four samples pictured here are from the Maskati family's private collection.

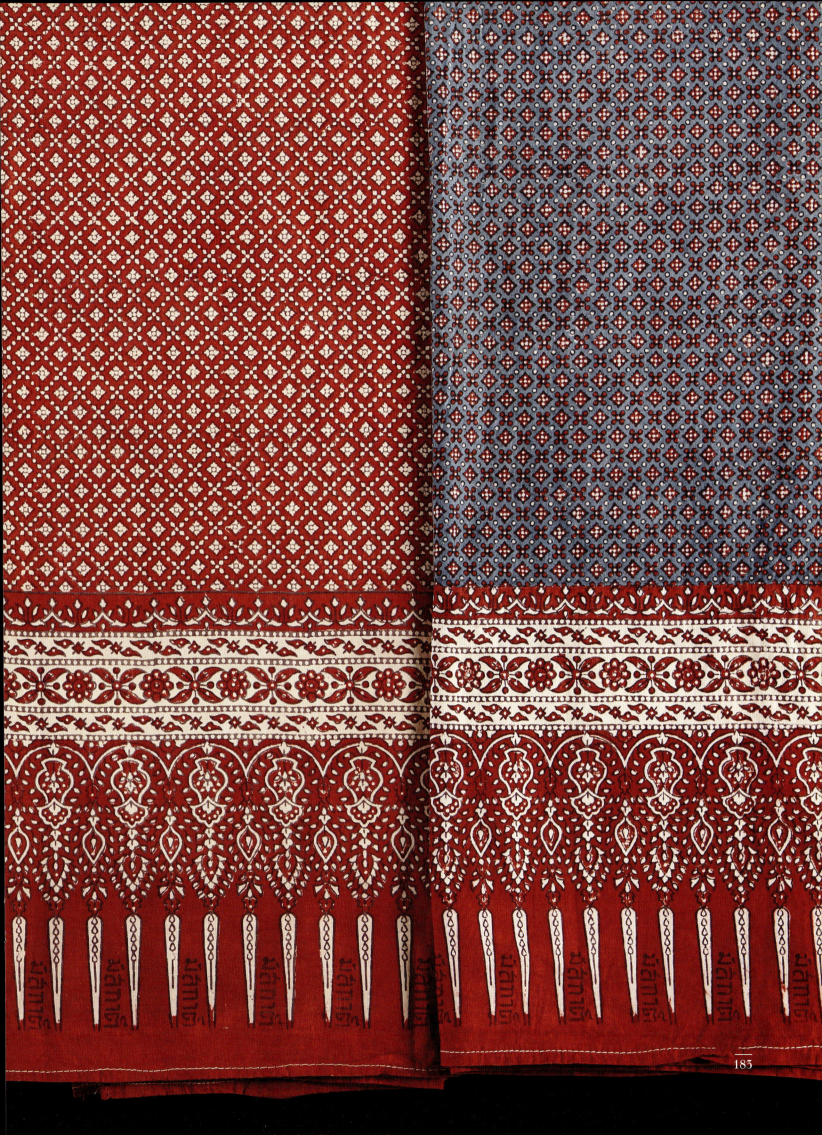

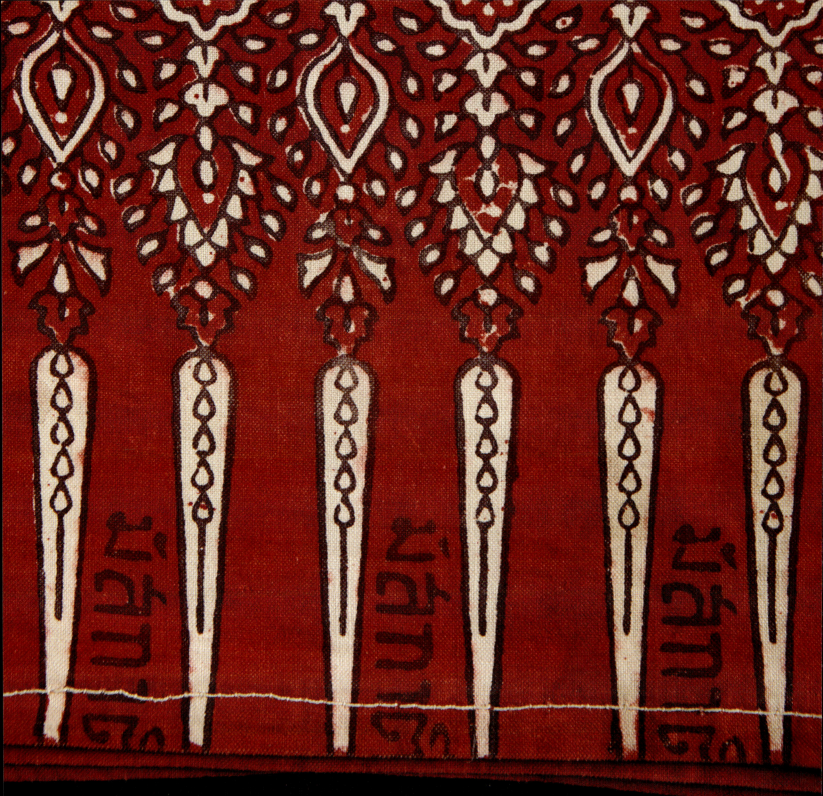

Maskati family members have saved pieces of *saudagiri*, handed down through the generations, and these can still be found folded away in cupboards or spread across beds and tables in various homes of the descendants of Abdul Tyeb Maskati. Over the past few years there has been a growing interest in reviving the art of *saudagiri*, with both Thai and Gujarati individuals launching efforts to recreate the fabric. Yasin Savaijiwala, whose descendants worked for the Maskati firm (his great-grandfather and grandfather are pictured with Abdul-tyeb Maskati on page 80), won the UNESCO South Asian Seal of Excellence for a hand-printed stole that represented his efforts to give *saudagiri* a new lease of life.

Right: This vintage Maskati advertisement states that Maskati cloth was favoured by *'women of every generation in the household'* because of its good quality, bright colours, beautiful patterns, and its strength and durability. The picture of scales in the top left-hand corner shows how one piece of Maskati *pha lai* (on the left) outweighs three other brands due to its superior, heavyweight texture. Finally, the ad cautions buyers to check for the name 'Maskati' along the edge of the cloth to ensure they are getting the real deal – this proof of origin can be seen, in Thai, on the fabric above and on other examples in this book.

HOUSE OF MASKATI FAMILY TREE

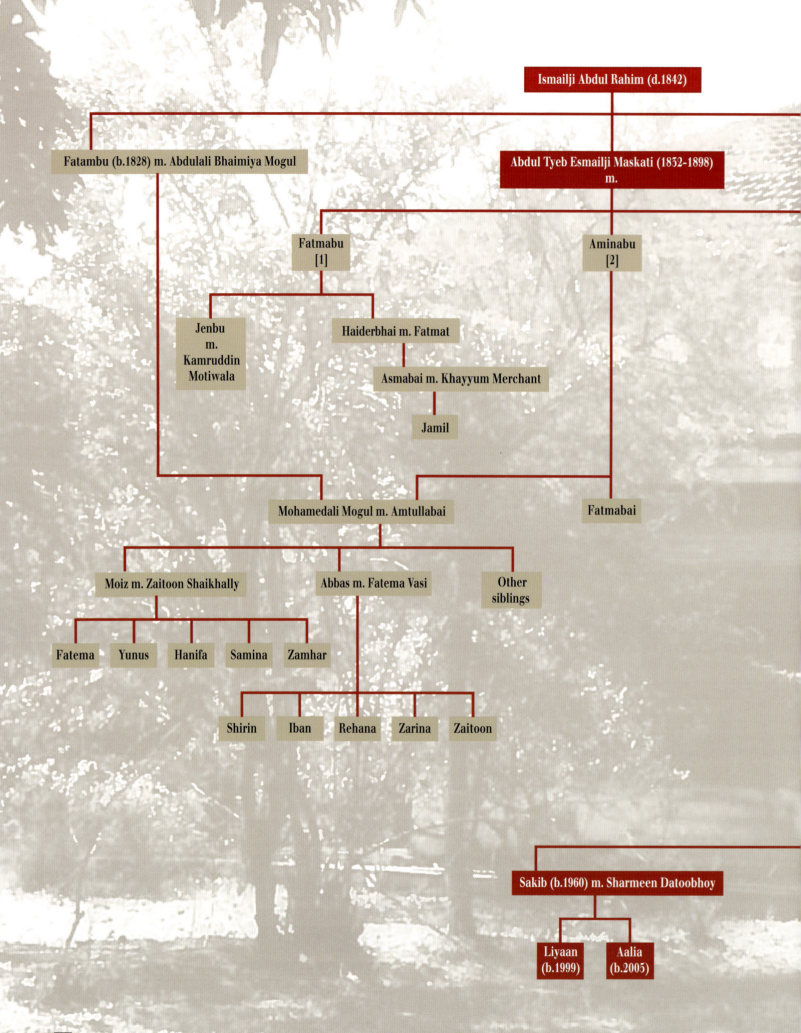

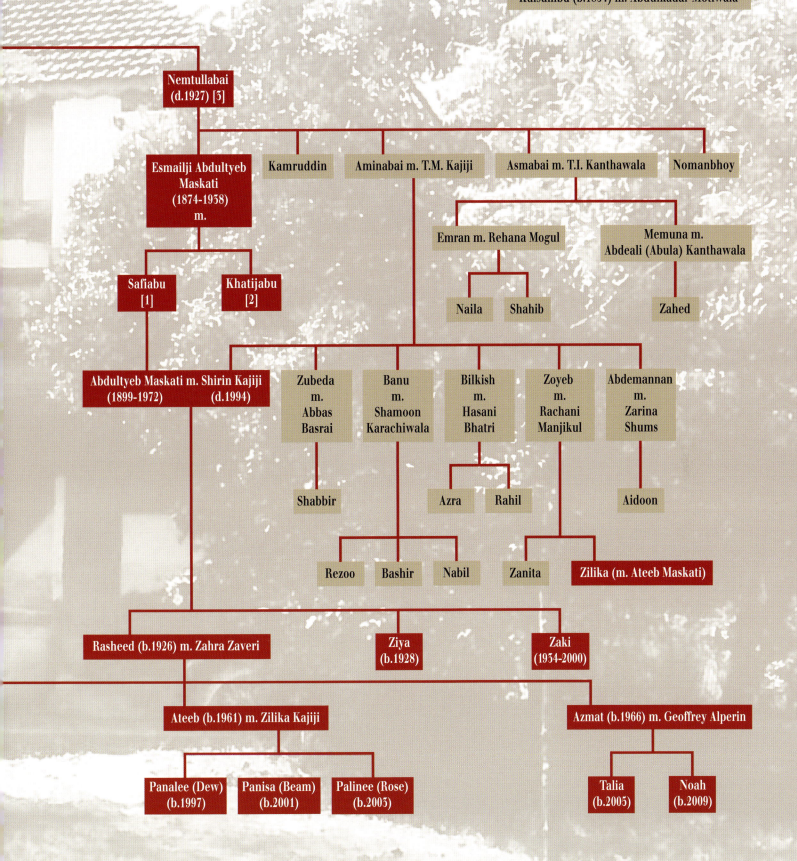

INDEX

A.E. Maskati & Co. (India) 149, 166, 167
A.T.E. Maskati Ltd. (Thailand 1948 onwards) 127, 128, 146, 150, 151, 152, 158, 159, 166
A.T.E. Maskati Co. Ltd. (current-day) 161, 166
Abdulali, Dawudbhai Shekh 49
Abdul Tyeb Abdulali (shop) 30, 43
Abdulhussein Hyderbhai & Co. (shop) 44
Adalja & Noorani 116-117
advertisements. See also *labels*
 A.E. Maskati & Co. 109, 149
 A.T.E. Maskati Ltd. 109, 149
 Garlick & Co. 115, 138
 Godrej 117
 Maskati cloth 101-103, 185
 New India Assurance 105
 Wasee & Co. 103
Ahmedabad 13, 30, 35, 39, 52, 54, 55, 57, 61, 63, 64, 70, 71, 73, 76, 83, 84, 85, 88, 90, 91, 114, 118, 124, 130, 137, 147, 171, 176, 177, 180, 181, 184
Ahmedabad Mirror 121
Alperin, Geoffrey 158, 159, 161, 172, 173, 189
American Civil War 33, 34, 35
Aminabu (second wife of Abdul Tyeb Maskati) 46, 188
Amtullabai (daughter of Abdul Tyeb Maskati) 46, 47, 64, 71, 188
Ang Eng Street (Rue Ohier, Phnom Penh) 49, 104, 105, 145, 146
Angkor Wat 52, 142. See also *wat (temples)*
Anik, Tyebjee 147, 167, 168, 172
Anjuman-I-Islam Association 121, 140, 145
Anuwongse Road (Maskati Bangkok office) 62, 81, 127, 134, 152, 158, 160
apsara 53
Aquasail Distribution Co. Pvt. Ltd. 171
Arnold, Sir Edwin 82
Asman Garh Palace 57
Astodia 55, 180, 181
astrologer 57
Atem Exports 164, 167
Atem Finance Pvt. Ltd. 163, 164, 167
Atem International Co. Ltd. 160, 162

Atemac (brand) 160
Atemsoftw 164, 167
Athwa Lines (house) 39, 57, 62, 63, 66, 67, 70, 91
Attaree, H.T. (Mrs.) 125, 131
Ayutthaya 20, 22-23, 26, 28, 32, 36, 28, 36, 79, 106
Bakhshi, Sandeep 164, 167,
Ballard Pier 88
Bangkok 11, 16, 22, 23, 24 (map), 25, 26, 28, 29, 30, 31, 32, 39, 44, 57, 59, 60, 79, 80, 81, 82, 99, 98, 121, 122, 123, 138, 158, 160, 170, 172. See also *Bangkok, Maskati business*
Bangkok, canals (*klong*) 16, 25, 26, 31, 59, 158
Bangkok, Maskati business 8, 12, 30-31 (first shop), 35, 36, 37, 38, 39, 44, 47, 49, 50, 52, 57, 58, 59, 62 (early office bdg.), 63, 67, 76, 79, 80, 81, 82, 88, 91, 98, 99, 100, 102, 104, 107, 108, 110, 121, 122, 123, 124, 127, 128, 130-131, 134, 137, 138, 146, 149, 150, 151, 152, 158, 159, 160, 161 (staff today), 166, 170 (charity), 178, 180
Bangkok, Maskati rental properties 81, 150, 152
Bangkok Calendar 25
Barking Deer Brewpub 171
Barmen Export-Gessellschaft 81
Basrai, Zubeda 131, 143, 154, 189
Basu, Nanda 150, 161
Battambang 38, 52, 104
Begumpura 46 (map), 63. See also *Begumpura, Maskati house*
Begumpura, Maskati house 10, 46, 38-39, 47, 57, 63, 70, 74, 93, 166
Bencharong 181
Bengal 20, 22, 88, 91, 98, 114
betel 16, 18, 67, 127, 128, 149, 151, 158, 160
Bidyalongkorn, Prince 91
block printing (of *saudagiri/pha lai*) 13, 52, 53, 54, 55, 57, 99-101, 171, 176, 177, 178-180. See also *block printers*
block printers 89, 101, 176, 178, 181, 52-55

Bohra (Dawoodi) 18, 25, 30, 31, 38, 46, 47, 55, 63, 67, 70, 72, 73, 74, 76, 79, 80, 82, 83 (dozdar), 88, 90, 91, 92, 93, 95, 98, 108, 118, 121, 127, 136, 140, 142, 146, 151, 152, 155
 dress 88, 93, 107, 118. See also *turbans*
 mosques 79, 80-81, 91
 reformist movement 93-95, 140
 syedna (leader) 72, 76
 thaal 25, 143, 155
Bombay (also Mumbai) 6-7, 12, 18, 22, 30, 33, 34, 35, 37, 38, 39, 43, 44-45, 47, 49, 50, 52, 55, 57, 59, 61, 62, 63, 64, 72, 74, 76, 81, 82, 83, 88, 89, 90, 91, 93, 106, 108, 114, 116, 117, 118, 119, 120, 121, 122, 123, 124, 126, 127, 131, 134, 135, 136, 137, 140, 141, 142, 146, 147, 148, 149, 151, 153, 154, 158, 159, 160, 163, 164, 167, 169, 180. See also *Mumbai (post-1995)*
Bombay, Baroda & Central India Railway, 34
Bombay Gazetteer 34, 83
Bombay High Court 64, 71
Bombay Samachar 84
Bombay Times 16, 29
Bose, Subhas Chandra 122
Bowring, Sir John 26, 28, 29, 36
Bowring Treaty, the 28, 29, 30 (Thai language), 31, 36, 38, 79
Bradley, Dr. Dan Beach 25
British East India Company 106
Burma (Myanmar) 13, 16, 19, 22, 28, 67, 76, 78, 79, 91, 103-104, 108, 114, 123, 134, 171. See also *Martaban, Moulmein, Rangoon, Tenasserim*
Burma, anti-Indian riots 103-104
Business Insider 149
Buildboard Distributors 167
Calcutta 35, 43, 91, 108, 134, 142
Cambodia 8, 13, 32, 38, 48, 49-50, 51, 52, 76, 79, 104, 105 (Maskati office), 127, 134, 140, 142, 143, 145-146, 150, 171, 182. See also *Angkor Wat, Battambang, Phnom Penh*
Cecil Street 42, 104, 129
centenary (Maskati) 130-131

191

C.F. Parekh Dispensary 140. See also *Maskati Hospital*
Chao Phraya River 16, 17, 25, 59, 81
Charoenphas riverside pier (Bangkok) 170
Chhaganlal, Trikamlal 55
China 16, 19, 29, 36, 38, 52, 55, 79, 90, 121, 123
Chinatown (Bangkok) 25, 27, 59, 81, 152, 160
Chinese merchants 22, 25, 44, 57, 81
Chiniwala, Haribhai 25
Chiniwala (shop) 26
chintz 22, 23
chippas 55, 180
Chotivudh, Pisamai (Miss Siam) 102-103
Chulalongkorn, King 43, 57, 59, 61, 79, 81, 82
Chulalongkorn, Prince 32
Churchgate 164, 169
Civil Disobedience Movement (India) 88, 114. See also *swadeshi*
Clarke, Sir George 72-73
Colaba 82, 114, 119, 120, 136, 140, 143, 151, 159, 172
Colonial Office (London), 28-29
colour (of *pha lai* or *saudagiri*) 13, 23, 35, 36, 54, 57, 61, 99, 101, 102, 176, 179, 180, 181, 184
Constitution Day Fair (Bangkok) 99, 100, 102
Contractor, Mohsin 118, 142
corge 44, 61. See also *culie*
Coromandel coast 20-21, 22, 79
cranes 129, 137, 141
Crawford, John 22
Crawford Market 34, 37
Cricket Club of India (CCI) 149, 153
culie 44, 57. See also *corge*
Daguan, Zhou 52
dammar 127, 158
Damrong, Prince 56-57, 98
Dawoodbhoy, Husain 167,
Dawoodkhan, A.S. 106, 107
Debsirindra, Queen 32-33
Desai, Morarji 127, 140
Desai, Mika and Madhavi 120
Divali 148, 151
Doon School 134, 147, 172
dress, Cambodian (*pha lai*) 50-51, 52
dress, Siamese (*pha lai*) 22-23, 32-33, 36-37, 44, 60-61, 102-103, 123. See also *jong krabaen*
Dumas (house) 66-67

dye 13, 23, 52, 55, 79, 99, 101, 102, 147, 180, See also *colour*
Ebrahim, Sir Currimbhoy 108
elephants 22, 49, 79
Elphinstone Circle 34
Empire Industries Ltd. 147, 148
England 33, 35, 45, 57, 119, 126, 134, 140. See also *London*
Eros Cinema 137
fabric. See *textiles*
fashion. See *dress* and *turbans*
Fatambu (older sister of Abdul Tyeb Maskati) 18, 47, 188
Fatmabai (daughter of Abdul Tyeb Maskati) 46, 49, 63-64, 71, 188
Fatmabu (first wife of Abdul Tyeb Maskati) 30, 188
Finlayson Green 42, 104
Flavours of the Orient 152, 160
Fort Stikine explosion (Bombay) 121
Frith, Francis 33, 34, 35
G.H. Café 104
Gajjar, Maneklal T. 178, 181
Gandhi, Indira 146
Gandhi, Mahatma 88, 90, 91, 114
Garlick & Co. 114, 117, 129, 134, 137, 139, 141, 142, 147, 153, 160. See also *advertisements*
German Remedies Ltd. 147, 167, 168
Germany 13, 99, 140
Godrej (company) 117, 142, 148, 149, 160
Golden Mount (Bangkok) 26, 27, 158
Grand Palace (Bangkok) 16, 30, 100
Great Indian Peninsula Railway 45
Gujarat, or Gujarati 20, 22, 23, 25, 34, 35, 38, 50, 52, 55, 74, 84, 88, 91, 98, 114, 138, 147, 176, 178, 181, 184
Guy, John 106
Hajeebhoy, Zia 171
Haynes, Douglas E. 38
Hobson Jobson 44
Hornaday, William 43
horses 13, 39, 56, 57, 63, 66, 67, 90, 122, 123, 154, 155
India 12, 13, 16, 18, 19, 20, 22, 23, 25, 26, 30, 31, 32, 34, 35, 36, 37, 38, 39, 43, 44, 47, 49, 52, 54, 55, 56, 57, 59, 61, 67, 70, 73, 76, 79, 83, 88, 90, 91, 92, 98, 99, 103, 104, 105, 106, 108, 110, 111, 114, 116, 117, 118, 124, 126, 127, 128, 129, 134, 137, 138, 140, 141, 142, 145, 146, 147, 148, 149, 151, 152, 153, 159, 160, 163,

164, 165, 166, 167, 168, 169, 170, 171, 176, 177, 178, 179, 180, 181, 182
Indian Harvest 167
Indian National Army (INA) 122
Indochina 13, 19, 28, 49, 50, 142, 146, 171
Indonesia 16, 18, 19, 23, 42, 61, 114, 123
Indus Creed (formerly Rock Machine) 164
Iraq 64, 108
Irwin, John 181
Isabhai, Abdulhussein Mulla 44, 49, 63
Italian Societa Commissionaria 81
Jataka Tales 19
Janati, Abbas 135, 146
Japan 88, 105-108, 110-111, 116, 121, 122, 123, 129, 168, 171
Japanese Imperial Army 121-123
jari (gold/silver thread) 50
Jeevan, Vrajlal 35, 52
Jenbu (daughter of Abul Tyeb Maskati) 46, 47, 56, 188
Jinnah, Muhammad Ali 126, 127
jong krabaen 13, 23, 32, 50, 60-61, 102-103, 123
jute 13, 91, 127, 128, 129, 145
Kajiji, Abdemmann. T. 137, 139, 143, 147, 167, 189
Kajiji, Aidoon 143, 147, 154, 189
Kajiji, Niloufer 143
Kajiji, Rachani 143, 158, 161, 162, 189
Kajiji, Shirin. See *Maskati, Shirin*
Kajiji, T.M. 72, 147, 169, 189
Kajiji, Zarina 143, 154, 189
Kajiji, Zoyeb. T. 128, 131, 137, 139, 146, 150, 151, 152, 159, 160, 189
Kamruddin Adultyeb (shop) 50
Kane, K.S. 163, 167
Kanthawala, Emran 139, 141, 143, 189
Kanthawala, Rehana 141, 189
Kapadia, Kishore 163
Kapasi, Badruddin A. 100, 107, 121, 123, 124, 125, 127, 151
Kapasi, Husamuddin B. 127
Kapasia Bazar Road 70, 71
Karbala (Iraq) 64
Khara, Himmat 172
Khmer, 25, 49, 50, 52, 127. See also *Cambodia*
Khmer Rouge 145-146, 150
kien 127
klong. See Bangkok, canals
Kobe 106, 107, 108 (map), 109, 116, 129
Kosmocare 168

Kosmochem Pvt. Ltd. 147, 164, 165, 167, 168, 169, 171,
Kuberd, Chhagan 35, 52
Kudrolli, Shakeel 171
labels (Maskati) 8, 98-99, 102-103, 176, 186, 190, 195, 200. See also *logos*
Lahore 18, 108
Lalbhai, Balubhai 11, 12-13, 26, 35, 38, 47, 56-57, 61, 63, 64, 93
Lambert, Gustav (photographs) 32-33, 36
Lampang (Maskati seedlac factory) 160, 162
Lenz, Robert (photographs) 32-33, 36, 59, 60
Lermit, Alfred 42
Letterheads (Maskati) 166. See also *logos*
logos (Maskati) 99, 100, 166
London 19, 28, 30, 141, 176, 181, 182, 185
Loubère, Simon de la 23
Lumpini Hall (Bangkok) 130-131
Mae Sot 79
Mahabaleshwar (house) 154-155, 172
Mahalaxmi race grounds 123
Makkawala, Y.M. 107
Malacca 16, 19, 22, 23, 79
Malay Peninsula or Malaysia 16, 19, 28, 52, 61, 121. See also *Malacca*
Malbari (*pha lai* business) 98, 124, 178
Malhotra, Satish C. 147, 172, 173
Malloch, D.E. 35
Manchester 52, 55, 61, 70
Maneklal, Dahyabha, 44
Manohar, Aneesh 154, 167
maps 19, 20-21, 24, 46, 108, 109
Marican, M.T.S. 81
Martaban (Mottoma) 76, 79, 103, 105
Mascom Electronics 148, 160, 163, 167
Maskati, Abdul Tyeb (founder) 4-5, 10, 12-13, 16, 18, 22, 23, 25-26, 30-31, 34-38, 39, 42, 43, 44, 46-50, 52, 55, 56-57, 59, 61-65, 66, 67, 70, 71, 72, 73, 74, 76, 79, 82, 85, 91, 92, 104, 110, 120, 130, 135, 136, 138, 141, 142, 147, 158, 160, 166, 171, 184, 188
Maskati, Abdultyeb 13, 81, 82, 83, 88, 91, 93, 95, 96-97, 104-105, 106, 107, 108, 111, 114, 116, 117, 118, 119, 121-124, 125, 126-127, 129, 131, 134, 135, 136, 137, 138, 139, 140, 141, 142, 143, 144, 145, 147, 151, 153-154, 166, 169, 170, 171, 184, 189
Maskati, Ateeb 10-11, 151, 152, 154, 158-160, 161, 162, 164, 167, 170, 171, 172, 189

Maskati, Azmat (married, Alperin) 11, 154, 158, 159, 161, 167, 172, 173, 189
Maskati, Esmailji 46, 63, 64, 70, 71, 74, 79, 81, 82, 88, 90, 91, 92, 93, 106, 107, 118, 119, 135, 189
Maskati, Haiderbhai 46, 47, 49, 63, 64, 71, 188
Maskati, Kamruddin 50, 74, 93, 189
Maskati, Nemtullabai 46, 50, 62, 63, 66, 70, 71, 72, 73, 74, 75, 76, 85, 92, 93, 95, 118, 120, 140, 189
Maskati, Nomanbhoy 93, 189
Maskati, Rasheed 11, 116, 118, 119, 120, 127, 131, 134-135, 136, 138, 139, 140, 143, 145, 147, 148, 152, 154-155, 158, 159, 160, 161, 162, 163, 164, 167, 168, 171, 172-173, 189
Maskati, Sakib 11, 148, 153, 154-155, 158-159, 160-171, 172-173
Maskati, Sharmeen (née Datoobhoy) 11, 161, 168, 173, 188
Maskati, Shirin (nee Kajiji) 88, 89, 91, 107, 118, 119, 131, 136, 139, 140, 143, 147, 153, 154-155, 159, 170, 188
Maskati, Zaki 118, 119, 131, 134, 135, 138, 139, 140, 145, 147, 148, 149, 151, 152, 153, 154-155, 160, 164, 167, 168, 188
Maskati, Zahra (née Zaveri) 11, 136, 143, 154-155, 158, 159, 161, 162, 172-173, 188
Maskati, Zilika (née Kajiji) 11, 129, 152, 160, 161, 162, 170, 172-173, 188
Maskati, Ziya 11, 67, 76, 118, 119, 120, 121, 131, 140, 142, 143, 151, 159, 161, 168, 170, 172-173, 188
Maskati Charitable Dispensary 72-74, 76, 92, 93, 114, 141
Maskati Charitable Properties Trust 93, 140, 141, 170
Maskati Cloth Market (Ahmedabad) 70-73, 84-85, 90, 91, 137
Maskati Court 164, 169, 171
Maskati Foundation (Thailand) 170
Maskati Hospital, C.F. Parekh Dispensary 140, 141
Maskati House 6-7, 116-117, 131, 135, 148, 149, 164, 169, 171
Maskati Mahajan (Guild) 71, 114
Maskati Market Guild. See *Maskati Mahajan*
Maskati Maternity Clinic 76, 93 141
Maskati Plots (Surat) 39
Maskati Villa 118, 119, 120, 121, 136, 140, 143, 148, 151, 159, 172

Mehta, Homi 154, 172
Merchant, Jamil 47, 142, 147, 165, 188
mill (textile) 33-35, 52, 54, 55, 70, 82, 84, 90, 91, 114
Miss Siam. See *Chotivudh, Pisamai*
Mogul, Abdulali 18, 22, 25, 30, 31, 34, 35, 36, 37, 42, 43, 44, 47, 49, 63, 141, 151, 188
Mogul, Shirin 74
Mogul, Yunus 151, 188
Mohammedali Road 6-7, 116, 117, 148, 164, 169, 171
Mohammadali, Tyabali 67
Moll, Herman 19
Mongkut, King 26, 27, 28, 30, 32
Moochalawala (shop) 26
Mosque, Saifee 79, 80-81
motifs (of *pha lai* or *saudagiri*). See *patterns*
Motiwala, Jenbu (ne Maskati) 46, 47, 56, 188
Mouhot, Henri 30
Moulmein (Mawlamyine) 76, 79
Mumbai 147, 165, 168, 169, 170, 171, 172. See also *Bombay*
Muscat 18, 73, 124
Mussulman Square (Bangkok) 25, 59
Myanmar. See *Burma*
Nagarajan, S. 163, 167
Nagdevi Street 35, 37, 63, 82, 116
Narai, King 22
Naris, Prince 56
National Museum (Bangkok) 23
Navalram (educationist) 55
Nehru, Jawaharlal 96, 123
Nemtullabai Trust 140
New India Assurance Co. Ltd. 105
New York 95, 110, 114, 119
Norodom, King 49, 104
notebook (Abdultyeb Maskati) 96-97
Noritake 107, 110-111, 137
Ohier, Rue. See *Ang Eng Street*
Oman 18
Ovington, John 23
Padung Krung Kasem canal 26
Pakistan 108, 126-127, 149, 176
partition (India) 126
Paskornwongse, Chao Phraya 32, 33, 57, 59
patterns (of *pha lai* or *saudagiri*) 13, 35, 36, 52, 54, 99, 102, 176-181, 184-185
Pethapur 176, 181
Pavie, Auguste 49
Persia, Persian 18, 22, 39, 52, 176

193

pha lai 9, 23, 32-33, 35, 36, 44, 50, 52, 57, 58, 61, 98-101, 102-103, 123, 127, 149, 176-185. See also *saudagiri*

pha nung 32, 50, 61, 123, 180

Phibulsongkram, Plaek Field Marshal 121, 122, 123

Phnom Penh 8, 38, 49, 50, 76-77, 91, 98, 99, 104, 105, 121, 124, 134, 135, 140, 142, 145-146, 150

pirates 16, 29

Plynet Traders 147, 167

porcelain. See *Bencharong, Noritake, Shimada*

Portuguese 23, 25, 106

postcards 37, 42, 48, 50-51, 78, 90, 154

Praneet Factory 102

Premjit, Yasmeen 35

Presswala, Munaf 165, 167, 168, 169

Presswala, Tyzoon 168

printing blocks (for *pha lai* or *saudagiri*). See *block printing*

property chart (Maskati Estates) 76-77

Raffles, Sir Stamford 42

Raffles Hotel 129

Raffles Place 42

Rahim, Ismailji Abdul (father of Abdul Tyeb Maskati) 18, 188

Ramasut-Mekhala, 101. See also *Seng, Ake and Praneet Factory, Thai Art Factory*

Ranchhod, Jethabhai 44

Rane Pvt. Ltd. 134, 139, 147, 148, 153, 165, 167, 169

Rangoon (Yangon) 79, 103, 108, 134

Raziki (company) 137

Rao, Narasimha 147, 169,

Rashid Mansions 116

Ratchawongse 59, 81

Rathaniyom (Cultural Mandates) 123

RMS Queen Mary 119

Rock Machine (band, later Indus Creed) 164

Rome 119

Royal Palace (Phnom Penh) 48-49

Sabarmati River 55, 171, 180

Sakar Bazar Road 70, 85

Sakai Works 129, 137

Saklatvala, Sir Nowroji 105

Sampeng 25

sample books (for *saudagiri* or *pha lai*) 35, 52, 54, 178-179

Santa Cruz Church 25

Saowapha, Queen 60-61

Saranrom Gardens (Bangkok) 99, 100

sarong. See *pha nung*

saudagiri 52, 55, 57, 61, 79, 88, 98, 104, 110, 124, 127, 130, 171, 176-185. See also *pha lai*

Savaijiwala, Yasin 184

seedlac 128, 158, 160, 162

Selwyn, Mark 164, 165, 167, 169

Seng, Ake 99-101. See also *Praneet Factory*

Seven Islands Craft Brewery Pvt. Ltd. See *Barking Deer Brewpub*

Shahani, Lalit 164, 167

Shimada 111

ships and shipping 12, 13, 16, 18-19, 22, 29, 31, 33, 37, 38, 42, 44-45, 47, 52, 55, 59, 67, 76, 79, 88, 104, 107, 108-109, 116, 119, 121, 125, 126, 134, 137, 166, 171, 172

Siam, 12, 13, 16, 18, 20, 22, 23, 25, 26, 28, 29, 30, 31, 32, 33, 35, 36, 37, 38, 43, 44, 47, 49, 50, 52, 54, 55, 57, 59, 61, 67, 73, 76, 79, 81, 82, 91, 98, 99, 102, 171, 176, 177, 178, 179, 181. See also *Thailand (after 1939)*

Siam Rath 99

silver miniatures (Maskati family collection) 90

Singapore 13, 16, 29, 38, 42, 43, 47, 49, 61, 64, 73, 76, 79, 88, 91, 104, 105, 108, 118, 121, 122, 123, 124, 125, 126, 129, 131, 150, 168, 169, 171

Sri Lanka 19, 108, 167

SS Khumri 76

SS Madina 76, 104

SS Mecca 104

Suan Pakkard Museum 23

Sumitomo Electric Industries Ltd. 107, 129

Sunday Gatherings 143

Surat 10, 12, 18, 19, 20, 22, 23, 26, 30, 35, 38, 39, 46 (map), 47, 49, 50, 56, 57, 61, 62, 63, 64, 66, 67, 70, 71, 72, 73, 74, 76, 83, 88, 90, 91, 92, 93, 95, 103, 118, 140, 141, 147, 166

swadeshi 55, 88, 90, 91, 99

Swettenham, Sir F.A. 76

syedna. See *Bohra*

Syseng Data Techniques Pvt. Ltd. 163-164, 167

Systemantics India Pvt. Ltd. 171

Tagore, Rabindranath 67, 96, 97, 98

Taj Mahal 99

Takuan, Chou. See *Daguan, Zhou*

Tapti River 56

Tata (group) 105, 108, 148, 163

Tenasserim (Tanintharyi) 22, 79

temples. See *wat*

Teuk Khao. See *Mosque, Saifee*

textile agents (India). See *Jeevan, Vrajlal; Kuberd, Chhagan; Maneklal, Dahyabhai; Ranchhod, Jethabhai*

textiles. See *colour (dye), chintz, jari, kien, mill, patterns, pha lai, block printing and block printers, sample books, saudagiri*

textiles from Maskati private collection 5, 12, 14-15, 40-41, 68-69, 84-85, 86-87, 112-113, 130-131, 132-133, 156-157, 174-175, 178, 182-183, 184, 204

thaal. See *Bohra, thaal*

Thai Arts Factory, 101. See also *Seng, Ake, and Praneet Factory*

Thailand, 9, 11, 12, 13, 23, 38, 61, 88, 98, 102, 108, 117, 121, 124, 127, 128, 129, 131, 143, 145, 146, 149, 150, 151, 160, 161, 162, 164, 168, 170, 171, 176, 177, 182. See also *Siam (pre-1939)*

Thamrongnawasawat, Thawan 125

Thomson, John (photographs) 17, 27, 37

Thong Soon Chiang 81

Times of India newspaper 61, 70, 71, 72, 74, 91, 93, 95, 141, 142, 171

Tonle Sap River 49, 104

Traiphum 20-21

turbans 49, 83, 88, 93, 118

Tyebjee, Amirudin Shalebhoy 93, 122, 123

Uniland Estates 164, 165, 167, 169, 171

Vajiravudh, King 79, 82

Vasi (family) 91, 98. See also *Wasee*

Venice 119

Vietnam 114, 142

Vincent, Frank Jr. 44

Walke, Mahesh 164, 167

Wasee (*pha lai* business) 102-1-3, 124, 178. See also *Vasi*

wat (temples)
 Angkor Wat 52, 142.
 Wat Arun (Temple of Dawn) 16, 158
 Wat Kalayanamitr 16
 Wat Matchimawas 23
 Wat Suwannaram 36

World War I 90

World War II 13, 39, 107, 114, 121-123, 125, 127, 129, 134, 142, 147, 171, 172, 181

Young Men's Bohra Association (YMBA) 93-95

Yule, Henry 44

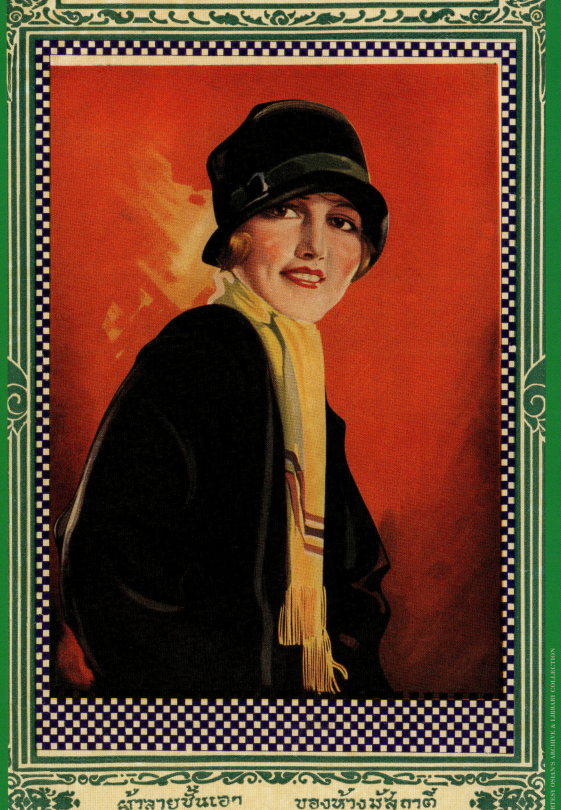

BIBLIOGRAPHY

Sources & further reading

1. Trade:
On history of trade between India and Southeast Asia

Arasaratnam, Sinnappah, 'The Coromandel-Southeast Asia Trade 1650-1740: Challenges and Responses of a Commercial System', *Journal of Asian History*, Vol. 18, No. 2 (1984): pp. 113-135

Baker, Chris, 'Ayutthaya Rising: From Land or Sea?', *Journal of Southeast Asian Studies*, Vol. 34, No. 1 (Feb., 2003): pp. 41-62

Breazeale, Kennon (ed.), *From Japan to Arabia: Ayutthaya's Maritime Relations with Asia*, Bangkok: Foundation for the Promotion of Social Science and Humanities Textbooks Project, 1999

Christie, Jan Wisseman, 'Asian Sea Trade between the Tenth and Thirteenth Centuries and its Impact on the States of Java and Bali', in *Archaeology of Seafaring: The Indian Ocean in the Ancient Period*, edited by Himanshu Prabha Ray, Delhi: Indian Council of Historical Research Monograph Series I, 1999

Kasetsiri, Charnvit, *The Rise of Ayudhya: A History of Siam in the Fourteenth and Fifteenth Centuries*, Kuala Lumpur and New York: Oxford University Press, 1976

La Loubère, Simon De, *A New Historical Relation of the Kingdom of Siam by Monsieur de La Loubere, Envoy Extraordinary from the French King to the King of Siam in the Years 1687 and 1688*, originally published as *Du Royaume de Siam* (Paris, 1691), Singapore: Oxford University Press, 1986

Pires, Tomé, *The Suma Oriental of Tomé Pires: An Account of the East, from the Red Sea to Japan, Written in Malacca and India in 1512-1515*, translated by Armando Contesão, London: Hakluyt Society, 1944

Smith, George V., *The Dutch in Seventeenth-Century Thailand* (Special Report No. 16), DeKalb: Northern Illinois University, Center for Southeast Asian Studies, 1977

Tagliacozzo, Eric, 'Ambiguous Commodities, Unstable Frontiers: The Case of Burma, Siam and Imperial Britain, 1800-1900', *Comparative Studies in Society and History*, Vol. 46, No. 2 (2004): pp. 354-377

Tarling, Nicholas, 'The Mission of Sir John Bowring to Siam', *Journal of the Siam Society*, Vol. 50, No. 2, (1962): pp. 91-118

2. Textiles:
On trade in textiles

Barnes, Ruth (ed.), *Textiles in Indian Ocean Societies*, Oxon and New York: Routledge Curzon, 2005

Beckert, Sven, *Empire of Cotton: A New History of Global Capitalism*, United Kingdom: Penguin Books, 2014

Guy, John, *Woven Cargoes: Indian Textiles in the East*, London: Thames and Hudson, 1998

Paskornwongse, Chao Phraya, 'Taxation on Indian Textiles' [Thai language], Bangkok: Custom Office (National Archive Thailand), 1884

Posrithong, Prapassorn, 'Muslim Indian and Textile Trade in Thai History' [Thai language], *Aksornart Journal*, Vol. 36, No. 1 (2007): pp. 173-188

Reid, Anthony, 'Southeast Asian Consumption of Indian and British Cotton Cloth, 1600-1850' in *How India Clothed the World: The World of South Asian Textiles, 1500-1850*, edited by Giorgio Riello and Tirthankar Roy, Leiden: BRILL, 2009

On textile production and composition

Archambault, Michele, 'Blockprinted Fabrics of Gujarat for Export to Siam: An Encounter with Mr. Maneklal T. Gajjar', *Journal of the Siam Society*, Vol. 77, No.2 (1989): pp. 71-73

Barnes, Ruth, with Steven Cohen and Rosemary Crill, *Trade, Temple and Court: Indian Textiles from the Tapi Collection*, Mumbai: India Book House, 2002

Bühler, Alfred, 'Patola Influences in Southeast Asia', *Journal of Indian Textile History*, Vol. IV, 1959

Damrong, Rajanubhab, Prince and Prince Naritsaranuwattiwong, *San Somdet* [Royal Letters, in Thai language], Bangkok: Kurusapa Printing Press, 1962

Edwards, Eiluned, *Block Printed Textiles of India: Imprints of Culture*, New Delhi: Niyogi Books, 2016

Gittinger, Mattiebelle, *Master Dyers to the World: Technique and Trade in Early Indian Dyed Cotton Textiles*, Washington, D.C.: Textile Museum, 1982

Posrithong, Prapassorn, 'Artistic Relations between Indian Textiles for the Thai Market and Bencharong Ware' in *Royal Porcelain from Siam: Unpacking the Ring Collection*, edited by Anne Håbu and Dawn F. Rooney, Oslo: Hermes, 2013

Shah, Deepika, *Masters of the Cloth: Indian Textiles Traded to Distant Shores* (Tapi Collection, Surat), New Delhi: National Museum, 2005

See also **Thailand**: On early advertising and *pha lai* textile production in Thailand (page 199)

3. Countries

3.1 Burma/Myanmar
On history of Martaban, Burma

Gutman, Pamela, 'The Martaban Trade: An Examination of the Literature, c. 7th-18th Centuries', paper presented at the Symposium on Trade Pottery in East and South-East Asia, Chinese University of Hong Kong, Hong Kong, September 4-8, 1978

Mills, Janell A., 'The Swinging Pendulum: From Centrality to Marginality – a Study of Southern Tenasserim in the History of Southeast Asia', *Journal of the Siam Society*, Vol. 85 (1997): pp. 35-58

See also, **Trade**: On history of trade between India and Southeast Asia (page 196)

On 1930s anti-Indian riots in Burma

Collis, Maurice, *Trials in Burma*, London: Faber and Faber, 1938

Myint-U, Thant, *The River of Lost Footsteps: A Personal History of Burma*, London: Faber & Faber, 2008

Tun, Than, 'Race Riots in Burma', *Workers' International News*, Vol. 1., No. 9, September 1938: 8-10

3.2 Cambodia
On Phnom Penh

Osborne, Milton, *Phnom Penh: A Cultural and Literary History*, Oxford: Signal Books, 2008

On dress in Angkor-era Cambodia

Daguan, Zhou (also Chou Takuan), *The Customs of Cambodia*, translated by Michael Smithies, Bangkok: The Siam Society, 2001

Green, Gillian, 'Indic Impetus? Innovations in Textile Usage in Angkorian Period Cambodia', *Journal of the Economic and Social History of the Orient*, Vol. 43, No. 3 (2000): pp. 277-313

Green, Gillian, 'Angkor Vogue: Sculpted Evidence of Imported Luxury Textiles in the Courts of Kings and Temples', *Journal of the Economic and Social History of the Orient*, Vol. 50, No. 4 (2007): pp. 424-451

3.3 India
General

Keay, John, *India: A History*, London: HarperCollins, 2000

Yule, Henry, *Hobson-Jobson: a glossary of colloquial Anglo-Indian words and phrases, and of kindred terms, etymological, historical, geographical and discursive*, London: John Murray, 1903

Newspapers: *The Times of India*

3.3.1 Ahmedabad
On history of Ahmedabad

John, Paul and Ashish Vashi, *Ahmedabad Next: Towards a World Heritage City*, New Delhi: Time Group Books, 2011

Yagnik, Achyut and Suchitra Sheth, *Ahmedabad: From Royal City to Megacity*, New Delhi: Penguin Books, 2011

On textile industry in Ahmedabad

Spodek, Howard, 'The 'Manchesterisation' of Ahmedabad', *Economic & Political Weekly*, Vol. 17, No. 11 (13 March 1965): pp. 483-490

Spodek, Howard, 'Traditional Culture and Entrepreneurship: A Case Study of Ahmedabad', *Economic & Political Weekly*, Vol. 4., No.8 (22 February 1969): pp. M27-M31

3.3.2 Bombay
On development of Bombay

Arnold, Edwin cited (pp. 14) in *A Handbook for Travellers in India, Burma and Ceylon*, London: John Murray, 1911

Dossal, Miriam, *Theatre of Conflict, City of Hope: Mumbai 1660 to Present Times*, New Delhi and Oxford: Oxford University Press, 2010

Dossal, Miriam, *Imperial Designs and Indian Realities: The Planning of Bombay City, 1845-1875*, New Delhi and Oxford: Oxford University Press, 1996

Edwardes, S.M. and Sir James MacNabb Campbell, *Gazetteer of Bombay City and Island*, Bombay: Times Press, 1909

Kidambi, Prashant, *The Making of an Indian Metropolis: Colonial Governance and Public Culture in Bombay, 1890-1920*, Aldershot and Burlington: Ashgate, 2007

London, Christopher W., *Bombay Gothic*, Mumbai: India Book House, 2002

Premji, Yasmeen, *Days of Gold & Sepia* (a novel), India: HarperCollins, 2012

Wright, Arnold (ed.), *The Bombay Presidency, The United Provinces, The Punjab, Etc.: Their History, People, Commerce, and Natural Resources*, London: Foreign and Colonial Compiling and Publishing Co., 1920

On bungalow architecture in Bombay

Desai, Madhavi and Miki Desai, 'The Adaptation and Growth of the Bungalow in India' in *European Houses in Islamic Countries*, edited by Attilio Petruccioli, Rome: *Journal of the Islamic Environmental Design Research Centre*, 1995

Desai, Madhavi with Miki Desai and Jon Lang, *The Bungalow in 20th Century India: The Cultural Expression of Changing Ways of Life and Aspirations in the Domestic Architecture of Colonial and Post-Colonial Society*, Farnham and Burlington: Ashgate, 2012

3.3.3 Surat
On history of Surat

Haynes, Douglas E., *Rhetoric and Ritual in Colonial India: The Shaping of a Public Culture in Surat City, 1852-1928*, Oakland: University of California Press, 1991

Haynes, Douglas E., 'From Tribute to Philanthropy: The Politics of Gift Giving in a Western Indian City', *The Journal of Asian Studies*, Vol. 46., No. 2 (May 1987): pp. 339-360

Khurana, Ashleshaa, *Khoobsurat: Hope for Heritage – Gem of a City in the Columns of the Times of India*, New Delhi: Time Group Books, 2013

Nadri, Ghulam A., 'The Maritime Merchants of Surat: A Long-Term Perspective', *Journal of the Economic and Social History of the Orient*, Vol. 50, No. 2/3 (2007): pp. 235-258

Ovington, John, *A Voyage to Suratt in the Year 1689*, edited by H.G. Rawlinson, Oxford: Oxford University Press, 1929

Parveen, Sagufta, 'Surat: As a Major Port-Town of Gujarat and its Trade History', *IOSR Journal of Humanities and Social Science (IOSR-JHSS)*, Vol. 19, Issue 5 (May 2014): pp. 69-73

3.4 Japan
On trade between India and Japan

Guy, John, *Woven Cargoes* (see, **Textiles**)

Shimizu, Hiroshi, 'The Indian Merchants of Kobe and Japan's Trade Expansion into Southeast Asia before the Asian-Pacific War', *Japan Forum*, Vol. 17, No. 1 (2005): pp. 25-48

Tolliday, Steve and Yasushi Yonemitsu, 'Microfirms: Industrial Districts in Japan: The Dynamics of the Arita Ceramic-Ware Industry in the Twentieth Century', *The Journal of Japanese Studies*, Vol. 33, No. 1 (2007): pp. 29-66

3.5 Thailand
General

Baker, Chris and Pasuk Phongpaichit, *A History of Thailand*, Cambridge: Cambridge University Press, 2014

Fine Arts Department, *Heritage of Thai Culture*, Bangkok: Rungsilp Printing, 1993

On history of Bangkok and Siam

Campbell, John G.D., *Siam in the Twentieth Century, Being the Experiences and Impressions of a British Official*, London: Edward Arnold, 1902

Child, Jacob T., *The Pearl of Asia, Reminiscences of the Court of a Supreme Monarch; or Five Years in Siam*, Chicago: Donohue, Henneberry & Co., 1892

Cort, Mary Lovina, *Siam: Or the Heart of Farther India*, New York: Anson D.F. Randolph & Company, 1886

Gervaise, Nicolas, *The Natural and Political History of the Kingdom of Siam*, Bangkok: White Lotus, 1989

Loftus, Alfred J., *A New Year's Paper on the Development of the Kingdom of Siam (1890)*, British Library: Historical Print Editions, 2011

Malloch, D.E., *Siam: Some General Remarks on its Productions, and Particularly its Imports and Exports, and the Mode of Transacting Business with People*, Calcutta, 1852

Neale, Frederick Arthur, *Narrative of a Residence at the Capital of the Kingdom of Siam, with a Description of the Manners, Customs, and Laws of the Modern Siamese*, London: Office of the National Illustrated Library, 1852

Smithies, Michael, *Old Bangkok*, Singapore: Oxford University Press, 1986

Thompson, P.A., *Lotus Land: being an account of the country and the people of southern Siam*, London: T. Werner Laurie, 1906

Vincent, Frank, *The Land of the White Elephant: Sights and Scenes in South-Eastern Asia*, London: Sampson Low, Marston, Low & Searle, 1873

Wright, Arnold and Oliver T. Breakspear, *Twentieth Century Impressions of Siam: Its History, People, Commerce, Industries, and Resources*, London: Lloyd's Greater Britain Publishing Co. Ltd., 1908

Young, Ernest, *The Kingdom of the Yellow Robe, being Sketches of the Domestic and Religious Rites and Ceremonies of the Siamese*, London: Archibald Constable & Co., 1898

Directories & Reports: *Directory for Bangkok & Siam*, Bangkok: Bangkok Times, 1892; *American Trade with Siam: a report*, Philadelphia: Commercial Museum, 1898; and *Importers & Exporters Directory for Siam*, Bangkok, Ministry of Commerce, 1924

On changing fashions in Siam/Thailand

Chitrabongs, M.L. Chittawadi, 'Cleanliness in Thailand: King Rama V's 'Strategy of Hygiene' from Urban Planning to Dress Codes in the Late 19th Century', unpublished Ph.D. thesis, 2010

Chongkol, Chira, 1982, 'Textiles and Costume in Thailand', *Arts of Asia*, Vol. 12, No. 6 (1982): pp. 124-31

Kepner, Susan Fulop, *A Civilized Woman: M.L. Boonlua Debyasuvarn and the Thai Twentieth Century*, Chiang Mai: Silkworm, 2013

Peleggi, Maurizio, *Lord of Things: The Fashioning of the Siamese Monarchy's Modern Image*, Honolulu: University of Hawaii, 2002

On Rabindranath Tagore in Thailand

Poolthupya, Srisurang, 'Rabindaranth Tagore's Contributions to Thailand and the World', *The Journal of the Royal Institute of Thailand*, Vol. III (2011): pp.16-28

Radhakrishnan, S. (ed.), *Rabindranth Tagore: A Centenary Volume, 1861-1961*, New Delhi: Sahitya Akademi, 1961

Tripathi, Manote, 'A Poet Remembered', Bangkok: *The Nation* newspaper, 13 June 2011

On early advertising and pha lai textile production in Thailand

Nawigamune, Anake, *Thai Advertisement Vol. 1 and Vol. 2* [Thai language], Bangkok: Saitarn publishing, 2008

Nawigamune, Anake, *Thai Merchants in the 1930s* [Thai language], Bangkok: Saengdao, 2016

Rakwitthayasart, Mana, *Brief History of Thai Printed Textiles* [cremation volume of Praneet Rukwitthayasart, Thai language], Bangkok: Graphic Art, 1984

On the Indian National Army (INA) in Thailand

Beaumont, Roger, *The Hidden Truth: A Tribute to the Indian Independence Movement in Thailand*, London: Minerva Press, 1999

On the jute industry in Thailand

Economic & Political Weekly, 'FAO Assesses 1970/71 Jute Needs', *Economic & Political Weekly*, Vol. 5., No. 8 (Feb. 21, 1970): pp. 358

Mahmood, Muhammad and Ross A. Williams, 'The World Jute Market', *The Bangladesh Development Studies*, Vol. 9, No. 4 (Autumn 1981): pp. 113-122

Reports: Annual reports of the Thai Jute Association

3.6 Singapore
On history of Singapore

Jayapal, Maya, *Old Singapore*, Singapore: Oxford University Press, 1992

Liu, Gretchen, *Singapore: A Pictorial History, 1819-2000*, Singapore: Archipelago Press, 1999

Newspapers: *The Straits Times* and *The Singapore Free Press and Mercantile Advertiser* (1884-1942)

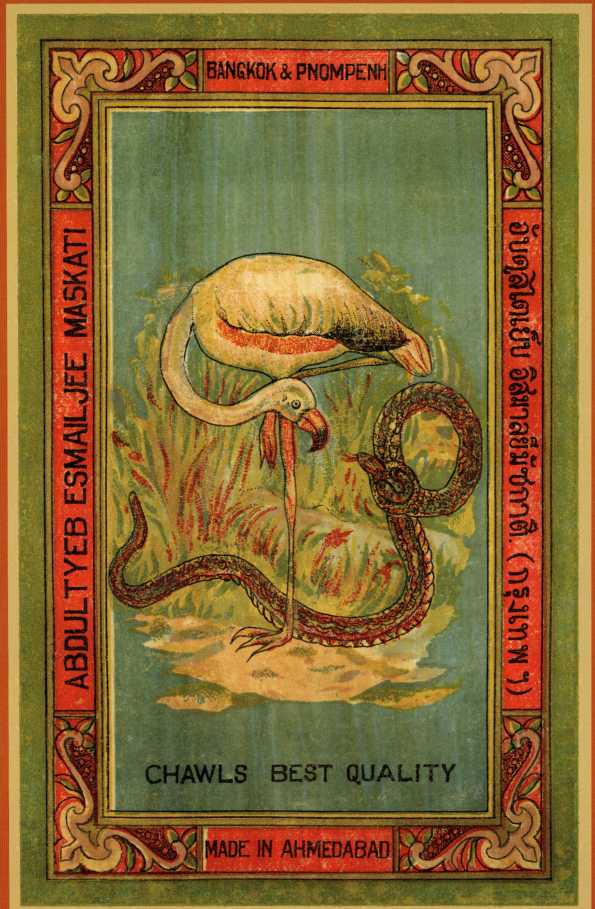

ACKNOWLEDGEMENTS

Many people have been incredibly helpful over the years it has taken to compile this book, generously sharing their time and energy to help piece together company histories, unearth documents, find books and articles, tour various properties and neighbourhoods, and share memories of childhood, family and friends.

In Cambodia: H.E. Son Soubert
In Canada: Bashir Karachiwala
In India: Anjuman-I-Islam Association, Tyebjee Anik, Mohsin Contractor, Abbas Janati, James Joseph, Rezoo Joseph, Aidoon Kajiji, Niloufer Kajiji, the late Rehana Kanthawala, Shahib Kanthawala, the late Maneklal T. Kajjar, Savan Kothari, Satish C. Malhotra, Homi Mehta, Jamil Merchant, the late Shirin Mogul (and her sisters Zarina and Zaitoon), Yasin Savaijiwala, Kunjlata Shah, Silpa Shah (and Tapi Collection staff), Sudha Shah, Usha Thakkar, Munis Varawalla, Abid Zaveri, Altaf Zaveri
In Japan: Osamu Izum
In Singapore: The late Aziz Abbasbhoy, Razia Attaree, Jamshed K. Fozdar, Rosy Nakhooda, Shoeb Mohamedbhai Vasi
In Thailand: Choomchet Arif, Nanda Basu, the late Rachani Kajiji, Husamuddin B. Kapasi, Yunus Mogul, Rabil Pornpatkul, Narong Raumbanleang, Dawn F. Rooney, the Thai Jute Association, Paothong Thongchua, Viratham Trakulngeonthai, S.K. Graphic Arts (River City, Bangkok), Justin Waller

Photo credits

Every effort has been made to trace copyright holders and to obtain their permission for the use of copyright material. The publisher apologizes for any errors or omissions in the below list and would be grateful if notified of any corrections that should be incorporated in future reprints or editions of this book. The images of fabric used throughout the book are from the Maskati private collection, photographed by Paisarn Piemmettawat, 2017.

Cover	Maskati Family Archive
Page 5	Maskati Family Archive
Page 6-7	Maskati Family Archive
Page 8	Courtesy Osian's Archive & Library Collection
Page 10	Altaf Zaveri, 2017
Page 17	(2 photographs) John Thomson, 1865-1866, from Siam: *Through the Lens of John Thomson 1865-66*, River Books
Page 19	Courtesy New York Public Library Digital Collections
Page 20-21	Folding book of Buddhist cosmology (Traiphūmlōkwinitchai), 1776, courtesy Museum for Asian Art, Berlin
Page 22	Photograph of lacquerware details, River Books
Page 23	(Top, etching) courtesy S.K. Graphic Arts, River City, Bangkok; (photograph, bottom) Prapassorn Posrithong, 2004
Page 24	Courtesy S.K. Graphic Arts, River City, Bangkok
Page 27	(Top, 2 photographs) John Thomson, 1865-1866, from *Siam: Through the Lens of John Thomson 1865-66*, River Books; (bottom) River Books
Page 28	(Left, etching) River Books
Page 28-29	(Backdrop) courtesy Mary Evans Picture Library
Page 31	River Books
Page 32	(Top, queen) River Books; (below, man) courtesy Prince Damrong Archives; (below, child) courtesy Paisarn Piemmettawat

Page 33	(2 photographs, left) John Thomson, 1865-1866, from *Siam: Through the Lens of John Thomson 1865-66*, River Books; (2 photographs, right), Francis Frith, 1850-70 © Victoria & Albert Museum, London
Page 34	(4 photographs) Francis Frith, 1850-70 © Victoria & Albert Museum, London
Page 36	(Left) Prapassorn Posrithong, 2010; (coloured etching, inset) courtesy S.K. Graphic Arts, River City, Bangkok
Page 37	(Top left, woman), Gustav R. Lambert, 1890s; (middle left, woman), Robert Lenz, 1890s; (bottom left, women & children), Gustav R. Lambert, 1890s, all courtesy Paisarn Piemmettawat; (right, postcards), Maskati Family Archive
Page 38-39	(Top, ceiling mural), Sakib Maskati, 2007; (middle, hanging lamps), Paisarn Piemmettawat, 2017; (bottom, wall cabinet), Paisarn Piemmettawat, 2017; all other photographs, Maskati Family Archive
Page 42	(Photograph and postcard) Maskati Family Archive
Page 43	(Top) River Books; (bottom, postcard) courtesy New York Public Library Digital Collections
Page 44-45	Courtesy S.K. Graphic Arts, River City, Bangkok
Page 48	(Postcards) Maskati Family Archive
Page 50	(Top, postcard) Maskati Family Archive; (bottom) from *Ruins of Angkor: Cambodia in 1909*, River Books
Page 51	(Postcards) Maskati Family Archive
Page 53	River Books
Page 54	(Left) Maskati Family Archive; (inset) Paisarn Piammettawat, 2017
Page 55	Realistic Travels Publisher, Maskati Family Archive
Page 56	Courtesy Paisarn Piammettawat
Page 58	Courtesy National Archive Thailand
Page 59	Robert Lenz, 1900s, courtesy Paisarn Piemmettawat
Page 60	Courtesy Sakchai Phanawat
Page 62	Maskati Family Archive
Page 65	Maskati Family Archive
Page 66	All photographs, Maskati Family Archive
Page 70-78	All images, Maskati Family Archive
Page 80	(Far left and bottom) Paisarn Piemmettawat, 2017; (top right) from *Sadet Praphutajaoluang* (Thai language, Matichon); (middle, right) courtesy Paisarn Piemmettawat
Page 81	All photographs, Maskati Family Archive
Page 82	River Books
Page 83	All photographs, Maskati Family Archive
Page 84-85	All images, Maskati Family Archive
Page 88-89	All photographs, Maskati Family Archive
Page 90	Paisarn Piemmettawat, 2017
Page 91	(Top, photograph) Maskati Family Archive
Page 92	(Top, 2 photographs) Maskati Family Archive; (bottom, 2 drawings) courtesy Jamil Merchant
Page 94	Maskati Family Archive
Page 96-97	(Notebook) Maskati private collection
Page 98	(Left, photograph) courtesy National Archive Thailand; (right) courtesy Osian's Archive & Library Collection
Page 99	(Left, advertisement) from *Thai Advertisement, Vol. 2, 1920s*, by Anake Nawigamune, Saitharn Publication House; (right, labels) Maskati private collection
Page 100	Maskati Family Archive
Page 101	(2 advertisements) courtesy Kyoto University Library, Japan

Page 102	(3 photographs) Maskati Family Archive
Page 103	(Top) Maskati private collection; (bottom, advertisement) courtesy Kyoto University Library, Japan
Page 104	Maskati Family Archive
Page 105	(Top) courtesy Paisarn Piemmettawat; (inset) Maskati Family Archive
Page 106-107	All photographs Maskati Family Archive
Page 108	(Map) courtesy S.K. Graphic Arts, River City, Bangkok
Page 109	Maskati Family Archive
Page 110	Paisarn Piemmettawat, 2017
Page 111	(Right, 2 photographs) Paisarn Piemmettawat, 2017
Page 116-120	All photographs, Maskati Family Archive
Page 121	Courtesy Paisarn Piemmettawat
Page 122	(Bottom) Maskati Family Archive
Page 123	(Bottom) courtesy H.B. Kapasi
Page 124	(Letter) courtesy H.B. Kapasi
Page 125-126	All photographs, Maskati Family Archive
Page 128	All photographs, Ariyant Manjikul
Page 129	Maskati Family Archive
Page 130-131	(Photographs and documents) Maskati Family Archive
Page 134-140	All photographs, Maskati Family Archive
Page 141	(Top) Courtesy Shahib Kanthawala; (bottom, 2 photographs) Maskati Family Archive
Page 142-146	All images, Maskati Family Archive
Page 150-151	All photographs, Maskati Family Archive
Page 152	(Top, right) Paisarn Piemmettawat, 2017; all other photographs Maskati Family Archive
Page 153-155	All photographs, Maskati Family Archive
Page 159	Maskati Family Archive
Page 161	(Top) Paisarn Piemmettawat, 2017; (bottom) Maskati Family Archive
Page 162-163	(Top) Anuchit Tangphrakittikhun; (bottom) Maskati Family Archive
Page 165	Maskati Family Archive
Page 169	Maskati Family Archive
Page 170	(Top, 2 photographs) Maskati Family Archive; (bottom) Paisarn Piemmettawat, 2017
Page 172-173	Maskati Family Archive
Page 176	© Victoria & Albert Museum, London
Page 177-178	All photographs, Paisarn Piemmettawat, 2017
Page 179	(Top) Paisarn Piemmettawat, 2017; (bottom) courtesy Dr. Sitthichai Smanchat
Page 180	Paisarn Piemmettawat, 2017
Page 181	(Top) Prapassorn Posrithong; (bottom left) © Victoria & Albert Museum; (bottom right) Paisarn Piemmettawat
Page 185	Courtesy Paisarn Piemmettawat
Page 186	Courtesy Osian's Archive & Library Collection
Page 190	Courtesy Osian's Archive & Library Collection
Page 195	Courtesy Osian's Archive & Library Collection
Page 200	Courtesy Osian's Archive & Library Collection
Page 204	Maskati private collection